Japanese Lacquer, 1600–1900

SELECTIONS FROM THE CHARLES A. GREENFIELD COLLECTION

Japanese Lacquer, 1600–1900

SELECTIONS FROM THE CHARLES A. GREENFIELD COLLECTION

ANDREW J. PEKARIK

The Metropolitan Museum of Art

This volume is the catalogue of an exhibition of
selections from the Charles A. Greenfield
Collection, shown at The Metropolitan Museum
of Art, September 4–October 19, 1980.

Published by The Metropolitan Museum of Art,
 New York
Bradford D. Kelleher, Publisher
John P. O'Neill, Editor in Chief
Rosanne Wasserman, Editor
Doris L. Halle, Designer

Library of Congress Cataloging in Publication Data

Pekarik, Andrew J.
 Japanese lacquer, 1600-1900.

 "Catalogue of an exhibition from the Charles A.
Greenfield collection, held at the Metropolitan
Museum of Art, September 4–October 19, 1980."
 Bibliography: p. 138
 Includes index.
 1. Lacquer and lacquering—Japan—Exhibitions.
2. Greenfield, Charles A.—Art collections—Exhibi-
tions. I. New York (City). Metropolitan Museum of
Art. II. Title.
NK9900.7.J3P44 745.7'2 80-18588
ISBN 0-87099-247-3

Jacket: Writing box no. 37 with spitting courtesan

Contents

Director's Foreword

Japanese lacquer is a special art. Working with unlikely materials—viscous lacquer sap, flaked and powdered metals, pieces of shell and ceramic—the lacquer artist creates objects of unusual refinement. In addition to the training of eye and hand and the cultivation of creative imagination, requirements of every art, a lacquerer must learn patience and devotion to detail, for his work is an elaborate construction of the most minute parts. Almost all lacquers are designed for use and are ordinarily handled; thus the collector's visual pleasure is enhanced by the sensuality of touch. The elegance of these exquisite implements reflects the sophisticated aesthetic of the lacquer patron.

The pioneer French collector of lacquer, Louis Gonse, claimed that Japanese lacquers are "the most perfect and finest objects ever issued from the hand of man." His point can easily be appreciated by anyone who considers the Charles A. Greenfield Collection. From writing boxes decorated with scenes that carry subtle poetic allusions, to tiny medicine containers with more popular themes, the wares in this exhibition combine visual richness with amazing technical facility. Mr. Greenfield has painstakingly assembled his large collection throughout a period of more than fifty years. Always concerned with quality, condition, and rarity, he has gathered an impressive range of lacquer boxes, removing lesser examples from his collection as more distinguished ones were discovered. Resourceful and persistent, Mr. Greenfield seldom failed to acquire a piece he coveted. Mr. Greenfield collected worldwide. He bought directly from Japan and from the finest collections in the United States. From the lacquers gathered by his friends Demaree and Dorothy Bess, which became available to him after the death of Mr. Bess, he was able to obtain superior examples previously in European collections. The result of his careful and tasteful selection will be evident to visitors to the exhibition and to the readers of this book.

Many people have contributed their efforts to creating this volume and mounting the exhibition. Special recognition for the design of the book is due to Doris Halle of the Museum's Design Department. Ms. Halle also assisted with exhibition preparations. Julia Meech-Pekarik, Associate Curator, Department of Far Eastern Art, has organized the exhibition. Exceptional photographs were provided by Otto E. Nelson especially for this publication; he was assisted by Rosanne Wasserman and Maureen Limond of the Museum's Editorial Department. Ms. Wasserman skillfully edited the catalogue, working closely with the author, the collector, and experts in the Department of Far Eastern Art.

Above all, the Metropolitan Museum wishes to thank Charles A. Greenfield, without whose generosity and patience neither the exhibition nor this volume could have been realized.

Philippe de Montebello

DIRECTOR
THE METROPOLITAN MUSEUM OF ART

Preface

Lacquerers were more active during the period 1600–1900 than at any other time in Japan. In general they were not unduly pressed by economic or political difficulties, their works were in demand, and the best of them received public recognition and personal reward. Native techniques had been fully developed and were being cross-fertilized by ideas imported from China and the West. Under such favorable conditions this three-hundred-year period became a creative peak in the long history of Japanese lacquer.

Although the Charles A. Greenfield Collection includes lacquer from the tenth century to the present, the majority of the objects were made after 1600. Due to the smaller scale of production and the upheavals of the fifteenth and sixteenth centuries little of the earlier lacquer survives. The later lacquers were discovered by the West when Japan was reopened from its self-imposed isolation in the mid-nineteenth century. The demand for these artworks was so great that, as in the case of the woodblock prints from the same period, many of the best had been exported to the West by the early twentieth century.

For over fifty years Mr. Greenfield has gathered the finest examples from these old collections and supplemented them with direct purchases from Japan, to create a comprehensive survey of three hundred years of lacquer history. Almost all of the Greenfield lacquer wares are boxes, and his collection of the small medicine boxes called *inrō* is unsurpassed. *Inrō* are the most characteristic lacquer ware of the period. Their tiny surfaces compelled restraint when lacquerers were generally tempted by excess, and their role as items of dress made them appropriate for design and technique experiments.

The *inrō*, incense containers, writing boxes, and other lacquers shown here were meant to be functional, although many of them have been so highly valued since the time of their creation that they have hardly been used at all. Almost all Japanese art is functional. In fact, the distinction between the crafts and the fine arts was unknown to the Japanese before its introduction from the West in the mid-nineteenth century. Painting, sculpture, ceramics, lacquer—all were professions producing items for daily use and enjoyment. This respect for utilitarian art was expressed as long ago as the early eleventh century in Lady Murasaki's novel, *The Tale of Genji* (translated by Edward G. Seidensticker; New York: Alfred A. Knopf, 1976):

> Let us think of the cabinetmaker. He shapes pieces as he feels like shaping them. They may be only playthings, with no real plan or pattern. They may all the same have a certain style ... they may take on a certain novelty as times change and be very interesting. But when it comes to the genuine object, something of such undeniable value that a man wants to have it always with him—the perfection of the form announces that it is from the hand of the master. [Vol. 1, pp. 26–27]

The 141 entries in this exhibition have been selected for that perfection of form and they represent a degree of talent, perseverance, and imagination that compels our admiration at the same time that it awakens our curiosity about the conditions under which they were made.

This text was made possible by the generous help of many friends and colleagues. Above all I am deeply indebted to Charles A. Greenfield and to Hakeda Yoshito, Professor of Japanese at Columbia University. Mr. Greenfield taught me how to understand lacquer. Visit after visit he answered my every question, explaining with great clarity. He gave me complete access to the collection, to his notes, and to his library. Professor Hakeda spent many months patiently helping me to read difficult documents, handwritten records, and obscure signatures. His advice, encouragement, and generous assistance are very much appreciated.

During my research trip to Japan I received help from many quarters. In Fukuoka, Ishibashi Hiroshi, Director of the Fukuoka City Museum for Historical Materials, and Tasaka Ōtoshi, Curator at the Fukuoka City Art Museum, gave me valuable information on seventeenth-century lacquer. In Kyoto I was fortunate to have the guidance of Suzuki Mutsumi and his wife Misako, traditional lacquerers, who interrupted a busy exhibition schedule to show me old lacquer, to demonstrate lacquering methods, and to let me try my own hand at complex techniques. Furthermore, they have generously prepared for this exhibition a set of boards illustrating the making of lacquer. Haino Akio, Curator at the Kyoto National Museum, and Yanagi Takashi gave advice, instruction, and the opportunity to study rare lacquers. Ishizawa Masao, Director of the Museum Yamato Bunkakan, Nara, guided my study of important lacquer objects, and Itō Toshiko took me to visit lacquerers and libraries. Both of them generously shared their time and knowledge. Director Tokugawa Yoshi-

nobu and Curator Kinoshita Minoru of the Tokugawa Art Museum, Nagoya, were extremely kind and went to great trouble so that I could carefully study many of the finest lacquers of the Edo period at their museum. In Tokyo I was fortunate to have the help of Arakawa Hirokazu, Curator at the Tokyo National Museum, as well as that of Higuchi Hideo, Chief Librarian. Yonekura Michio of the Tokyo National Research Institute of Cultural Properties helped me to obtain books and articles that I could not find elsewhere. Yanagibashi Tadashi of the Agency for Cultural Affairs gave me access to important study materials, and Uchida Masami of the Suntory Museum of Art allowed me to study lacquer in his museum's collection.

Matsuda Gonroku, the Living National Treasure lacquer artist, took time out from a busy work day to answer my questions and show me his work. Yamaguchi Ryūsen, *inrō* artist, explained his profession and its tools and materials. Takeyama Chiyo graciously introduced me to the incense ceremony and gave me extensive infor-mation on its history and practice, as well as an appreciation of its subtle pleasures.

At The Metropolitan Museum of Art I am grateful to Professor Wen Fong, Special Consultant for Far Eastern Affairs, for his wholehearted support and to John P. O'Neill, Editor in Chief. Above all I am indebted to Julia Meech-Pekarik, Associate Curator, Department of Far Eastern Art, who guided and coordinated this project from its inception and assisted me in more ways than I could begin to list. I am very grateful to Otto and Marguerite Nelson for their outstanding photographs and to Rosanne Wasserman of the Metropolitan Museum for her help in editing the text, supervising photography, and guiding the production of this book. I would also like to express my thanks to my other expert editor, Jane Herman, and to Jean Schmidt, Yasuko Betchaku, Marise Johnson, Tasia Pavalis, Stephanie Wada, Mary White, and Megan Baldridge of the Metropolitan Museum who have helped me in the preparation of this book.

CHRONOLOGY

Jōmon Period	ca. 8000 – 300 B.C.
Yayoi Period	300 B.C. – A.D. 300
Kofun Period	300 – 552
Asuka Period	552 – 645
Hakuhō Period	645 – 710
Nara Period	710 – 784
Heian Period	784 – 1185
Kamakura Period	1185 – 1333
Muromachi Period	1333 – 1573
Momoyama Period	1573 – 1615
Edo Period	1615 – 1867
Meiji Period	1867 – 1912
Taishō Period	1912 – 1926
Shōwa Period	1926 – present

NOTE ON JAPANESE PRONUNCIATION AND NAMES

In the English transliterations of words, the vowels *a, e, i, o, u* should be pronounced *ah, eh, ee, oh, oo*. Each vowel should be sounded separately; for example, *makie* is pronounced *ma-key-eh*. The consonants should be pronounced as in English, with *g* always hard, as in *get*.

All Japanese names are given with the surname first. Subsequent references to the same name follow the Japanese custom, using only the given name or the art name for individuals who lived before the twentieth century.

1 The Art of Japanese Lacquer, 1600–1900

Looking uncomfortable and worried, an early sixteenth-century lacquer artist (Fig. 1) brushes a final coat of lacquer on the kind of basin that high-ranking men and women used for washing their hands. In the text that accompanies this illustration, he bitterly recalls the order: "'Cover it all over with gold powder,' they said, 'there's nothing to it.'" Working in villages or on large estates, most lacquerers were paid so little that they could not afford to work without an advance to buy materials, and they were completely dependent on their feudal lords, their chief clients.

After Japan was unified at the end of the sixteenth century and the first Tokugawa shogun, Tokugawa Ieyasu (1542–1616), established a new feudal government, the status of craftsmen changed markedly. Trade barriers fell, commerce increased, and artisans left the countryside and moved into the burgeoning towns that surrounded the castles of local rulers. Lacquer wares were bought by a newly expanded consumer class that included aristocrats, the traditional patrons of lacquer; samurai who had left their farms; and merchants, as well as other craftsmen. Everyone benefited from the general prosperity that the newly achieved peace and stability had brought.

Nakama, professional organizations similar to the European guilds, were established. They bound the independent craftsmen together and protected them from excessive competition. In general, the flood of commissions considerably improved the lot of the seventeenth-century lacquer artist.

The Tokugawa government recognized four major classes of citizens:

samurai, farmers, artisans, and merchants. These groups were not exclusive; depending on economic conditions, there was some mobility between them. Every feudal lord, for example, numbered among his dependents a group of artisans who occupied official positions in his organization. Like other retainers, they received regular stipends, special privileges, and housing. Some artisans were even allowed to continue wearing their swords as if they were still warriors. The samurai, or military class, was theoretically superior to artisans, but was nonproductive. In the eighteenth and nineteenth centuries, feudal lords with economic problems encouraged or required many of their vassals to become artisans, while other samurai voluntarily chose that course because their fixed stipends were diminished by inflation. At the same time, some artisans were rewarded with samurai status or became successful merchants.

In 1600, lacquering had already been a major profession in Japan for over a thousand years. The art is said to have begun when the legendary prince Yamato Takeru broke a branch from a tree during a hunting expedition. He admired the oozing black sap so much that he had it applied to his things. When it hardened, he was so pleased with the results that he established a lacquer workshop.[1] Actually, the sap of the Japanese lacquer tree is a milky gray color.[2] In Southeast Asia, there are lacquer trees with a naturally black sap, but in China and Japan the rich black color is the result of special additives and techniques that were developed very early in Japan. The oldest extant examples of Japanese

lacquer are from the Jōmon period (ca. 8000–300 B.C.); red and black lacquer was applied to some pottery and wooden objects to protect and beautify them.[3] The hardening of lacquer is a chemical reaction that takes place in high relative humidity, ideally eighty percent. Because the hardened lacquer is impervious to liquid, it not only beautifies but also preserves more fragile materials.

Great advances in lacquer decoration were made during the Nara period (A.D. 710–784), when Japan assimilated many aspects of continental Asian culture. The Shōsō-in, Nara, a repository of treasures belonging to Emperor Shōmu (701–756), contains lacquer objects skillfully decorated in a variety of techniques using inlay and metal powders. It is impossible to determine whether these impressive works were made in Japan or imported from China, but beginning with the mid-eighth century, the most characteristic Japanese lacquer decoration consisted of gold or silver powders applied over a deep black ground. Such lacquers are known as sprinkled designs (*makie*) because the embellishment is drawn in wet lacquer and metal powders or flakes are sprinkled over it. As the lacquer hardens, the powders are trapped in the pattern of the drawing. They are usually protected by a thin coat of transparent lacquer applied over the drawing. The design is polished with sticks of charcoal after the protective coat dries. Although this technique was inspired by or perhaps learned from the Chinese, it continued to develop in Japan while it was completely neglected in China. One fifteenth-century Ming emperor sent a Chinese lacquerer to

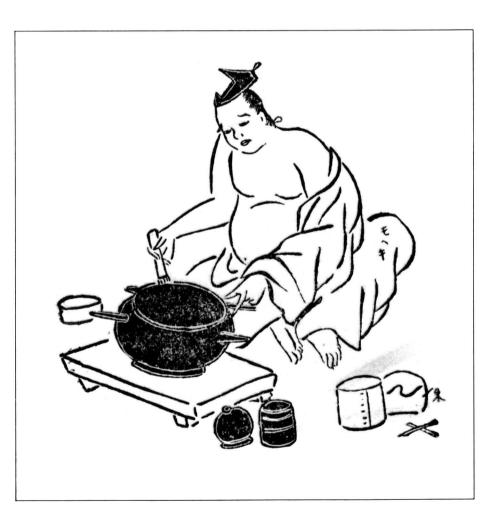

*Fig. 1. Sprinkled-design artist (*makieshi*)
at work. Late fifteenth century. Kanroji, ca.
1500, p. 515*

Japan to learn the techniques of *makie* that he admired on imported Japanese wares, but Chinese lacquerers continued to favor other techniques.[4]

The Japanese applied lacquer to everything—from temple pillars to sword scabbards. Under Chinese influence, the typical upper-class Japanese home of the Heian period (784–1185) contained many lacquered furnishings, including tables, stands, and boxes. Because native ceramics were not very refined, most of the eating utensils were also decorated with lacquer. Demand for fancy sets of lacquered utensils declined in the thirteenth century when authority passed to less sophisticated warriors. It was revived, however, under the Ashikaga shoguns in the fifteenth century.

By the beginning of the Edo period (1615–1867) the art of lacquer, especially sprinkled designs, was fully developed, as the first catalogue entry shows. The rectangular box, containing a tray (Fig. 2; colorplate 1), and the cylindrical container that matches it (Fig. 3) are from a large set of utensils that originally included scores of

boxes and a number of multileveled stands on which to display them. Inside these boxes were smaller boxes. The rectangular box may have been one of the convenient containers in which a lady would keep small utensils. The round box probably fit inside a cosmetic box. The designs on each piece in the set were carefully coordinated. Still in the collection of the Kuroda family is another part of this set, a box with drawers containing a complete manuscript of *The Tale of Genji,* Lady Murasaki's well-known early eleventh-century novel.

The swirling wisteria design on these boxes is the Kuroda family crest and the inset geometric design is the Ogasawara family crest. These lacquers were made when Kuroda Mitsuyuki (1628–1707), later the third-generation lord of Fukuoka, married Ichimatsu, daughter of Ogasawara Tadazane (1596–1667), lord of Kokura. Fukuoka and Kokura were large, neighboring fiefs in the north of Kyushu, the southernmost of the four main islands of Japan. Since the marriage took place in 1647, these boxes would have been commissioned be-

Fig. 2. Rectangular box no. 1 with bamboo, peony-rose, and crests. Ca. 1647. 19 x 22.7 x 12.1 cm.

Fig. 3. Cylindrical container no. 1 with bamboo, peony-rose, and crests. Ca. 1647. D. 5.6, H. 4.4 cm.

fore that date by the father of the bride.

Large sets of lacquer ware were required by all lords with eligible daughters and several types of lacquerers were available to make them. The most important sets were commissioned from the old, established families of lacquer workers. The most famous and most complete of the seventeenth-century marriage sets is the Hatsune set, belonging to the Tokugawa Art Museum, Nagoya, made by Kōami Nagashige (1599–1651) for the daughter of the shogun Iemitsu between 1637 and 1639. Nagashige had to employ numerous assistants and disciples in order to produce so many complex and detailed works in such a short period.[5]

Every important lord had his own staff of lacquer artists. The Kuroda family, for example, had their own lacquer workers as early as 1602.[6] They were among his better-paid artisans and received annual stipends of 100 *koku*, a small sum compared to Lord Kuroda's annual income of 520,000 *koku*. The records of the Ogasawara family are unavailable, but the marriage set made for Ogasawara

Tadazane's daughter was probably made by his own official lacquerers.

Much care and skill has been lavished on the boxes no. 1. Although the rectangular box has suffered some damage, the wooden core was dried so thoroughly that it has neither cracked nor warped. On top of the wooden core, foundation layers of lacquer were added to seal the core and provide a smooth base for the background of gold flakes that was applied on all surfaces. This background was produced by sprinkling relatively large flakes of gold evenly and densely over a layer of wet lacquer. After the lacquer with the flakes embedded in it hardened, covering layers of translucent lacquer were applied, allowed to harden, and lightly polished.

Glittering gold-flake grounds (*nashiji*) like that on box no. 1 (see Fig. 4) are a unique characteristic of Japanese lacquer work. *Nashiji* (literally "pear ground") received its name because of its slightly irregular surface and is translated as "aventurine" because of its resemblance to a type of Venetian glass with that name. Inside these boxes, the aventurine is

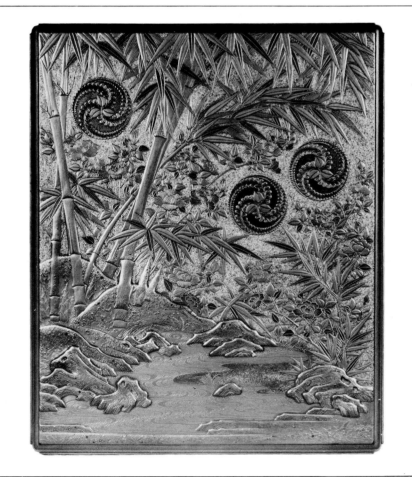

Fig. 4. Detail of nashiji, *rectangular box no. 1*

Fig. 5. Rectangular box no. 1, under lid

somewhat orange in tone because the gold is seen through the amber lacquer covering it. On the outside, however, some of the surface coating has worn away and exposure to light and air has increased the transparency of the topmost layers of lacquer so that the aventurine is much yellower and closer to the natural color of the gold flakes.

On top of this aventurine ground the artist drew his design in lacquer. When he wished the design to stand out in relief, as in the case of the bamboo and rocks, he used a lacquer thickened with powders. The final design was colored by sprinkling different alloys and densities of gold powders. Additional highlights were added by inlaying small pieces of gold foil and a few gold nuggets in the rocks and at the bamboo joints. Each type of gold powder was applied separately over the wet lacquer and polished. Despite the repetitions of such a delicate and tedious process, the finished result is relaxed and realistic.

The flowers and plants of the design symbolize the virtues of the bridal couple and the felicity of their union. The bamboo is noted for its numerous offshoots, many of which are visible on the cover of the box, and probably refers to the groom. The flower beside the bamboo is a peony-rose, a type of rose with a peonylike blossom. The peony connotes abundance of wealth and happiness while the rose is auspicious because it blooms in all four seasons, suggesting unending youthfulness.

The dominant flower on the underside of the lid of the rectangular box (Fig. 5) is a relative of the rose native to Japan, called *yamabuki*. A 1705 work on flowers by the poet Morikawa Kyoroku (1656–1715) directly identifies it with feminine charms: "The *yamabuki* is fresh and pure, with excellent features, a fine nose, a lovely neck, and what can be called natural translucence."[7] The tray that fits inside the box is decorated with water plants in autumn. This fall imagery may be meant to suggest maturity and fruition just as the spring design on the lid represents youth and potential.

Large sumptuous wedding sets of lacquer utensils, such as the one made for Lord Ogasawara's daughter,

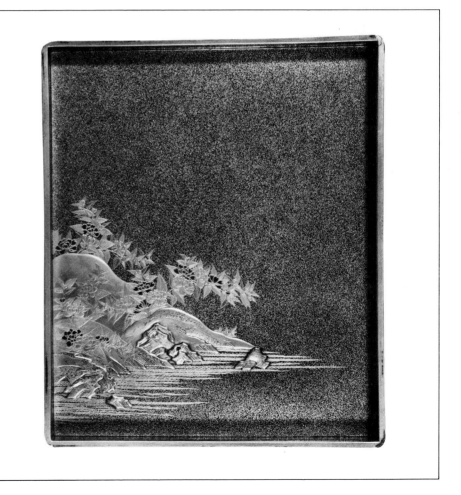

were a bride's most important possession but were often considered too precious and costly to use. The Hatsune set was taken out of its wooden storage boxes only for display on important occasions. Although each part of a set was utilitarian in design and construction, the true function of the set was symbolic, signifying the social importance of the bride and the high regard in which she was held by her family. For subsequent generations the set was an heirloom and a reminder of the glory of their lineage.

In addition to artists retained by important lords, independent lacquerers in the cities made fine wares, like the writing box no. 2 with a design of a carriage by the shore (Fig. 6; colorplate 2). There are no family crests on the box, which was meant to be used rather than treasured, but the literary theme of the design would have appealed to the conservative taste of the aristocracy. The carriage, a type that was pulled by an ox and commonly used by Kyoto nobility until the mid-fifteenth century, alludes to *Yūgao,* the fourth chapter of *The Tale of Genji.* It tells of the amorous prince Genji's affair with an attractive but timid woman whom he discovered in an out-of-the-way place in Kyoto and secretly visited. One morning he took her away in his carriage to a deserted mansion where they spent the day together. That night the lady died in her sleep, presumably the victim of the jealous spirit of another of Genji's women. Genji was deeply troubled by the eerie episode. The lady's funeral was held in secret and Genji fell dangerously ill with grief. He recovered near the end of the ninth month, the height of autumn, a season the Japa-

nese find particularly poignant.

Designs based on this melancholy chapter are frequently found on seventeenth-century lacquer boxes. The version on no. 2 does not literally depict any moment in the story, but provides a subtle evocation of mood by a clever combination of literary clues. The unhitched carriage identifies the basic theme and recalls Genji's abduction of the lady. Beside the carriage is a blossoming autumn plant called *fujibakama,* which is known for its fine fragrance and traditionally reminded the ancient poets of absent friends. The fernlike plant beside the *fujibakama* is called *shino-bugusa* ("longing grasses") and is also used in poetry to symbolize the poet's longing for lost or absent loves. The seashore setting alludes to Genji's lady. Because he was afraid of rumors that would damage his reputation at court, Genji had refused to identify himself to her. She, in turn, refused to tell him anything about her background, describing herself facetiously as a fisherman's daughter.

The artist or his client was well acquainted with classical literature, for the seascape inside the lid (Fig. 7) and around the inkstone (Fig. 8) includes those poetic images that were commonly associated with unhappiness and longing: pines by the shore, sheds where salt is made from brine, waves, a boat, and shells. They recall immediately the old poems that would have crossed Genji's mind as he sought words to express his sorrow. By remembering these poems we relive Genji's despair:

I have no place to go.
I am adrift like a floating boat
Entrusting itself to the waves.[8]

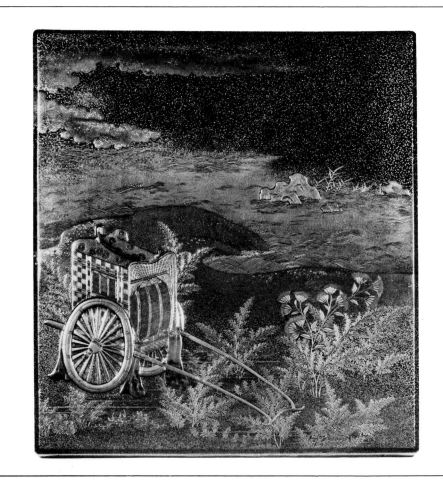

Fig. 6. Carriage writing box no. 2. Second half seventeenth century. 16.9 x 18.5 x 3.8 cm.

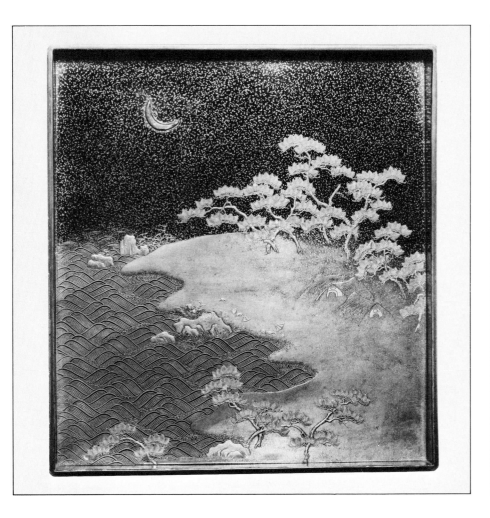

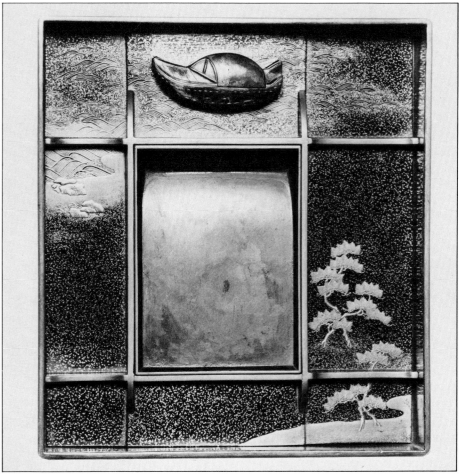

Between the tides I went everywhere
Visiting from shore to shore
But now my life is an empty shell.[9]

The ancient fishermen have died,
Turned into smoke.
On the shore of the salt-kettles
There is no one to be seen.[10]

Am I a pine by the shore
When the winds blow and the
 waves rise
That I should be wet with
 spraylike tears?[11]

Judging by the sophisticated design, the thick strips of gold in the spokes of the carriage wheel, and the silver rim, this writing box was intended for a wealthy aristocrat. The drawing is carefully sprinkled in a range of techniques and materials. The carriage is raised above the surface, and different thicknesses of gold powders depict distance and the texture of sand and earth. Silver, used for variety on and under the carriage, has tarnished with age.

The town lacquerers of the late seventeenth century, under heavy competitive pressure, could not prepare their materials as carefully as they may have liked. In order to guarantee that a box would not warp with age, it was essential that the wood for the core be carefully chosen and dried for many years. When there was not enough time or money to cure the wood properly, the lacquerer had to resort to various devices to reduce the chance of warpage. The lid of the rectangular box no. 1, for example, was made of a single piece of wood onto which the four sides were glued; the lacquer was applied directly to this well-seasoned core. In the case of the carriage box, the wood was not well prepared, so the

top of the lid had to be made of three separate pieces to reduce the possibility of warpage. In addition, a piece of cloth saturated with lacquer was applied over the entire surface of the lid to inhibit cracking. Despite these precautions, the lid became warped.

The preparation of the base wood was important for the durability of lacquer boxes but it did not affect their appearance when new. Unscrupulous merchants took advantage of this:

Once there were two merchants who sold lacquer wares. One of them was consumed with greed, the other was a man of modest desires. Together they went to another province to sell their wares. The greedy man had never discussed with the lacquerers whether the wood bases were good or bad and he had deliberately stocked pieces that were attractive but cheap. The other man sold only wares with high-quality wood bases. When they arrived at their destination they competed furiously, but everyone wanted to buy the cheap lacquer that looked good. So within a few days the greedy merchant had sold everything and went back home. The other man, because of the quality of his lacquer, had to charge a high price and sold his wares very slowly. Eventually, after a number of months, he was able to return home.

The greedy merchant said to him, "You're just an old-fashioned amateur who doesn't know anything about modern-day marketing. If you had gone out with good-looking, low-priced lac-

quers like I did, you would have made a tremendous profit. It's really a shame." The other man answered, "You're right. Because I choose my wares for their fine materials the price is high and they are hard to sell. But I don't want to make a profit if it means having people buy useless things with lacquer that keeps peeling off." [12]

Of course, honesty triumphs at the end of this Edo period tale, for when the two merchants returned to that province no one would buy anything from the greedy merchant.

Traveling merchants had a tremendous influence on lacquer production. They supplied lacquerers with capital in exchange for a steady supply of objects that could be marketed around the country. Because they often bypassed the guild system in the interest of higher profit, they created unfair competition for many town lacquerers.

The writing box no. 3 with a chrysanthemum design (Fig. 9) was probably one of several made in quantity rather than on special order for a client. The chrysanthemums on the lid are drawn in a flattened sprinkled design (togidashi makie), a time-consuming and delicate process in which the surface of the design is made flush with the surrounding lacquer (Fig. 10). On top of the base layers, a background was made by sprinkling gold flakes in wet lacquer. After it hardened, a protective layer of lacquer was added. When that layer was set and polished, the design of chrysanthemums was drawn in wet lacquer and gold sprinkled on it. At this stage the chrysanthemum design in gold was raised above the surface

because of the thickness of the lacquer onto which the gold powder was sprinkled. After the last layer hardened, the entire lid was coated with several layers of relatively clear lacquer. The elevated areas were continually polished with pieces of charcoal until the lacquer layers were rubbed away and the gold design became level with the rest of the lid. A final thin coat of lacquer protected the freshly exposed gold powders.

The art of fine lacquer requires as much skill with the small charcoal sticks as it does with the brush. With too little polishing the chrysanthemums would remain elevated, and with too much polishing the thin layer of gold powder on the design would be rubbed away. Polishing is more difficult at curves and corners and the artist flaunts his talent by leading the design over the curve and tiny ledge at the right side of the lid.

The interior decoration of no. 3 is very simple (Fig. 11). The large gold flakes were probably set into place individually rather than sprinkled. The sides and interior surfaces were not as well polished as the top of the lid, and marks left by the brush that applied the final coat of lacquer are still visible. The master lacquer artist apparently decorated the lid and left the rest of the box to his apprentices and assistants. Although the outside of this tasteful writing box required a good deal of work, the box as a whole could have been made rather quickly, priced moderately, and easily produced in quantity.

In the Suntory Museum of Art, Tokyo, is a writing box of exactly the same size and shape as this one (Fig. 12), and it might well have been made by

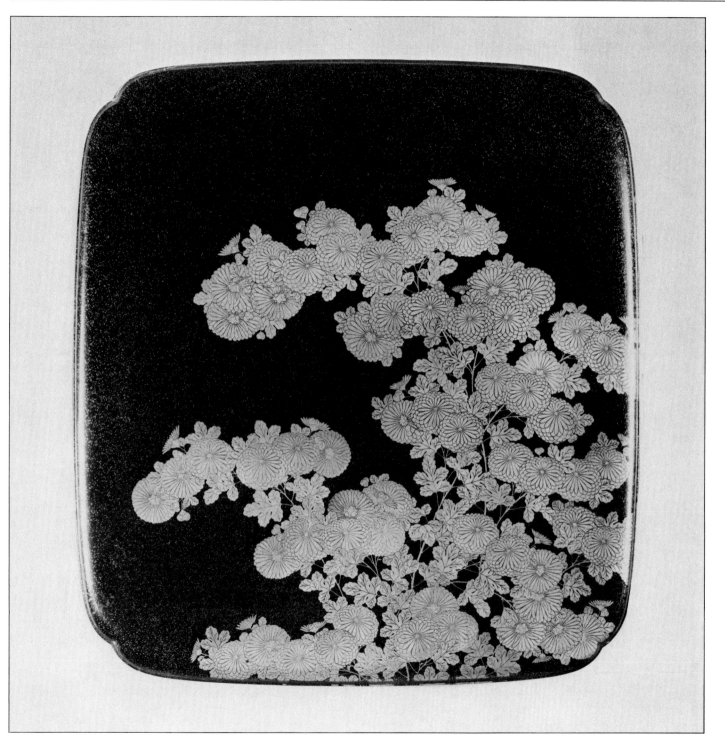

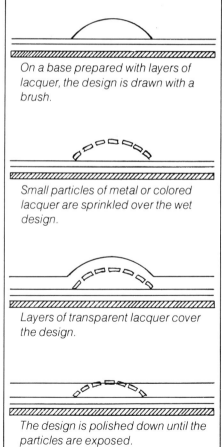

Fig. 9. Chrysanthemum writing box no. 3. Late seventeenth century. 21.1 x 22.9 x 5 cm.

Fig. 10. CROSS SECTION OF FLATTENED SPRINKLED DESIGN (TOGIDASHI MAKIE)

On a base prepared with layers of lacquer, the design is drawn with a brush.

Small particles of metal or colored lacquer are sprinkled over the wet design.

Layers of transparent lacquer cover the design.

The design is polished down until the particles are exposed.

Fig. 11. Writing box no. 3, inside

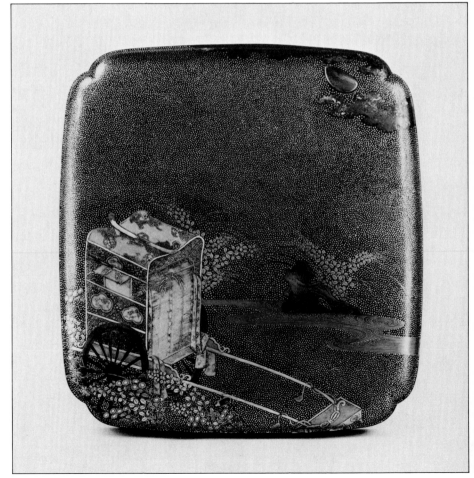

*Fig. 12. Writing box. Seventeenth century.
22.1 x 22.9 x 4.5 cm. Suntory Museum of
Art, Tokyo*

Fig. 13. *A gentleman torn between a man and a woman. Colored woodblock print by Okumura Masanobu (1686–1764). The Metropolitan Museum of Art, Purchase, Fletcher Fund, 1926, JP1499*

This scene from life in the pleasure quarters of Edo shows several types of lacquer. The young man in the foreground wears an inrō and uses a lacquer writing box with a red interior. In the back, the writing-box lid, inverted, is used as a tray for snacks. Other lacquers are the sake cup and stand to the left of the tray and the smoking box in the foreground

the same artist. The Suntory box also has a ground with individually positioned gold flakes and a design concentrated in a lower corner.

When a writing box is used, water is poured from the water dropper onto the inkstone, where it accumulates in the well at the top. The inkstick is rubbed on the flat surface of the stone with some of the water to make the ink. The inkstick is stored in the space between the foot of the stone and the lower edge of the box while the trays to the right and left hold brushes, a paper knife, and a paper punch. In the most expensive writing boxes this equipment had lacquer handles that matched the box design and included a device to hold the inkstick to spare the writer the annoyance of dirty fingers.

Writing boxes appear frequently in Japanese genre paintings, but are usually shown without their lids. Originally, these separated lids were turned top down and used as small serving trays, but by the late seventeenth century this function was being given over to specialized lacquer trays and

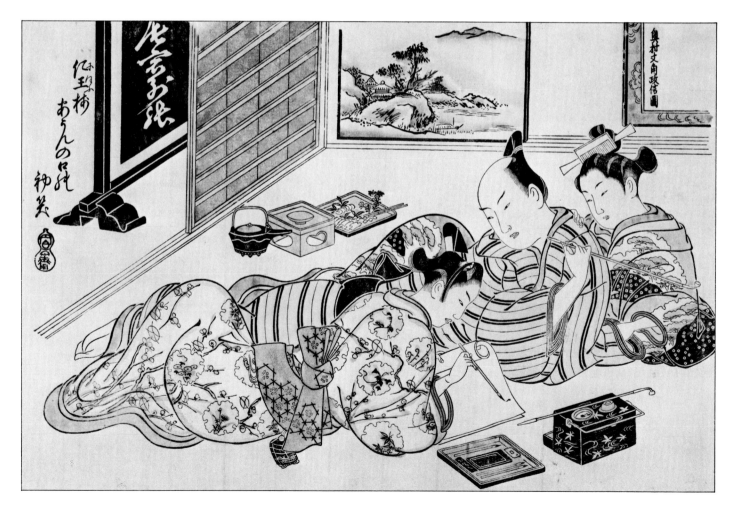

Fig. 14. Incense container no. 4 with two cormorants. Late seventeenth century. 4.6 x 3.5 x 1.8 cm.

stands, and the lids were simply put away for safekeeping (Fig. 13).

In addition to the official lacquerers and town lacquerers of the seventeenth century, there was a third significant group of lacquer artists, the itinerant lacquerers. In the first half of the seventeenth century they were producing work of high quality, but by 1700, when most wealthy clients had moved to the cities and towns, their work was held in low regard. Their life was described by the Confucian scholar Ogyū Sorai (1666–1728):

In my house there is a set of red lacquer bowls that had been made in Ise for my father's great-grandmother. It has been handed down from my father's grandfather to my father and now to me. After more than one hundred years the color is unchanged and the bowls have no cracks and are extremely strong. I have observed that out in the countryside, when they make layered boxes, the lacquerers are not in a hurry. One lacquer worker walks a set section of the province and does his work. He

lives in one place for twenty or thirty days and applies his lacquer. Then he moves elsewhere and works on something else, calculating how long it took for the lacquer he applied in the first location to dry. Then he comes back and applies the sprinkled design. The lacquer itself has also been bought and prepared in advance. Because the wood bases are made well ahead of time they are strong and the result is exactly as he wants it.

A certain retainer of the Toku-gawa family, when he was living in Mikawa, had a daughter who would be getting married one day. From the time when she was four or five years old, he planned for her wedding day and the itinerant lacquerer worked on the various furnishings that would be needed. Every year when he came he would add just one or two colors. When I was small I saw what remained of that set. Because all of the parts were made in advance they were indescribably strong.[13]

Sorai lamented the commercial pressures that forced craftsmen to work as quickly as possible for little reward. Speed is particularly disastrous in the case of lacquer since each of the many layers on a fine work must be thinly and carefully applied, slowly hardened, and painstakingly polished.

Attention to detail at every stage in the lacquer-making process is so important that miniature works are as painstakingly made as the larger boxes. The box no. 4 with two cormorants (Fig. 14) may have been made to be carried inside the fold of a kimono and to hold a small quantity of medicine. In more recent times it would have been used as a container for incense in the tea ceremony.

Medicines were usually carried in layered boxes called *inrō*, a type of lacquer ware unique to the period after 1600. The word *inrō*, literally "seal basket," was used as early as the fourteenth century to describe layered boxes imported from China. According to a much later source, these first *inrō* were in three or four layers and

about 3.5 inches square.[14] As their name suggests, they were originally made to contain seals and seal ink. These seal boxes were standard accoutrements of a scholar's study, and in Japan they were displayed, along with other exotic implements from China, for the admiration of guests. A drawing in a 1523 guide for formal displays shows a layered seal box with cords strung through the cases.[15] What we now call *inrō* are smaller versions of this design. They are thin, layered containers that were suspended from the waist on cords and held medicines, like the *inrō* no. 5 (Fig. 15).

The idea of wearing these lacquer boxes seems to have arisen in Japan about the end of the sixteenth century. In China at that time there was a similar custom. A late sixteenth-century Chinese text describes small round incense containers of three or four layers that were suspended from the waist in groups of three to five.[16]

In the seventeenth century, the Japanese wore their *inrō* together with

small money pouches called *kinchaku*. The two containers, each on its own cord, hung together from a single netsuke, the toggle that kept the cords from slipping out from under the sash. *Inrō* and money pouches seem to have been worn exclusively by men (Fig. 16). At first they were very popular with young samurai, who found them modish and exotic. Military subjects, such as the horses of *inrō* no. 6, are common among early *inrō* (Fig. 17). Their gradual spread throughout society owed much to the growing fascination with the rare medicines that might be carried inside them. The *inrō* is a perfect holder for small quantities of medicine. Each compartment has a tall inner lip, called a riser, over which the lid of the next layer fits. When the *inrō* is carefully made, this fit creates an airtight seal that keeps the contents of each level fresh and uncontaminated.

The knowledge of medicine was brought to Japan by Buddhist priests; for centuries, temples had been centers of care for the sick. It was only natural, then, that the clergy were in the forefront of those interested in the new medicines being imported from Europe as well as China. In his 1664 diary, a monk recorded that while discussing European medicines with a friend, "I mentioned layered boxes with gold designs and he took one from inside his kimono and gave it to me. It held marvelous European medicine."[17]

The new medical materials and formulas, brought first by the Portuguese (until 1638, when they were forbidden to enter the country) and then to Nagasaki by Dutch traders, were enthusiastically received by the Japanese. One of the most exotic of these new medi-

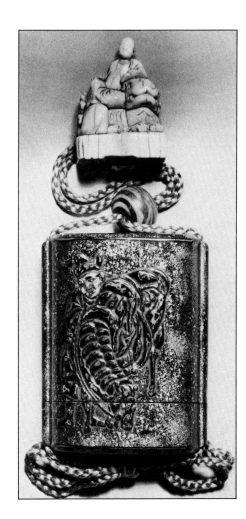

Fig. 15. Inrō no. 5 with horse and attendant. Seventeenth century. 5.5 x 6.8 x 2.4 cm.

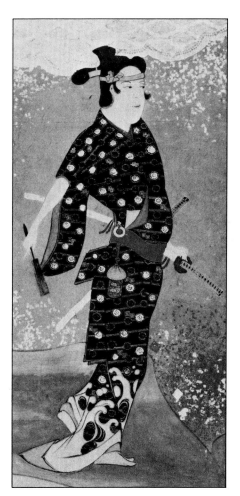

Fig. 16. A young samurai dandy. Detail from a four-fold screen of amusements. Early seventeenth century. Yahata Yōtarō Collection, Tokyo

This young gentleman on a picnic wears the most fashionable style. From his sash, a money bag and an inrō hang, attached to a ring-shaped netsuke. A packet of papers protrudes from the breast fold of his kimono

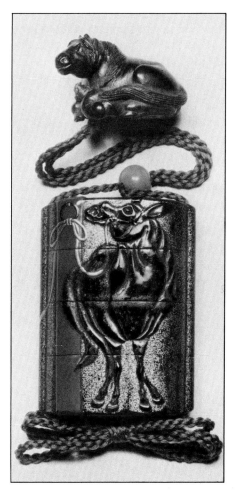

Fig. 17. Inrō no. 6 with horse tied to post. Seventeenth century. 5.0 x 6.7 x 1.8 cm.

cines was mummy powder (*miira*). From the Middle Ages until the eighteenth century, mummies exhumed in Egypt were sent to Europe to be ground into powder that was subsequently included in medicines. The Portuguese, for example, recommended that it be mixed with vinegar and taken internally as a cure for contusions. They brought it to China and Japan in the late sixteenth century. Like the *inrō,* its popularity increased enormously in the seventeenth century. All levels of society, from lords to peasants, took mummy medicine to relieve ills ranging from excessive drinking to chest pains. With all the patent medicines peddled across Japan, the users had no idea what was contained in the pills and powders they consumed. The recipes were closely guarded secrets. When the Dutch first imported whole mummies into Japan about 1700, the more fastidious customers lost interest in mummy powder. Despite its critics and the problem of fake mummies made in Japan, mummy medicine continued in use until the mid-eighteenth century.[18]

The *inrō* no. 7 with dragons (Fig. 18) still has the names of the medicines it once contained written on the undersides of the lids. The top level held *enreitan* ("extending-life pills"), a noted patent medicine of the seventeenth century and later. In 1644 the monk Hōrin Oshō (1593–1668) mentions receiving "two shells of 'extending-life pills.'"[19] Medicines for sale were packaged in seashells, which make a natural box. Six days later he received a shell of *enjūtan* ("extending-longevity pills"), the medicine written on the lid of the second level of this

inrō. These "extending-life pills" were thought to be very effective. They were made from cinnamon, sandalwood, cinnabar, frankincense, camphor, and honey.[20] The monk Takuan Sōhō (1573–1645) thanked a friend for sending him these pills when he was in exile about 1630: "Thanks to them my declining age will be extended so that we can meet again."[21]

The *inrō* no. 7 is unsigned but its shape and design imply that it was made in the seventeenth century. The metal channels in which the cords run are differentiated from the body of the *inrō.* At the top and bottom of the cord channels are demon masks. The aventurine on the inside surfaces is made with finely flaked, high-quality gold similar to that found on the outsides of nos. 5 and 6.

A number of *inrō* in Western collections show foreign, usually Chinese, designs framed in silver scrollwork with distinct cord channels and fine aventurine. Tortoiseshell inlay is also common, as in *inrō* no. 8 with a dragon amid waves (colorplate 3). The translucent tortoiseshell is deeply and expressively carved and is brightened with a gold-foil backing. The soft feel of the raised tortoiseshell makes the *inrō* pleasant to touch and parts of the design have been worn down to the light brown lacquer used to raise the waves.

The group of *inrō* whose style is illustrated by nos. 7 and 8 was probably made in Nagasaki, where foreign influence was strong and tortoiseshell was a major industry. They were probably produced over an extended period of time, but these two *inrō* can be dated to the late seventeenth or early eighteenth century on the basis of the

type of aventurine and small pieces of shell inlaid in the dragon *inrō* no. 7.

It is difficult to date lacquer ware, for lacquer workers were the most conservative of all artists. Popular designs and shapes were deliberately repeated, sometimes over centuries, and most lacquer wares are not signed. As a result, technical details of construction and materials often offer the best clues to the age of the piece. Although lacquer workers on occasion deliberately tried to imitate archaic materials and methods, they generally used those peculiar to their own school and time.

The simplest technical guide to the age of lacquer is aventurine. The gold flakes used in aventurine were rarely pure gold. Alloys of silver and gold were most common, and as gold became increasingly expensive the silver content in the alloy increased. To give this lighter-colored alloy the look of gold, later lacquerers were compelled to add coloring agents to the translucent covering layers of lacquer. This technique was such an effective disguise that it became possible to use pure silver or even flakes of tin if they were buried deep enough in orange-colored lacquer.

The shapes of the gold flakes are also significant. At the beginning of the seventeenth century, lacquerers who specialized in sprinkled designs and aventurine still prepared their own gold powders and flakes. In this busy interior of a lacquer shop about 1600 (Fig. 19) the man with rolled sleeves is making gold powder or flakes that others are sprinkling on wet lacquer drawings. Later lacquerers used powders prepared in advance by specialists.

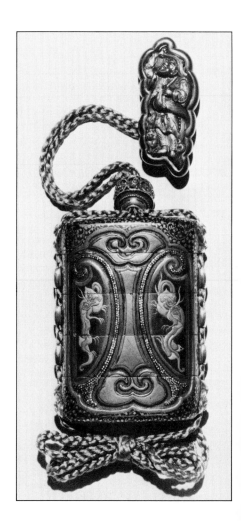

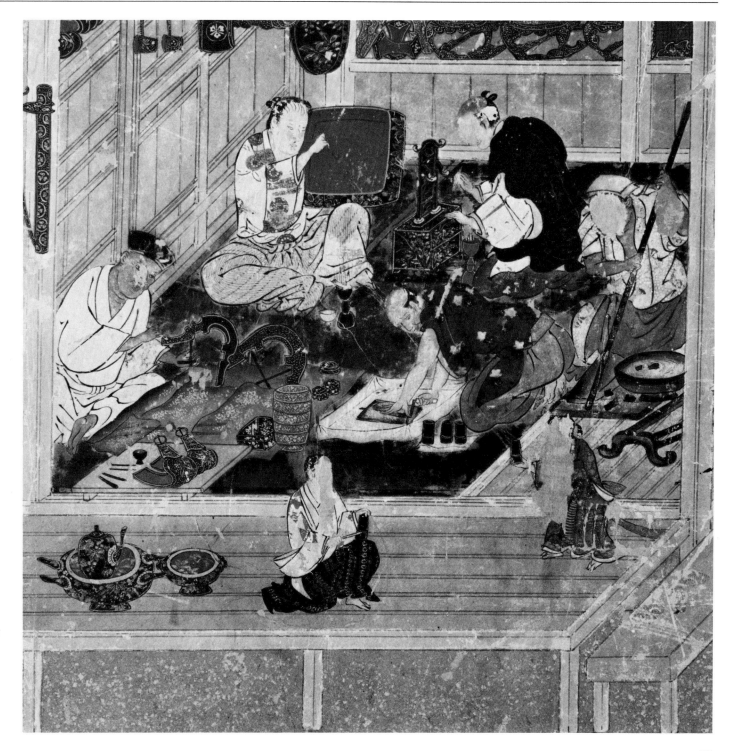

Fig. 19. Sprinkled-design artists at work.
Detail from one of two six-fold screens of
artisans, by Kanō Yoshinobu (1552–1640).
Registered Important Cultural Property,
Kita-in, Saitama Prefecture

This view of a lacquer shop about 1600
shows sprinkled-design artists at work in a
small eight-mat room. Behind and above
the room are living quarters. On the far left,
the head of the family applies sprinkled
designs to a lacquer saddle. Around him
are stirrups, a writing box, a layered food
box, and several small boxes. On the far
right, his wife polishes a pole that is part of
a kimono rack. On the verandah two small
children, a girl at right and a boy at left,
hold containers, perhaps for the gold
flakes made by the man with a green robe
and rolled-up sleeves. He and the man in
the black coat working on the mirror stand
may be apprentices. The eldest son works
on a large red and black tray. Finished
wares are lined up along the back of the
shop or hang from the walls and pillars.
On the verandah in front is a finished set of
pitcher and wash basins

Fig. 20. *Inrō no. 9 with peasants tying rice sheaves. Late seventeenth century.* 5.8 x 7.2 x 2.0 cm.

The raw lacquer also changed gradually during the Edo period as the major production areas shifted to northern Japan. In the seventeenth century, lacquerers bought their lacquer directly from those who gathered it. In the lacquer shop the lowest apprentices were assigned the tedious task of slowly stirring the lacquer in the sun until the water content evaporated and the lacquer turned dark. Raw lacquers were differentiated according to the time when they were gathered, the age of the tree, and the method of collection. Each type had unique characteristics and the lacquerer would blend them into the combination preferred for a particular task, adding oils or coloring agents where necessary. From the early eighteenth century on, however, this preparation was done by newly established lacquer supply shops. These shops began to import inferior Chinese lacquer, but in limited quantities until the second half of the nineteenth century. As a result of these developments, lacquerers were forced to pay more for their materials and could rarely prepare them to their own specifications. They altered their methods of lacquer production accordingly.

The study of technical details is complicated by the effects of age and wear on lacquer. The *inrō* no. 9 with peasants tying rice sheaves, for example, once had an allover sprinkled background (Fig. 20). The gold flakes were sprinkled in a single layer and covered with a thin coating of lacquer. This thin coating became more transparent in time, and frequent rubbing, from both normal use and cleaning, removed much of the gold.

The rice stalks lying on the ground,

the straw hat, and the hanging sheaves on the other side are inlaid pieces of abalone shell, cut from shells that had reached an advanced age. Abalone shell was admired because of its luster and its color.

Since fine lacquer ware was being purchased by a broader spectrum of society in the seventeenth century, lacquer artists were freer in their choice of subject matter. At the same time the wealthier members of society seem to have found new interest in scenes of daily life and the occupations of the less fortunate. A design of field workers preparing rice sheaves would have been unacceptable on the wedding furniture of an important lady or even on the writing box of a conservative aristocrat, but those willing to follow the modern trend found lacquer boxes decorated with people hard at work refreshingly new and amusing. *Inrō* were appropriate for such new themes because they were widely popular and did not have a long tradition. As a visible part of dress, they were sure to attract comment, and customers were most pleased with *inrō* that were both well made and clever.

One problem that the *inrō* maker faced was how to integrate the designs on the front and back of the *inrō*. The earliest solutions were the simplest. On *inrō* no. 5 with the Chinese groom, for example, the horse is seen from the front on one side (Fig. 15) and from the back on the other. On the rice harvest *inrō* no. 9 we see the workers on one side and the finished product, the tied and hung rice sheaves, on the other.

The choice of decorative technique was also very important. Extant prelim-

inary sketches by skilled lacquer workers prove that many of them were excellent draftsmen—some were professional painters as well as lacquer artists. Yet, although it is technically possible to make lacquer designs resemble paintings, the technique does not use the medium to its best advantage. In sprinkled designs, the most characteristic Japanese lacquer decoration, a finely detailed scene or well-modeled figure is rendered more abstract by its covering of gold or silver. There is tension between the recognizable image and the sensual, glittering material. The activity of the farmer in the foreground of no. 9 is the point of the scene. He is reaching for rice stalks with one hand while he prepares a tie with the other. But his lustrous and multicolored hat is the focus of the design. A few lines are inscribed into the inlaid shell of the hat to identify it. The similarly inlaid rice stalks rhythmically integrate the hat into the rest of the scene.

Patterns of wear on lacquer are often admired and can make a design more attractive. The *inrō* no. 10 with a bamboo grove and spider webs (Fig. 21) was originally decorated entirely in shades of gold. The sprinkled powders wore away where the design was most raised. Touches of the black and red lacquer underlayers that have been uncovered make this *inrō* much more interesting in its present state.

Natural wear has also improved the incense container no. 13 with a chrysanthemum design (Fig. 22). This box was made for the tea ceremony. When the charcoal fire is prepared for the kettle the host adds to it a small piece of fragrant wood taken from a lacquer box much like this one. The host then

Fig. 21. Inrō no. 10 with bamboo and spider webs. Late seventeenth century. 5.3 x 6.3 x 2.2 cm.

Fig. 22. Chrysanthemum incense container no. 13. Seventeenth century. 7.7 x 7.7 x 3.2 cm.

passes the box to his guests for their inspection. If the charcoal is not prepared in front of the guests, the incense container is displayed during the ceremony in the alcove (*tokonoma*) of the tearoom.

In size and shape, no. 13 imitates the small boxes included in larger cosmetic sets dating from as early as the twelfth century. Those cosmetic sets usually contained two round boxes for incense, two rectangular boxes for tooth-blackening powder, and two square boxes for white face powder. The designs on these small boxes matched that of the larger box containing them. Over the centuries, as the larger boxes were damaged and their contents scattered, the small ones were adapted to other uses. Their size and age made them perfect as incense containers for the tea ceremony when the rarer and more costly Chinese boxes were not available. But there were few of these old Japanese boxes, and in the seventeenth century, when the tea ceremony became a popular avocation, lacquerers made new incense containers based on the old shapes.

Since the chrysanthemum is associated with autumn, in particular with the ninth day of the ninth month of the lunar calendar, this container would most appropriately have been used in that season. Chrysanthemums are also associated with long life:

Every year with the ninth month
The chrysanthemum blooms again.
Autumn must understand eternity.[22]

The individual chrysanthemum blossoms are allowed to overlap in a dynamic arrangement. The artist tried to give new life to an old motif by depicting all but four or five of the flowers from the bottom of the blossom, and by showing several in profile. This unusual point of view is not immediately obvious and enhances the value of this box in the tea ceremony, where heightened perception is traditionally emphasized.

The bottom of the box and its inside are undecorated except for a branch of mandarin oranges, another felicitous product of autumn, on the underside of the lid. The drawing inside the lid would not be visible to the tea ceremony guest unless he took the box in

his hands for close inspection. Its simple design and elementary technique are in strong contrast to the outside of the box and would be a pleasant surprise for the guest.

Chrysanthemums are frequent images in Chinese poetry. The original owner of the inrō no. 14 with chrysanthemums growing by a fence (Fig. 23; colorplate 4) would have known that it referred to the poem by T'ao Yüanming (365–427):

I built my house where others live
Yet there is no noise from
 carriage or horse.
Do you know how this can be?
As long as the mind is distant
 the place is remote.
I pick chrysanthemums by the
 eastern fence.
I quietly gaze at the southern
 hills.
How fine is the mountain air
 at dusk.
Birds fly home in pairs together.
Here I have found the true
 meaning of life.
I want to explain it, but have
 lost the words.[23]

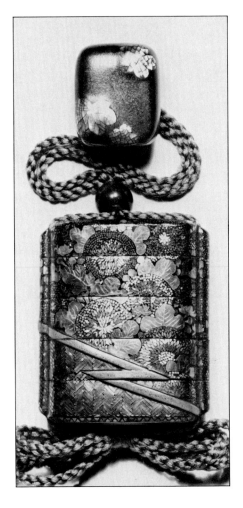

The maker of inrō no. 14 probably lived in Kyoto in the second half of the seventeenth century. Even after the political capital was moved to the new city of Edo (present-day Tokyo) in 1603, Kyoto remained a crowded city. Despite his immediate surroundings, the Kyoto dweller could always look up to the cool, forested hills east of the city, perhaps as he picked chrysanthemums by his fence.

The design of inrō no. 14 is fashioned with thin pieces of abalone shell and gold foil set in wet lacquer and occasionally incised. The fence top is an inlaid strip of pewter. The idea and manner of cutting abalone shell so thin that it seemed green was invented around this time by a Kyoto lacquerer named Chōbei, who was therefore called "Green-shell Chōbei." The decoration is impressive but more fragile than other types of lacquer design. The jagged line of the fence enlivens the composition and the sparkling pieces of gold foil help to distinguish individual flowers and to organize the pattern.

The writing box no. 15 with a pheasant (Fig. 24) was made to order in the

early eighteenth century for a wealthy client. On the lid of the box a pheasant, in raised sprinkled design (*takamakie*), sits on a rock from which project two trees. A few scattered plants stand out on the ground, and the background is filled with particularly large flakes of gold individually set in place. Because pheasants are together during the day but separate at night, they are regarded as symbols of loneliness. This pheasant is probably meant as a poetic allusion. The solitary bird, so large in relation to the trees behind it, is emphatically isolated. He sits in a barren landscape and the heavy flakes of gold behind him look like snow. The poets were fond of describing the frost that coated the pheasant's tail and the cold nights he spent alone on mountain peaks.

The underside of the lid is much more elaborately worked than the top (Fig. 25). Rice fields ready for harvesting lie beside a mountain village next to a river. A scarecrow guards ripe stalks blowing in the wind (Fig. 26) while an aqueduct directs water down the mountains. In the sky are two descending geese. The trays on either

Fig. 25. Pheasant writing box no. 15, under lid

Fig. 26. Detail of scarecrow, pheasant writing box no. 15, under lid

side of the inkstone show more geese and a few rocks and trees. The solid gold water dropper is in the shape of a koto (a stringed musical instrument).

The relationship of the various parts of this design to one another is puzzling. The focus of the inside design is rice fields in the autumn wind, a common subject in Japanese poetry, particularly when combined with the geese, river, and mountain village. But the waterfall, aqueduct, pines, and especially the koto have no traditional connection to autumn or mountain rice fields. It is possible that the artist had some specific poem in mind that would link these unexpected elements. One of these might well be:

The autumn winds tune the
 sound of the pines
To the song of my koto.
I wonder if it blows through the
 waterfall
Plucking its streams.[24]

The waterfall on this lid actually makes a sound as it runs. Inside the lid is a reservoir of mercury. When the lid is held vertically the mercury streams down the falls and the aqueduct with a gurgling sound. The mercury flows for as long as fourteen seconds when the lid is lifted and recharges invisibly and silently when the lid is pointed downward. Since the surfaces of the falls and aqueduct are glass, the sparkling flow is visible as well as audible. There are a number of eighteenth-century writing boxes that incorporate such mercury-activated waterfalls and waterwheels.

An inscription carved into the underside of the inkstone identifies it as "the purest stone in the universe" and its carver as Nakamura Chōbei. The Nakamura family were the leading inkstone carvers in Japan. According to a 1690 list of craftsmen, three of the four most important stone carvers in the city of Edo were named Nakamura, and one member of the family worked in Kyoto.[25] They were exclusive stone carvers for the shogun, and the head of the family always took the public name Nakamura Ishimi, the name that appears in all the records of the Nakamura family from the seventeenth through the nineteenth centuries. But they signed their inkstones with Chōbei, an art name.

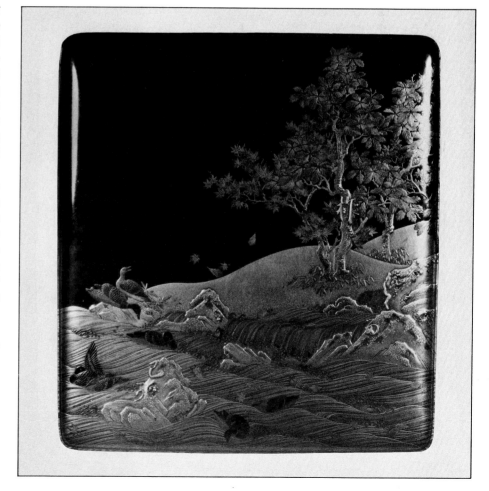

The lacquer artist who applied the design to an important writing box was not a decorator choosing an arbitrary, copybook pattern that would fill the space and show off his technique. He was the director and chief artist of a cooperative project (see Appendix 1). Together with the woodworker he would decide upon a shape and base material. With an overall theme and appearance in mind, he would order a water dropper from the metalworker and an inkstone from the stone carver. The drawing of this theme was approved by the client and executed by the lacquer worker and his subordinates.

Lacquer artists were always sensitive to the needs and desires of their patrons, and were themselves among the most educated of artisans. An early eighteenth-century lacquer worker, in a text meant exclusively for the use of his descendants, wrote: "You will have to make or illustrate not only saddles and stirrups for the military, but also musical instruments, poems, and utensils for the incense ceremony, for flower arrangement, for the tea ceremony, etc. Do the best you can to learn and to correct your knowledge of the rules and principles of all these arts. If you do, you will usually be safe, your mistakes will be few, and what you make will be usable."[26]

Subtle allusions to classical poetry are common in lacquer boxes made for learned aristocratic clients. Traditionally, poetic themes were popular subjects for lacquer ware. Classical Japanese poetry concentrated on a limited range of subjects that were considered suitably evocative. As these subjects were combined and recombined in poems over the centu-

ries their overtones became increasingly richer. A single image on a lacquer box could begin a long chain of literary associations in the mind of the educated reader and establish a complex mood. But because there are so many thousands of poems, there was always the chance that the viewer would think of the wrong one and miss the point the lacquer artist wished to make. To prevent this the lacquerer often included words from the poem in the design.

The writing box no. 16 with ducks and autumn leaves (Fig. 27; colorplate 8) illustrates the poem:

Ducks slip between the rocks
Where oak leaves fall.
Their own young plumage
Has also turned to crimson.[27]

Words from this poem are inlaid in solid gold in the lid. On the trunk of the tree is "oak," on the rocks to the right is "slip between," and on the rocks to the left is "their own." There is only one classical poem on this subject that contains these words. The theme continues on the underside of the lid and the inside of the box (Fig. 28). The water dropper is in the shape of a rock with small areas of enamel imitating moss. To the right of the inkstone is a niche that originally held a second, smaller inkstone. The larger inkstone would have been used for black ink and the smaller for red. Red ink was used for marginal annotations and punctuation in texts. As in all boxes of this quality, even the normally invisible areas beneath the inkstones were decorated.

Although the basic techniques of raising, sprinkling, and inlaying are the same as on earlier boxes, the design

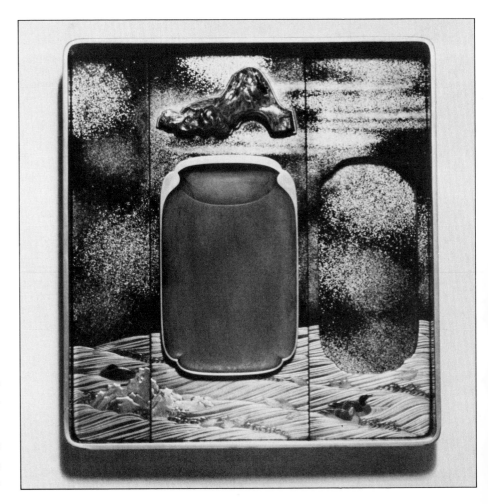

Fig. 28. Writing box no. 16, inside

32

of this late eighteenth-century box is much more naturalistic. The autumn leaves are tinged with reddish lacquer and the ducks are drawn with red and green lacquer. The sky on the outside of the lid is plain black; on the inside, gold flakes are applied to resemble clouds. The shapes of the small inlaid fragments of gold foil are affected by painting conventions. At the top of the rocks they are wedge-shaped and pointed downward in the manner of ink painting. The artist is deliberately trying to reinvigorate his large-scale lacquer decoration by moving it closer to painting.

Innovation was easier in the making of lacquer utensils for the tea ceremony because the traditions for such utensils were not very long. Only in the late sixteenth century did it become customary to prepare tea with Japanese implements rather than Chinese. Compared to ceramics, the roles for lacquer were limited. The principal lacquer containers were the tea caddy and the incense container. Although ceramic caddies are also used in the tea ceremony, lacquer ones are better suited for holding the delicate tea powder. The tea leaves are stored in large jars in a cool place and ground into a fine powder before use. If the ground powder is left exposed it quickly loses its flavor and becomes bitter. Lacquer tea caddies can be made airtight so that the tea powder inside can be preserved for a longer time. Lacquer came to be used to store the ground tea for informal ceremonies, while ceramic caddies held the tea that was ground immediately before each formal tea ceremony.

Most lacquer tea caddies are predominately either red or black. The artist who decorated the caddy no. 17 with a camellia design (Fig. 29) combined both red and black in a novel way. Over the wet black lacquer ground he applied tiny fragments of red lacquer. These fragments were made by brushing red lacquer on a nonporous surface, such as glass, peeling it off after it hardened, and cutting it up. On the top of the lid is a sprinkled design of a blossoming camellia branch with silver petals; raised drops on the leaves represent dew.

The red on black technique is not only unusual, it is also very difficult.

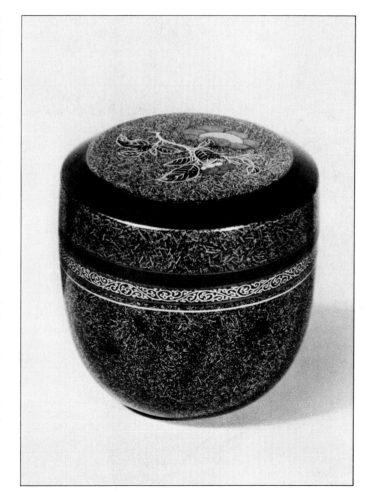

Although the red particles appear at first to have been haphazardly sprinkled on the black, they were in fact very carefully placed for they neither touch nor overlap one another.

The small round incense container no. 18 (Fig. 30) is conservative in design and probably meant for the tea ceremony. On a simple black background are two landscape vignettes drawn inside fan-shaped outlines. On the left is a close-up view of rocks and ferns by water, on the right a distant view of trees. Traditional sprinkled techniques are used, and the inside has aventurine imitating the type used in the seventeenth century. The nervous outlines and clever subject suggest that this container was made in the later eighteenth century.

It is often difficult to tell whether an incense container was made for the tea ceremony. The incense container no.19 is certainly the right size for the tea ceremony but its implicit subject matter would have been unusual (Fig. 31). All of the outside and inside surfaces are covered with a continuous drawing of the type of fern called "longing grasses." As noted earlier, its literary association is with absent lovers. This theme is reinforced by the shape of the box, an imitation of a folded love letter. As a result of these delicate grasses the small box seems elegant and light. The pewter rims are proportionately thin and well finished. The box was probably made in the eighteenth century.

The design of no. 19 is so masterfully drawn that it maintains a uniform density. Experience with evenly sprinkled aventurine grounds gave lacquer artists a special sense for the distribution of complex patterns. The precision of the drawing is also remarkable. The artist used a brush peculiar to lacquer drawing, made of a small number of very fine and long animal hairs. The transparent tips of the hairs have just the right degree of resiliency. The very best hairs, those with the longest transparent tips, grow along the spines of rats that live in dark earthen storehouses. (In a stone building the back hairs are worn down.) Artists who draw delicate sprinkled designs treasure their best brushes.[28] A very steady and sure touch is required to keep the slowly drawn lines from wavering or thickening. The lacquer with which the design is painted is viscous and sits on the surface of the ground. It is important that the whole design be applied evenly, with every stroke equally raised, so that after the gold is sprinkled and the drawing hardens, the metal can be polished without damaging the design. When some strokes are thicker than others, the gold is raised too much and will be worn down too far by the flat charcoal used for polishing. This has happened to a limited extent on the underside of the lid of no. 19, where the artist might have understandably begun to lose patience.

The three square boxes nos. 20–22, modeled on the type once used for tooth-blackening powder, were all used as incense containers in the tea ceremony. On the smallest box, no. 20 (Fig. 32), is a bridge, a favorite motif for seventeenth-century artists. The one shown on no. 20 might be either Uji Bridge or the long bridge at Seta, two famous scenic sites not far from Kyoto. Two chrysanthemum medallions on the underside of the lid probably had some special connection with the orig-

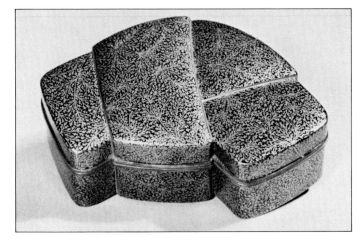

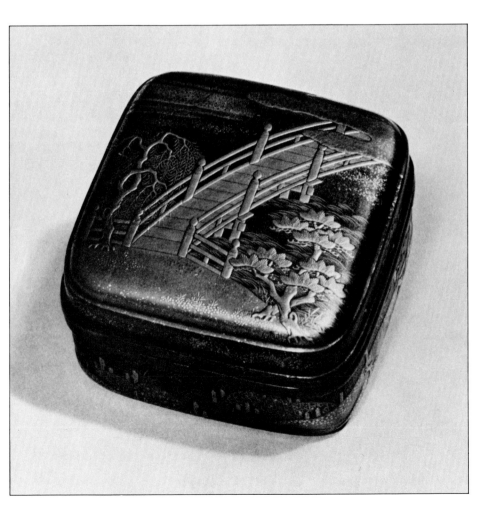

inal owner. In style and technique, this incense container is very conservative. Its only concession to the late seventeenth century is the addition on the sides of the box of tiny fragments of green shell representing stones inside the baskets that serve as erosion barriers along the riverbank.

The eighteenth-century box no. 21 with maple leaves represents a new departure in lacquer style (Fig. 33). Its theme is drawn entirely from classical poetry. On the outside, maple leaves are being swept along the Tatsuta River. As early as the tenth century, maple leaves were closely linked with this river near the city of Nara:

> Were it not for the crimson leaves
> On the Tatsuta River
> Who would guess that water too
> has an autumn?[29]

The waves and water sweep completely around the box and across the bottom. The sprinkled design is very thin and almost flush with the soft brown surrounding lacquer. On the underside of the lid (Fig. 34) and inside the box are pines along the shore, also a traditional poetic subject. The overall design is too general to refer to a specific poem, but a tea master might have readily worked this box into the theme of an autumn tea ceremony. The most carefully planned tea meetings are centered around one or more literary or religious themes. The scroll that hangs in the tearoom, the name of the tea scoop, even the type of kettle and bowl might all subtly relate to the central motif. The contrast between the outside of this box, with its falling leaves and the gentle stream, and the inside, with eternally green pines and a rough sea, helps to focus the attention of both host and guest on such deeper truths as the unchanging reality beneath the world of appearances.

The originality of this box lies in the abstraction of the drawing. The oversized leaves fall from the tree on the left of the lid and are blown over the water. Only at the bottom of the box are a few leaves allowed to slip into the waves. The waves form a mannered, repeated pattern of curves and curls. On the inside of the box the clumps of pine needles are reduced to sets of radiating lines. This patterned abstraction is inspired not by painting,

Fig. 33. Incense container no. 21 with maple leaves in Tatsuta River. Eighteenth century. 7.0 x 7.0 x 3.8 cm.

Fig. 34. Incense container no. 21, under lid

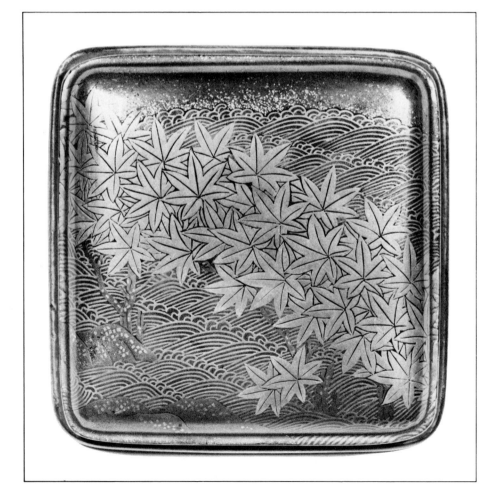

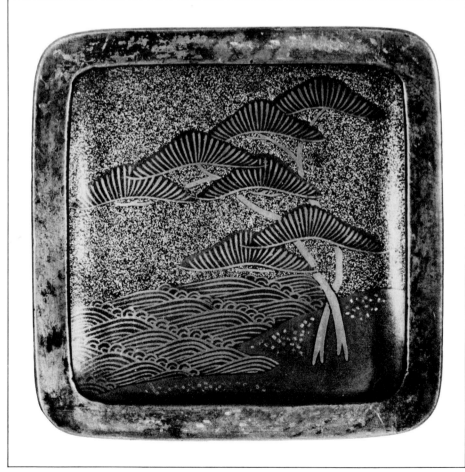

but by contemporary textile designs. The waves, leaves, and pines look as if they were stenciled. Different weights and densities of gold powder create the various tonalities of the drawing. The brown background, for example, is not brown lacquer, but the usual deep black lacquer with a thin dusting of very fine gold powder on its surface. The box is unusually heavy, perhaps because of the oversized pewter rim, and the lid and bottom are about one-fourth inch thick.

Another incense container with pines on the shore, no. 22, also has a design that seems inspired in part by textile stencils (Fig. 35). The jagged shapes that cover the background are so abstract and unusual that it is hard to tell at first glance what they represent. The pines with gold trunks and green-shell needles stand on a shore covered with sprinkled silver that would have originally been bright and whitish. Inside the box lid, plovers fly across a gold sprinkled ground.

The combination of plovers and pines on the shore is a traditional poetry topic associated with winter. The jagged background might be either snow or waves. The confusion could be based on the poem:

The crying plovers—who can tell
 which is which?
White waves in the snow
By the beach where winds blow in
 from the sea.[30]

The guest who examined this incense container at a tea ceremony might also have wondered whether the drawing was meant to show waves or snow. When he opened the container to view the underside of the lid, the guest would have expected to recall such a poem as the one above. A com-

prehensive knowledge of poetry seems much more remarkable now than it did in the eighteenth century. Serious and cultured men of leisure who aspired to be poets would commit entire anthologies of poetry to memory so that they could draw on established traditions when composing their own verse. For many poets, the overwhelming weight of this tremendous body of classical literature stifled originality. Creative poets of the Edo period often turned instead to the new, shorter form of the haiku, which drew more from the experiences of daily life and less from the themes and poems of the ancients. But the verse that would stifle a poet, could inspire a lacquer artist. The wave-snow design is unique and seems to have been devised for this particular eighteenth-century box.

Another elegant pastime, the incense ceremony, reached the peak of its popularity in the eighteenth century. Tea was grown and consumed everywhere in Japan, and the tea ceremony was practiced on all levels of society. In the face of the burgeoning popularity of tea, the aristocracy jealously clung to the exclusive and rarefied incense ceremony. The fragrant woods appreciated in this ceremony were imported into Japan from Southeast Asia during the fifteenth to early seventeenth centuries. They were obtained at great effort and cost. Selected fragrant jungle trees were cut down and buried until the outside layers of wood rotted and only the resin-impregnated heart of the wood remained, a process that took many years. A tiny chip from a precious log was placed on a silver-rimmed fragment of mica and set on top of a hot coal in a bed of ash inside a small

Fig. 35. Incense container no. 22 with pines by shore. Eighteenth century. 7.7 x 7.7 x 3.8 cm.

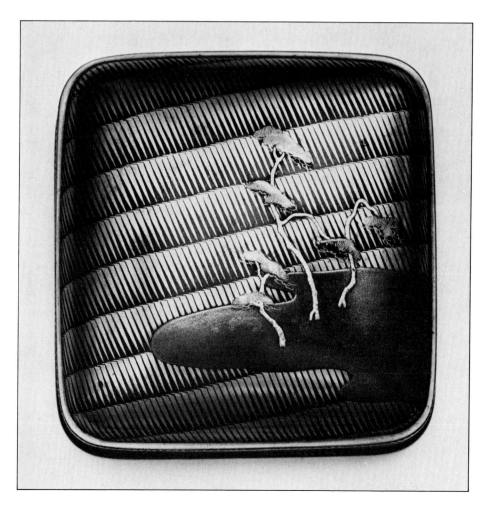

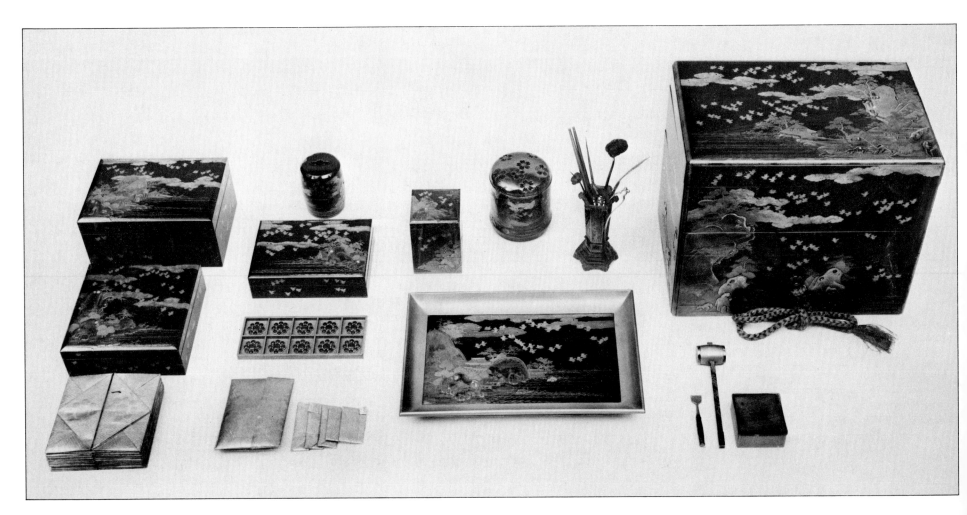

Fig. 36. Incense ceremony set no. 23 with plovers and landscape by sea. Eighteenth century. Box: 25.0 x 16.8 x 20.0 cm.

incense burner. The participant would hold this incense burner up to his nose in the left hand, cupping his right hand over the top to direct the delicate fragrance. Each tiny chip had a distinct fragrance, depending upon the log from which it was cut. In the sixteenth and seventeenth centuries each of these fragrances had been given poetic names. There were hundreds of them, and the serious student of incense knew them all.

The detailed procedures of the incense ceremony were developed in the sixteenth century by the influential courtier and man of letters Sanjōnishi Sanetaka (1455–1537). The tradition he originated is known as the Oie school. Another major tradition of incense ceremony is the Shino school, which was directed to the feudal aristocracy rather than the courtier nobility.

There is a wide variety of incense ceremonies. In its simplest form, two friends might meet to sample a rare fragrance on a beautiful day. The incense chosen would be one whose name suited the season or mood. There is less conversation during incense ceremonies than during tea ceremonies. The incense burner is quietly passed back and forth as each person savors the fragrance, listening to the sound of the garden, and letting the poetic associations of the aroma and its name carry their thoughts. More commonly, incense ceremonies tested the knowledge of the participants. A variety of incense was burned in succession and the guests were asked to identify them. A record of the event was kept and presented to the first guest who was correct. Elaborate sets of counters or dolls were sometimes employed to keep track of the

score. As in the tea ceremony, the placement of utensils and the ways of handling them evolved into aesthetic and harmonious practices. However, the main goal of the incense ceremony, to heighten awareness and sensitivity in a tranquil and thoughtful setting, remained.

Incense ceremony utensils were almost entirely made of lacquer with gold sprinkled designs. Their elegance and expense suited the rarity of the incense itself. Complete matching sets were part of every aristocratic lady's dowry. The incense set no. 23 is virtually complete (Fig. 36; box lid, colorplate 7). All the parts are contained in a three-layered box. The smallest implements are the miniature chisel, hammer, and chopping block that were used to prepare suitable splinters of the fragrant woods. The size of the chips depended on the number of participants; the old incense was so precious that it was used very sparingly.

Let us imagine that the host used this set to give a simple incense ceremony in May. First he would choose from his collection three woods whose names suited the occasion—for example, *Ikoi* (Relaxation), *Kimpū* (Fragrant Breezes), and *Hototogisu*. The *hototogisu*, a bird frequently mentioned in poetry, comes down from the mountains and is generally heard singing in the fifth month. Two pieces of Relaxation and Fragrant Breezes would be prepared. But since *Hototogisu* is the most distinctive and rarest of these three fragrances, only one splinter of it would be cut from the larger piece. Each of the five fragments would be folded in a separate piece of paper. Usually these wrappings are made of

ordinary paper with numbers on the outside to distinguish the contents. The incense set no. 23 has several of these papers left from the last time the set was used. One of them still contains a piece of incense. This set also has packets made of paper covered with gold foil on both sides for special occasions. Rather than being numbered on the outside to distinguish the incense, these fancy packages were folded in five different ways. The host would know from the folds which package contained which incense. The five distinctive packages would be held in the larger piece of folded gold-covered paper.

The incense burner was prepared by surrounding a glowing coal with soft gray ash. The charcoal had to be hot enough to drive the fragrance out of the wood but not so hot as to set the chip on fire. The ash would cover the coal almost completely and would be shaped to resemble Mount Fuji. Four of the long-handled utensils in the standing silver holder were used to prepare the ash. The pointed tool was used to measure the depth of the ash above the coal and to provide an air hole through the top of the ash. The spatula was used to shape the sloping ash. The pair of metal chopsticks was used to place the coal and mark decorative lines on the ash, and the feather would brush away any stray ash on the sides or top edge of the burner. This incense burner has an unusual cover, made of silver pierced with a design of cherry blossoms; it was probably used when the burner was formally displayed.

When it was time to smell the incense, the host would lift a square sheet of gold- or silver-edged mica

with the silver tweezers from inside the layered incense box. He would place the mica on top of the mound of ash in the burner, then open a package of incense. With the silver spoon, he would set a fragment of the first incense, perhaps Relaxation, in the center of the mica. The host would raise the burner and test the fragrance before passing it to the guests. The guests would be told the names of this first fragrance and of the second, Fragrant Breezes, as they tested it. Each time a new incense was put on the fire a new piece of mica was used.

When three packets of incense were left, two being the same as those already sampled and one the rare *Hototogisu,* a game began. Each guest had a box with twelve ebony tags, with a lacquer drawing of a plant or animal on one side. The set no. 23 has ten sets of tags for ten different guests. On the back of the tags is either the numeral 1, 2, 3, or the syllable *u.* After sampling an unnamed fragrance, the guest would decide whether it was the first incense, Relaxation; the second, Fragrant Breezes; or the unknown, *Hototogisu.* Accordingly, he would take the tag with 1, 2, or *u* and deposit it in the square gold-paper holder marked 1 that the guests passed following the burner. The set no. 23 has ten of these holders to accommodate up to ten such rounds. It also has a cylindrical box with a slot in the top that could be used to gather the votes of the guests. The pieces of incense and mica used for these rounds would be set on the rectangular board with ten medallion designs. After all three incenses had been sampled, a record would be made of the identification given by each guest.

This set contains a writing box for this purpose. The host would then reveal the order of the last three fragments. If one of the guests identified the fragrances properly it would be indicated on the record, which he would be given as a souvenir of the event.

Some of the lacquer boxes in this set were not used during the incense ceremony. They simply store important pieces such as the gold-paper holders. The most important utensils, such as the incense burner, were stored in blue and gold brocade bags, a few of which still remain with the set.

The design that unifies the ensemble shows plovers frolicking by a mountainous shore. No specific literary reference is suggested and no season is clearly intended. Although plovers are a winter theme in poetry, this is not a winter scene. Broken reeds in the shallows may recall autumn; the cherry blossom design on the incense burner is a symbol of spring; and the plum blossoms on the utensil stand bring us back to late winter, as do a number of leafless trees. The solitary fisherman on one box is the only human figure represented. By avoid-ing definite references the artist has made this expensive set appropriate to all seasons.

The set no. 23 was made for a specific person. The lacquerer's client had a family crest consisting of eight circles around a slightly larger central circle. This crest appears on the board that holds the used mica and incense, on the gold-paper folders, and on the incense holders. The crest has also been incorporated into the lacquer on the outside of the box in a very unusual way. When he prepared the lower layers of lacquer, before adding the sprinkled design, the artist painted the nine-circle design in lacquer slightly lighter than the dark lacquer around it. There are at least six of these hidden crests on the outside of the three-layered box, some of them partially obscured by the sprinkled design that was added later. The crest easiest to find is at the left of the lowest cloud band on the lid.

It is hard to imagine why the original owner of this box wanted to be so discreet. The nine-circle design was one of the most popular of all crests; twenty-four feudal lords and over ninety lesser retainers used some variation of the nine circles, and a precise identification of the owner is impossible. Judging from its lacquer style, the set was probably made in the second half of the eighteenth century.

The sprinkled designs on this set are remarkable for the alloys of gold they employ, especially the reddish gold used for the plovers and the clouds. The artist was very conscientious about details; the individual eyes and beaks of the plovers, for example, are drawn with touches of silver. Labor was cheap, but gold was expensive and hard to get in the late eighteenth century. The artist used silver and cheaper alloys in order to cut costs; however, he did so in ways that made the design more interesting.

Many lacquer boxes that might once have belonged to incense ceremony sets survive independently. The box no. 24 with a maple-branch design (Fig. 37) has only two layers. Incense was probably held in the top level and the mica pieces in the second. The used mica and incense would have been discarded in a metal-lined lacquer box made specifically for that purpose. On the inside and underside of each level are more maple branches and falling leaves. The branch on the lid has a letter tied to it. In the time of *The Tale of Genji,* about the tenth and eleventh centuries, it was customary for courtiers to attach their correspondence to a seasonal twig or blossom. The poem inside the letter would then refer obliquely to the object in order to extend its meaning. This simple and elegant box evokes both autumn and the courtly tradition and is perfectly suited to the incense ceremony. The artist has varied the inside drawings just enough to avoid monotony. The gold flakes as well as the design are characteristic of the seventeenth century.

On the layered incense container no. 25 with swallows and cherry blossoms, made in the eighteenth century, two cherry trees extend their branches around the sides (Fig. 38). The sprinkled gold is much denser than on box no. 24, but it is sprinkled onto a brown ground and covered with a yellow-tinted lacquer so it looks like a purer gold than it really is. Five metal swallows are attached to the outside of the

Fig. 37. Layered incense container no. 24 with letter tied to maple branch. Seventeenth century. 6.1 x 7.2 x 3.6 cm.

Fig. 38. Layered incense container no. 25 with swallows and cherry trees. Eighteenth century. 5.6 x 7.5 x 6.5 cm.

lid and the top level. Two more swallows on the lower levels are not as well made and may have been added later.

Cherry blossoms are a very popular theme in classical poetry, but swallows are rarely mentioned. Swallows made their nests beneath the deep eaves of the poet's house and were too common and familiar to be an engaging lyrical subject. But the writers of haiku, the short verse form popular from the seventeenth century on, were not bound by convention, and it is in the spirit of haiku that this design was composed. Nevertheless, the design is more impressive in execution than in subject. The trees and branches on the sides are so cleverly drawn that, although each side is different, individual levels can be put on backward without harming the overall pattern.

A typical nineteenth-century incense container, no. 26, has abandoned the attempt to suggest poetry of any kind and is devoted to technically perfect design (Fig. 39). The chrysanthemum is very similar to the crest of the Aoyama family, hereditary vassals to the shogun. The black lacquer ground is smooth and rich, the aventu-

Fig. 39. Layered incense container no. 26 with chrysanthemum crest. Early nineteenth century. D. 5.5, H. 6.8 cm.

Fig. 40. Writing box no. 27 with bamboo and peony-rose. Eighteenth century. 22.4 x 24.3 x 5.2 cm.

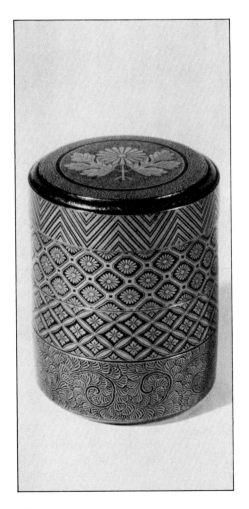

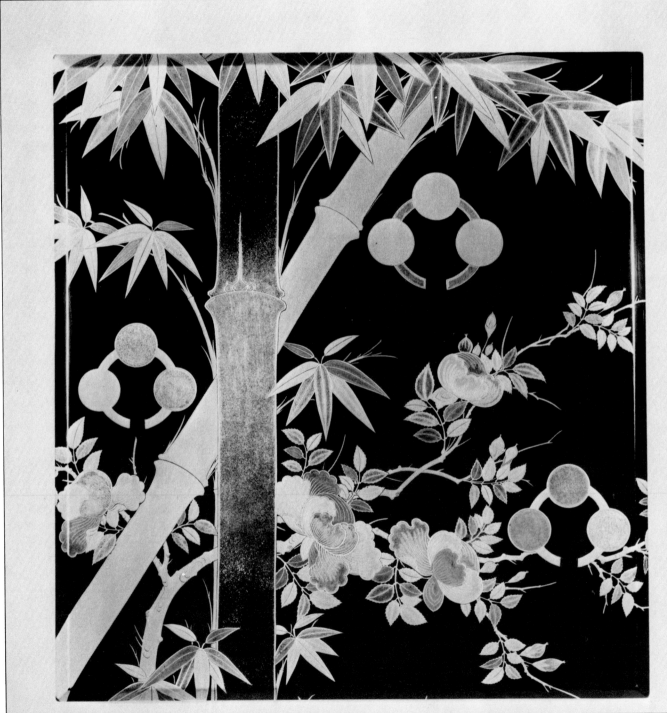

rine thick and pure. The lowest level seems to be lined with solid gold.

The tradition of lacquer dowry sets continued in the eighteenth century. On this pair in no. 27, a writing box (Fig. 40) and a stationery box (colorplate 5), only one crest appears, but the felicitous bamboo and peony-rose theme is the same as on the 1647 set (colorplate 1). This theme shows that the set was probably made for the daughter of a feudal lord in anticipation of her marriage. The unusual crest, three circles on a broken ring, does not appear in any of the available lists of feudal hierarchy. Inside both box lids a silver moon rises behind fields of autumn flowers and grasses (stationery-box lid, colorplate 6). An inscription carved into the underside of the inkstone identifies it as Takashima stone, a type found in Ōmi province, near Kyoto.

As in many sprinkled designs, the sketch was first drawn on thin paper and then transferred to the box surface by tracing the drawing on the underside of the paper with lacquer and pressing it onto the box. When the paper was removed, a very faint tracing of the design was left in wet lacquer. Powder or metal dust (in this case, silver dust) was scattered over the lines to make the pattern more visible and then the lines of the design were drawn as usual following the transferred outline as a guide. When the outline has been followed scrupulously, the underdrawing disappears; however, in many cases the artist changed parts of the design as he drew it and some of the underdrawing is still visible, as in these boxes. The lines of underdrawing appear red because the silver powdered lines are

seen through layers of the brownish black lacquers that were added to the ground.

Impressive boxes like these were always popular despite sumptuary regulations. The Tokugawa shoguns issued numerous edicts to insure that no vassal would appear more or less important than he was officially deemed. A samurai's annual income determined everything from the size and shape of his gate to the type of lacquer he was legally permitted to use. A 1724 prohibition, for example, stated that samurai receiving 10,000 *koku* of rice per year, even if they were lords of fiefs, could not have more than a light sprinkled design on their possessions. Their wives could only have a sprinkled-design crest on black lacquer to decorate their palanquins and luggage chests.[31] Similarly, the government repeatedly tried to restrict gold sprinkled designs on the lacquer owned by nonsamurai. In the middle levels of society, fine lacquer was a symbol of status and prosperity as well as of taste. For people whose wives did not travel in palanquins surrounded by luggage bearers, the *inrō* they wore at their waist were their most visible lacquer possessions (Fig. 41).

In the seventeenth century *inrō* were used to keep the medicines they held as fresh as possible. Appearance was supposedly secondary. In the late seventeenth century, for example, the shogun Tokugawa Tsunayoshi invited the physician Gensetsu to his castle to see a Nō play. Although he had better-looking *inrō,* Gensetsu wore his ordinary, everyday *inrō* but had the freshest possible medicines put in it. During an intermission the shogun asked to see Gensetsu's *inrō* and smiled when

Fig. 41. Shops at Hiyoshi Shrine. Detail of a six-fold screen of genre scenes at famous places. Ca. 1600. Registered Important Cultural Property, Dōmoto Shirō Collection, Kyoto

The shop on the left contains small accessories, including five inrō *that hang from a horizontal bar with a tobacco pouch and a kinchaku (money bag) on the right and small gourds and swordguards on the left. A pilgrim at the shrine, near Ōtsu on Lake Biwa, stops to buy sandals from the nursing proprietress of the shop next door, which specializes in tea ceremony equipment*

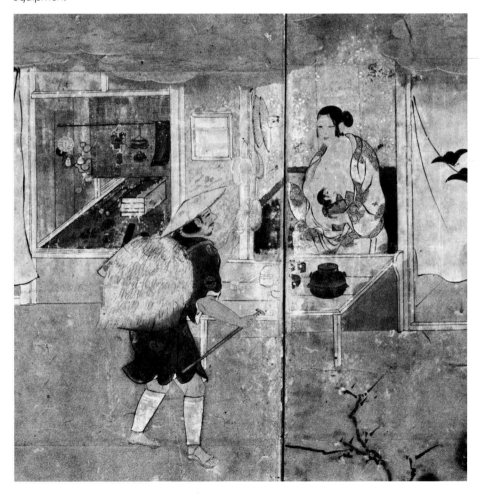

he saw how worn and simple it was, but he praised Gensetsu publicly when he found the fine, fresh medicines inside. Calling Gensetsu into his presence, the shogun rewarded him with a new *inrō* on which was written the character for long life.[32]

By the eighteenth century the *inrō* had gained more importance as an ornament than as a medicine container. Prosperous townsmen were preoccupied with fashionable dress. A 1773 guide to contemporary fashion divides well-dressed men into four categories. The ultimate goal was the highest men's style: "One who wishes to fit this style must own the very best things....In particular, he must first master the essentials of the incense ceremony, the tea ceremony, and *kemari* [a courtly type of football], then he will be able to create this look." Only the highest style included *inrō* as part of the well-dressed man's ensemble. "A red lacquer *inrō* in a low flat shape is extremely bad. They should have sprinkled designs and about four cases. The money bags that hang with them should be made of soft leather or else Russian leather [*musukobeya*]. Hemp is fine. The cords should be black or brown. Only novices use purple."[33]

Since the *inrō* were so small, the very finest materials could be used without raising the cost prohibitively. The pieces of shell used for the fish in the two-cased *inrō* no. 29 must have been highly prized for their fine color (Fig. 42). The translucent white shell turns red or green as the light strikes it differently. Good pieces of shell were so highly valued that the inlay on a lacquer box was sometimes removed and replaced when a better shell was found. The shells on no. 29 are the

originals; the simple raised seaweed drawing is no more than a setting for them. The *inrō* was made by Nomura Chōbei, a lacquer artist who lived in Edo in the late eighteenth century and specialized in shell inlay and carved lacquer. About 1767 Nomura Chōbei was appointed official lacquerer to the shogun and his descendants continued in this position until the middle of the nineteenth century.

Large lacquer boxes were rarely signed until the nineteenth century, but many *inrō,* particularly those made in the eighteenth century and later, have the signature or seal of their maker. It is not clear whether these names meant much to the original owners. A late eighteenth-century book on sword furnishings contains a short section listing famous *inrō* makers, but the author seems to have known very little about most of them beyond where they lived and what alternate name they used.[34] An important nineteenth-century collector of *inrō* mentioned only one *inrō* maker when describing the best examples in his collection (see Appendix 2). The signature was probably more important for the artist than for the client. Many *inrō* makers made their living designing and decorating larger works. *Inrō* were a hobby, a personal pleasure, a private challenge on which they could lavish time and explore ideas unacceptable in larger works.

In 1899 the fifth-generation lacquerer Yamamoto Rihei said of his grandfather, who worked in the early nineteenth century:

He studied Kanō school painting and created both plain lacquer and sprinkled designs. He did not depend on commissions and

fashioned everything himself, including the base. He also made sculptures and *inrō*. He worked incessantly. We have a turtle *inrō* he made. He liked to be original and on the shell of the turtle he wrote "This I will sell."

In those days the artist did not put his name on lacquer presented to the lords so we cannot identify his work. Only his *inrō* were signed. These were not presented officially but were sold privately to the accessories merchants at the back door.

In those days gold was very precious, and for the turtle *inrō* he used what had accumulated on the waste heap. There were silver and gold guilds and gold was hard to obtain. Aside from what was used at the imperial palace or for the shogun or other important lords, there was no distribution except for the little the goldsmith shops had, so you could not buy much gold at a time But it was easy for the ruling lords. When one of their daughters married, the gold guild was directed to release whatever gold was needed for her things. If you needed one hundred pieces you asked for two hundred and used the rest elsewhere.[35]

The handsome *inrō* no. 30, imitating a bamboo basket filled with persimmons, gingko leaves, and maple leaves (Fig. 43; colorplate 23), is signed *Jitokusai*. Jitokusai is an art name, but apparently some works by this master are signed Jitokusai Gyokuzan. Unfortunately, we are not sure who Gyokuzan was; his common

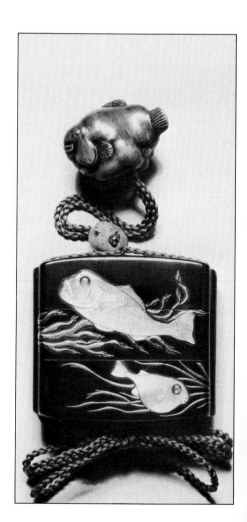

Fig. 42. Fish inrō *no. 29 by Nomura Chōbei. Late eighteenth century. 8.5 x 7.2 x 2.5 cm.*

Fig. 43. Inrō no. 30 with persimmons and leaves in basket. Late eighteenth century. 6.8 x 9.8 x 2.2 cm.

Fig. 44. Inrō no. 31 imitating Chinese ink painting, by Seki Naotaka. Late eighteenth —early nineteenth century. 6.6 x 7.6 x1.7cm.

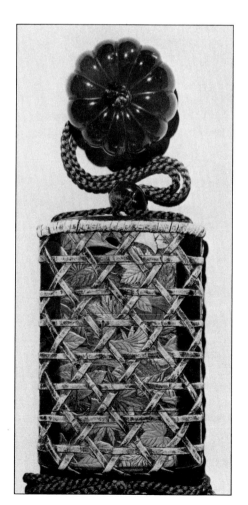

Fig. 43. Inrō no. 30 with persimmons and leaves in basket. Late eighteenth century. 6.8 x 9.8 x 2.2 cm.

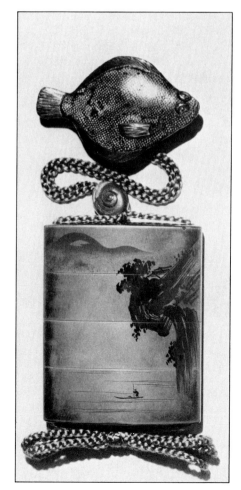

Fig. 44. Inrō no. 31 imitating Chinese ink painting, by Seki Naotaka. Late eighteenth —early nineteenth century. 6.6 x 7.6 x1.7cm.

identification as an artist named Ōmura Gyokuzan, who worked about 1800, is only circumstantial.

The identification of inrō artists is difficult because so little basic research has been done on them. About the 1900s, a few Japanese scholars, inspired or commissioned by Westerners, assembled the first lists of lacquer workers, but these tentative initial efforts have not been expanded. As the eighteenth and nineteenth centuries recede even farther into the past, the necessary research becomes more difficult.

Lacquer artists had the unfortunate habit of using multiple names. The name signed on a lacquer box is rarely the one the artist used in any other context. The inrō no. 31 with a silver landscape design (Fig. 44), for example, is signed *Seki Naotaka*. An early reference source suggests that Seki Naotaka might be an alternate name for Seki Ōsumi, who is known to have worked for the shogun between 1854 and 1868 as a maker of lacquer sword sheaths.[36] But two other members of the Seki family worked in the same capacity. From about 1791 to 1843 the

official sword-sheath maker is listed as Seki Sūma; an 1847 listing has the name Seki Monjirō instead.[37] The period from 1791 to 1843 is so long a span of time that the name Seki Sūma may refer to at least two generations. It was a common practice for lacquerers to take the same public name as their fathers and grandfathers, even if they used a different art name on their lacquers. One of these Seki family lacquerers is probably Seki Naotaka.

The inrō no. 31 has the virtuoso technique of a sword-sheath maker. Lacquer sword sheaths were often decorated to imitate other materials. Their makers were masters of deception. On inrō no. 31 the artist imitated an ink painting on gray paper. Lines that a painter could make with a single sweep of his brush on paper had to be painstakingly constructed out of the intractable lacquer. On top of the prepared base, the design was drawn in black rather than the usual red lacquer. The very darkest areas, such as the foliage and tree trunks on the protruding cliff, were drawn first and sprinkled with black powder made from camellia-wood charcoal or dried

black lacquer. When this hardened, the next darkest area, the rest of the cliff, was drawn and sprinkled with a slightly lighter black. The black powder was made lighter by mixing it with some silver.

On the reverse of *inrō* no. 31, the artist copied the Chinese poem that describes the landscape. It is a well-known verse by the T'ang dynasty poet Li Po (701–762):

In the morning I left Pai-ti
through radiant clouds
Returning to Chiang-ling, three
hundred miles in one day.
On both banks monkeys cry
incessantly.
My swift boat has already passed
ten-thousand layered peaks.[38]

The *inrō* is a copy of a Chinese painting that included the poem with the ink sketch. The calligrapher's name and seals appear with the poem. *Inrō* based on paintings and featuring the drawing on one side and an inscription on the back were popular in the eighteenth century. A guide for *inrō* makers, published in 1705, illustrates a number of such designs said to be the work of famous Japanese artists.[39]

Late Edo period lacquerers were drawn to unusual shapes and subjects. The figure on the round writing box no. 34 is the venerable Bodhidharma, the fifth patriarch of Zen Buddhism (Fig. 45). Beautifully drawn in a flattened sprinkled design, he has the odd appearance characteristic of paintings of this Indian sage. His eyes and teeth probably seemed more natural when the box was new and the silver powder had not yet tarnished. On the underside of the lid is a Zen monk's fly whisk. The shading on Bodhi-

dharma's red robe is exceptional for the difficult technique of flattened sprinkled design. Like iridescent shell, this mixture of red and gold alters in appearance as the position of the viewer changes.

A less reverent portrait of Bodhidharma is found on *inrō* no. 35 (Fig. 46). The holy man is shown beside a courtesan with whom he has exchanged clothes. The courtesan is amused and Bodhidharma chagrined. On the reverse side the girl's maid carries Bodhidharma's whisk and on the netsuke another lady stifles her laughter as she points at the incongruous pair. Little is known about the lacquerer, Hasegawa Shigeyoshi or Jūbi, who made this *inrō* and its netsuke, beyond the fact that he worked in the early nineteenth century.

Courtesans and religious parody are favorite subjects of the popular ukiyo-e school of Japanese painters. These artists were patronized by the same affluent townsmen who eagerly bought and wore *inrō,* and their prints and paintings were popular sources for lacquer designs. The drawing on no. 35 is said to be based on a print by Okumura Masanobu (1686–1764). Bodhidharma frequently appears in such parodies because his name in Japanese, Daruma, was also the slang word for prostitute.

The idea of the great holy man parading around dressed as a courtesan is meant as a joke, but ironically it has a basis in Buddhist teaching. The world of the senses and delusion is not separate from the world of enlightenment. The great monk Takuan Sōhō explains: "All phenomena are like phantoms or dreams; when one perceives that they are essentially nonex-

Fig. 45. Bodhidharma writing box no. 34. Eighteenth – early nineteenth century. D. 15.3, H. 3.3 cm.

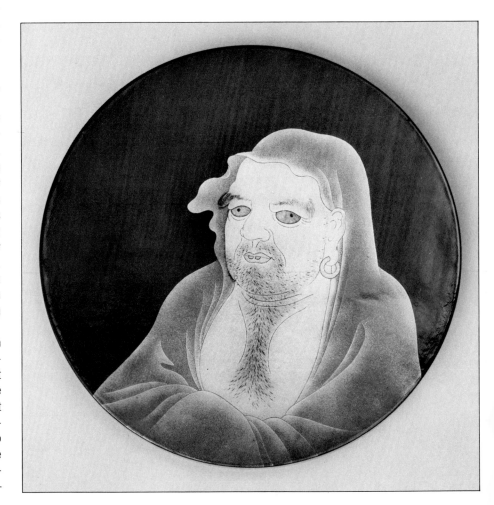

46

Fig. 46. Inrō no. 35 with Bodhidharma, courtesan, and attendant, by Hasegawa Jūbi. Late eighteenth—early nineteenth century. 4.8 x 7.9 x 2.6 cm.

Fig. 47. Inrō no. 36 with kimono on rack. Eighteenth—nineteenth century. 5.6 x 7.0 x 2.0 cm.

istent, one sees no particular marks of individuation in them and thus is free from attachment to them."[40] The enlightened have no regard for ritual pieties, and the truth is as available to the courtesan as it is to the monk.

The subtlest of all ukiyo-e designs are those in which the courtesans are not shown, but only suggested by their abandoned garments. This theme, called "whose sleeves," appears on the unsigned inrō no. 36 (Fig. 47). The rightmost sleeves swing outward as if tossed on the kimono rack a moment before. The robe on the front is decorated with cherry blossoms and waves. The clawlike curves of the waves and the downward slant of the rack enliven this close-up composition and tempt one to turn the inrō over to investigate the other side. There we find another robe, with autumn leaves, and the lady's fan.

At the other extreme from this subtle and evocative mood is the writing box no. 37, showing a courtesan spitting on a wall (colorplate 22). With her tooth-blackening mixture she is putting the finishing touches on her graffiti message: "Secret love." The girl to her

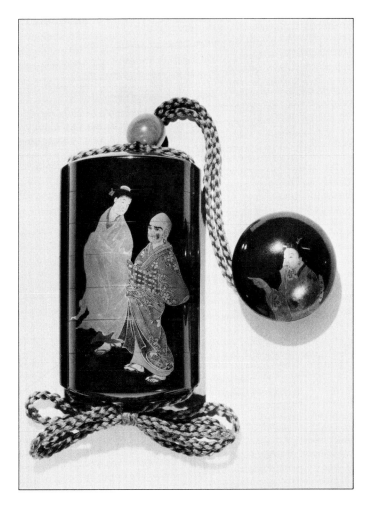

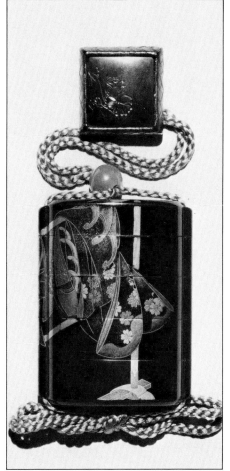

Fig. 48. *Spitting courtesan writing box no. 37, inside lid, with two ladies watching fireflies. Eighteenth–early nineteenth century. 20.9 x 25.1 x 6.3 cm.*

side holds fresh ammunition and urges her on while a friend watches from the bench and smiles appreciatively. The typically brash ukiyo-e theme on the outside is counterbalanced by a quiet, poetic scene inside the lid (Fig. 48). Two ladies, probably the same two that appear on the top of the lid, sit on a bench in early autumn watching fireflies in the bush clover. The setting is probably the Uji River, famous for fireflies and waterwheels, and the overall design may be an allusion to *The Tale of Genji*. In the last part of that novel we are told of two ladies, daughters of an imperial prince, who live in neglected loneliness by the turbulent waters of the Uji River. They are discovered and courted in secret by two noblemen from the capital. The romance of the older sister is ill-fated and the text abounds in sad autumnal images. Although ukiyo-e artists are best known for their drawings of courtesans and actors, they frequently drew upon such classical literary subjects as *The Tale of Genji*. Viewing themselves as direct descendants of the native painting tradition, *yamato-e,* they sought to bring ancient subjects

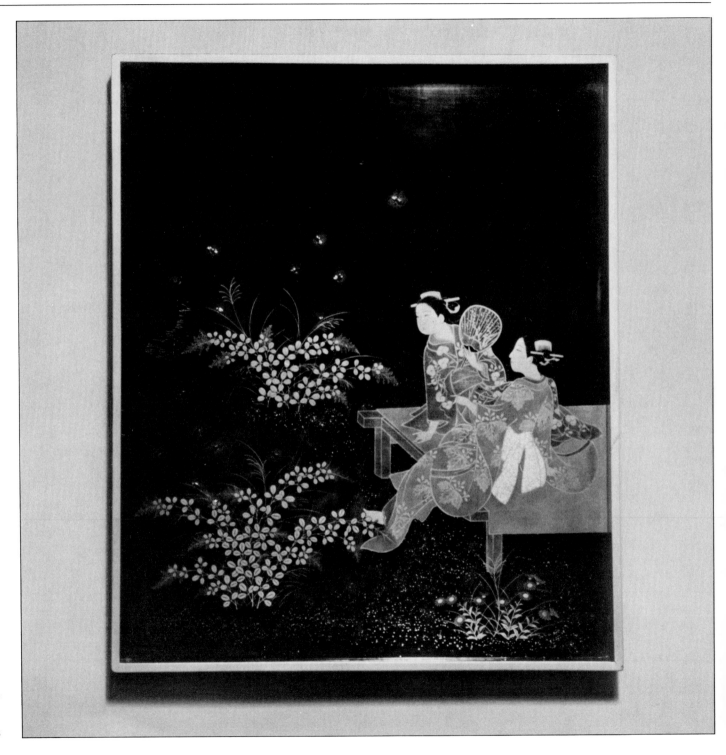

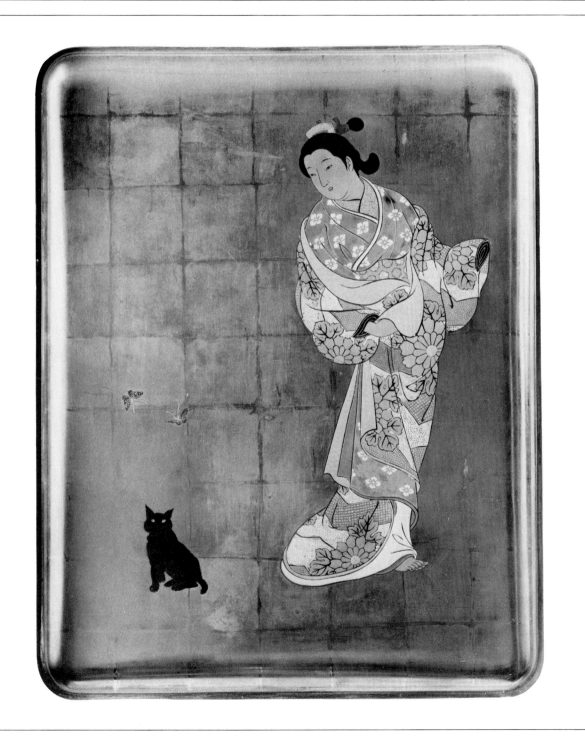

Fig. 49. Box no. 38 with courtesan, cat, and butterflies. Early nineteenth century. 21.3 x 27.4 x 11.7 cm.

to life by showing them in contemporary settings. The Victoria and Albert Museum, London, owns a writing box signed *Shunshō* with a later, partial copy of this design.

The box no. 37 is signed *Kanyōsai* on the bottom and has a seal reading *Tō*. Kanyōsai is said to have been an early nineteenth-century lacquerer and the style of this box would confirm that.

The artist who designed box no. 38, with a courtesan, cat, and butterflies on the lid (Fig. 49), used the unrecorded name Gyūhōsei. He was so intent upon imitating a woodblock print that he went to the trouble of outlining the figure of the courtesan in black and used an unusual amount of colored lacquers. The sides and inside of the box are done in the more traditional lacquer techniques of inlay and sprinkling, and illustrate the theme of snow, moon, and flowers. The snow is indicated by stylized snowflakes, the moon by the Chinese character on the underside of the lid, and the flowers by the cherry-blossom designs. The association of snow, moon, and flowers probably began with the Chinese poet Po Chü-yi (772—846), who

49

Fig. 50. Stationery box no. 39 with genre
scene. Nineteenth century. 12.1 x 21.0 x
4.6 cm.

wrote in one of his poems:

> Zither, poetry, wind: these three
> friends deserted us.
> Snow, moon, flowers: those are
> the times I miss you most.[41]

A similar and technically impressive style is used on the unsigned box no. 39 with a genre scene (Fig. 50). Passersby stop to marvel at a revolving lantern on which is drawn a continuous procession of retainers. Such processions were frequent sights in the Edo period, as each lord was required to spend half his time in the capital and half in his own territory. The costumes and poses of the people are realistic and brightened by such details as silver for their faces and brilliant pieces of inlaid shell. But the setting for the scene has been entirely eliminated. The lantern seems to hang from the top edge of the box and the figures stand in a black void. The point of view is even higher than the lantern, and despite the brightness and clarity of the crowd, there is the sense of a street scene viewed at night from a second-floor window. Inside this mid-nineteenth-century box are scattered

triple comma shapes sprinkled in varied tones of gold and silver.

These three boxes, nos. 37, 38, and 39, are heavily influenced by ukiyo-e prints and paintings. The figures are elaborately drawn, with red lips, black hair, and complex robe patterns, but their settings are unnaturally empty. The lacquerers are asserting the ability to use color as effectively as the ukiyo-e artists to create pleasant, two-dimensional drawings.

Similar preferences can be seen in the early nineteenth-century *inrō* no. 40 with two robins (Fig. 51), which was made by a lacquerer named Nakaoji Mōei, who demonstrates his control of the color red. By mixing gold powder with red powder he was able to produce the pink flowers and reddish joints of the plant. By more elaborate means he obtained a range of red colors in the raised bodies of the birds. The two sides of this *inrō* are well coordinated. The bird on shore is looking toward a bird bathing happily in the water on the other side. Together, they dominate their landscape.

The *inrō* no. 41 with cat and feather (Fig. 52) is even more like a painting

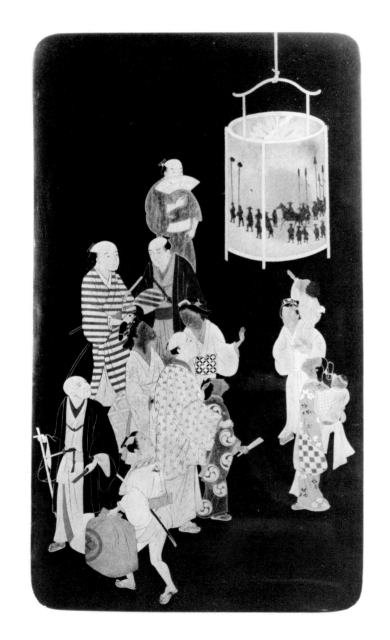

than no. 40. The surface is completely flat and the artist has used color with great delicacy, especially in the feather and the face of the cat. Most extraordinary is the blue lacquer used in the lower half of the feather. This color is rarely seen in lacquer ware. The basket of flowers on the back is nicely drawn, but it seems to have no connection with the cat. The *inrō* is the work of Sekigawa Katsunobu, who is said to have worked in the mid-nineteenth century.

The *inrō* nos. 40 and 41 are remarkable for the sensitivity and expressiveness of their drawings. By drawing the robins in slightly raised lacquer the artist has attempted to extend the possibilities of painting, but the *inrō* are still essentially two-dimensional pictures realized in lacquer. Another *inrō* with cats, no. 42, makes better use of the lacquer medium (Fig. 53). These two cats are toys and, together with the doll couple on the reverse, are probably allusions to the Doll's Festival in the third month. Generously applied gold and silver and the isolation of the images against a deep black background make this a satisfying and effective work, even though the images have a self-conscious charm.

Nakayama Komin (1808–70), one of the most famous lacquer artists of the early nineteenth century, worked counter to the trend of his time; he is best known for his copies of old lacquer. The *inrō* no. 43 with chrysanthemums and birds (Fig. 54) imitates the design and technique of a famous thirteenth-century writing box. Pieces of shell are buried in a gold lacquer ground which used small flakes scattered amid an evenly applied gold powder. Komin's study of old lacquer

Fig. 51. Robin inrō *no. 40 by Nakaoji Mōei. Early nineteenth century. 6.3 x 7.8 x 2.5 cm.*

Fig. 52. Inrō *no. 41 with cat holding feather, by Sekigawa Katsunobu. Mid-nineteenth century. 6.3 x 6.8 x 2.1 cm.*

Fig. 53. Inrō *no. 42 with toy cats and paper dolls. Nineteenth century. 6.9 x 7.8 x 2.5 cm.*

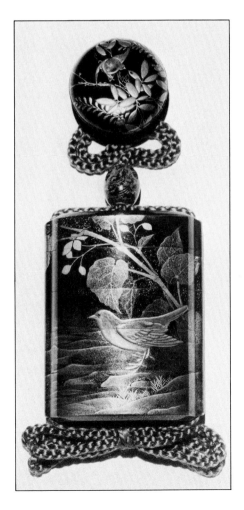

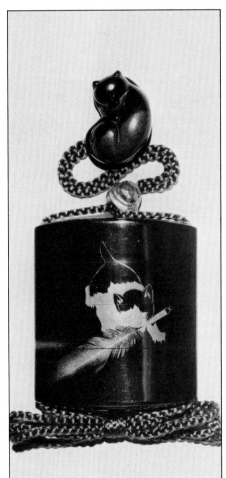

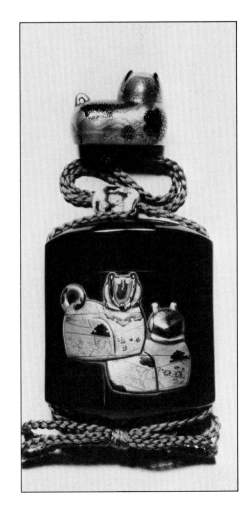

was inspired by his desire to research old techniques and by his other antiquarian and scholarly interests. He was very fond of the tea ceremony and was a skilled haiku poet. Komin was one of the last artists to receive the honorary title of *hokkyō* ("bridge of the law"), a title traditionally bestowed by the court in recognition of exceptional artistic ability. The custom was abandoned in 1873.

Novelty was greatly admired in the early nineteenth century. On the *inrō* no. 44 with swordguards (Fig. 55), for example, the artist constructed the ground out of sharkskin which was then covered with lacquer and polished flat. On top of this ground he placed lacquer swordguards imitating every type of fancy metalwork.

A lacquerer who called himself Bunsai made the *inrō* no. 45 with crests (Fig. 56). The designs were made by a cloisonné technique that used colored lacquers poured into areas bounded by thin metal wires. The three-leafed oak crest was used most notably by the Makino family, lords in Echigo province.

Other artists of the nineteenth century continued to develop the traditional sprinkled-gold techniques. By the mid-nineteenth century the *inrō* had become completely decorative, a piece of jewelry with little practical function. The gold on the *inrō* no. 46 with two warriors and two birds is so richly applied that the design seems to have been carved from gold rather than sprinkled (Fig. 57). The two warriors in this design are Ōba Saburō and Matano Gorō, soldiers from the army of the Heike clan sent to find Minamoto no Yoritomo (1147–99), who had been defeated at the battle of Ishi-

Fig. 54. *Inrō no. 43 with chrysanthemums and birds, by Nakayama Komin (1808–70). 6.1 x 8.8 x 1.8 cm.*

Fig. 55. *Swordguard inrō no. 44. Nineteenth century. 5.2 x 8.8 x 2.5 cm.*

Fig. 56. *Inrō no. 45 with crests. Nineteenth century. 4.9 x 9.8 x 2.7 cm.*

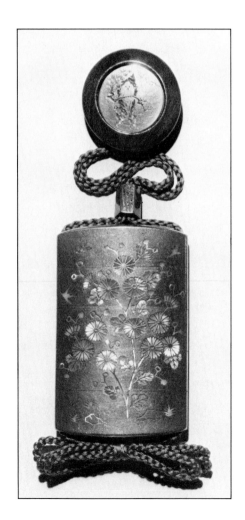

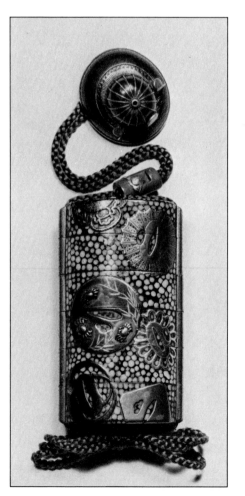

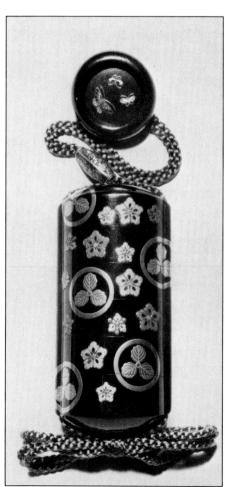

bashiyama in 1180. Yoritomo had attacked the Heike army as the first step in his rebellion against their de facto rule of Japan. His escape, after his initial failure, was almost miraculous. Pursued into the hills, he is said to have hidden in the hollow trunk of a tree. His pursuers were almost upon him when they were distracted by the sudden flight of a pair of pigeons. Yoritomo was eventually able to rejoin his forces and direct his successful campaign. The many historical legends that grew around the great struggle of the Minamoto and the Heike always cast Yoritomo in the role of the hero attempting to regain for the emperor the legitimate authority that had been usurped by the scheming Heike family.

In the middle of the nineteenth century the question of imperial authority was much discussed. The Tokugawa shogunate, which had ruled Japan since 1600, was hard pressed by a general collapse of authority in the wake of Western attempts to open the country. The fall of the shogun and the beginning of the Meiji period, in 1867, mark an important point in the history of Japan. The entire nation turned eagerly to the West and with incredible energy and optimism sought to transform itself from an isolated kingdom into a modern nation. Many traditional arts suffered in the initial burst of enthusiasm for Western ways. Commissions for large sets of fancy lacquer, the work that had supported important artists, stopped completely. Old works were either sold abroad or thrown away. In the words of a contemporary lacquer merchant, "Good sprinkled lacquers were burned. Only the gold was picked off.... It was that sort of period."[42] Fortunately, it did not last

long. Government officials traveling abroad discovered enlightened foreigners treasuring those same lacquers that the Japanese were throwing away, and in 1871 the government began to advocate the preservation of old art, including lacquer.

The number of lacquer workers had decreased drastically but those who had persevered were encouraged to display their works in various international expositions in which Japan participated. The exhibition at Vienna in 1873 was a great success and offered the world further evidence of the quality of Japanese lacquer.

The export of lacquer began in 1856 when an American ship stopped at Izu and picked up lacquer made in Shizuoka prefecture. When trade began officially at Yokohama in 1858, lacquer factories were established there to serve the export market more directly. The response to the Vienna exposition was so favorable that a semigovernmental export company specializing in lacquer (*Kiritsu kōshō kaisha*) was established in Tokyo in 1874, with branch offices in New York and Paris. Leading lacquer workers connected with this organization included Ogawa Shōmin (1847–91) and Shirayama Shōsai (1853–1923). The company was dissolved in 1893.

A number of similar companies were formed. In 1879 a German merchant, lamenting the poor quality of Yokohama export wares, started his own production center by assembling workers from Shizuoka and Aizu prefectures and Tokyo. Among his innovations was the use of kilns to dry the wood used for the bases. The merchant soon went out of business, but the demand for Japanese lacquer was

Fig. 57. Inrō no. 46 with warriors seeking Minamoto no Yoritomo. Nineteenth century. 7.2 x 7.3 x 1.7 cm.

Fig. 58. Bamboo inrō no. 49 by Shirayama Shōsai (1853–1923). 3.8 x 7.5 x 1.8 cm.

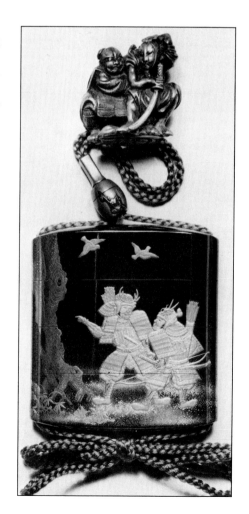

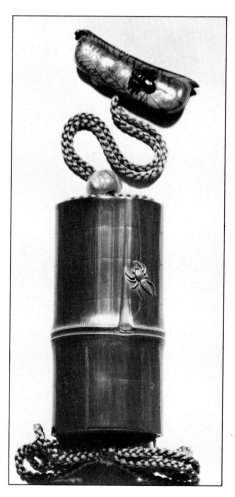

still strong and his managers established their own shops to supply it.

Fine lacquer cannot be produced in quantity. Foreign customers became disenchanted with the steadily decreasing quality of exported lacquers. A government study which had been commissioned in 1885 to investigate the situation reported 137 independent shops specializing in lacquer with sprinkled designs in Tokyo and 40 in Kyoto, but the yen volume of sales in Kyoto was twice that of Tokyo because the Kyoto wares were generally of higher quality and not intended for export.[43]

Shirayama Shōsai was the most prestigious lacquerer of his generation. His *inrō* no. 49 is a convincing recreation of bamboo (Fig. 58; colorplate 32). The side with the spider is brown, like the polished old bamboo one might find indoors; the other side is yellow, with all the marks and grain of a fresh pole. Shōsai started training at the age of eleven and proved capable in every type of technique. From 1891 to 1922 he was an instructor in lacquer at the Tokyo School of Fine Arts. In this *inrō* he displays an amazing eye for detail. The breaks between compartments are almost invisible and, except for the flat shape, the illusion of real bamboo is complete. On the top and bottom he realistically reproduced cut edges, and to avoid disturbing the design he put his signature inside the lid.

The elongated, eight-sided box no. 50 with chrysanthemums (Fig. 59) is an incense container for the tea ceremony. It epitomizes the best of anonymous late nineteenth-century lacquer. The shape is that of a children's toy called a *buriburi,* which was carved

out of wood and had a handle on one end and two decorative wheels on the side. It was given to children at New Year's, appropriately painted with cranes or pines. Originally used as a ball bat, it came to be thought of as a mallet to keep away demons and was used as a decoration.

This incense container follows the New Year's tradition with its felicitous chrysanthemum design, symbolic of long life, and would have been used at a New Year's tea ceremony. Many varieties of chrysanthemum have been included in the drawing and each one is drawn differently. Inlaid fragments of shell or cut gold decorate the centers of some of the flowers, and the petals are so expressively and freely drawn that the overall design conveys a gay, lively impression.

Fig. 59. Incense container no. 50 in shape of buriburi *toy. Late nineteenth century. 13.9 x 6.5 x 6.5 cm.*

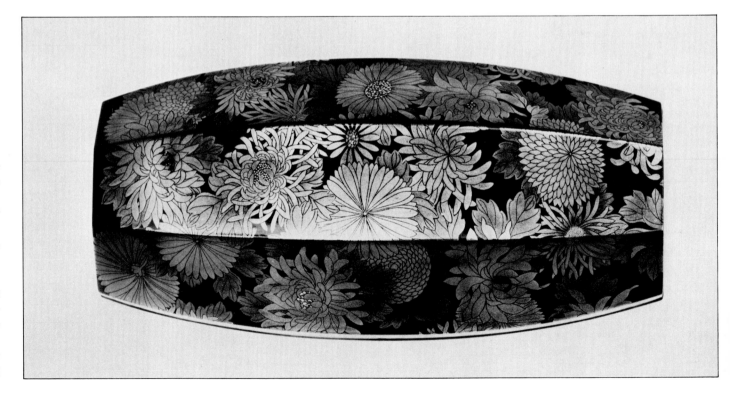

One of the most significant innovations in Japanese art and design between 1600 and 1900 was the development of the Rimpa style. The name Rimpa, which means "school of Kōrin," was applied only after the death of Ogata Kōrin (1658 –1716), the most renowned painter in this tradition. The style actually originated before him, about 1600, with Hon'ami Kōetsu (1558 –1637) and Tawaraya Sōtatsu (died ca. 1640).

The Hon'ami family members were professional sword experts. They polished, cleaned, and judged blades. In the martial world of the sixteenth century this skill was highly valued; the Hon'ami family was quite wealthy and had excellent connections with the most important people in Japan. Kōetsu was raised as a sword appraiser but was able to devote much of his time to artistic pursuits. He was a tea master, a disciple of Furuta Oribe (1543 –1615); a potter; and perhaps a painter and lacquerer. Above all he was a calligrapher, one of the three greatest of his time. His writing was usually applied to paper that had been decorated with original and distinctive paintings of plants and animals. The union of calligraphy and painting was so perfect on these works that until the twentieth century Kōetsu was assumed responsible for both.

These paintings, the first works in the Rimpa style, are now thought to be the work of Sōtatsu, Kōetsu's relative through marriage and the head of a Kyoto fan-painting shop called the Tawaraya. These two men together are credited with creating a new style of painting that on one hand reached back to the classic Heian period for its themes and on the other advanced the decorative tendencies long inherent in Japanese art. Their interest in ancient literary themes reflected Kōetsu's close personal connections with court nobility, the traditional guardians of classical culture who were limited in power by increasingly rigid military rule. Kōetsu's deep commitment to the Nichiren sect of Buddhism, traditionally concerned with the preservation of the emperor, may also have led him to these Heian courtly themes.

In 1615 the shogun Tokugawa Ieyasu granted Kōetsu land at Takagamine, an isolated area northwest of Kyoto. Here Kōetsu founded a small community of fellow Nichiren Buddhists, including a number of craftsmen. Sōtatsu stayed behind in Kyoto.

There are two lacquers in the Greenfield Collection similar to works attributed to Kōetsu: the *inrō* no. 51 with inlaid deer (Fig. 60) and the rabbit writing box no. 52 (Figs. 61, 62; colorplate 9). Deer and autumn are themes favored by Kōetsu and later Rimpa artists. The melancholy cry of the deer in autumn was frequently mentioned in old poetry. Designs of deer wandering in autumn woods appeared on lacquer boxes made long before Kōetsu, but the treatment of the theme on no. 51 is more decorative than ever before.

A flute case attributed to Kōetsu, in the Museum Yamato Bunkakan, Nara, is covered with a herd of deer (Fig. 63). These deer are not part of a realistic or naturalistic scene; they form lively and complex patterns. Their arched backs and thin legs establish a curvilinear rhythm, and the variety of inlay techniques and poses carries the melody, all within the extremely restricted surface area of the cylindrical case. The deer *inrō* no. 51, while similar to the

Fig. 60. Deer inrō no. 51. Seventeenth century. 6.4 x 7.6 x 2.0 cm.

OVERLEAF:
Fig. 61. Rabbit writing box no. 52. Early seventeenth century. 17.0 x 28.0 x 5.1 cm.

Fig. 62. Rabbit writing box no. 52, under lid

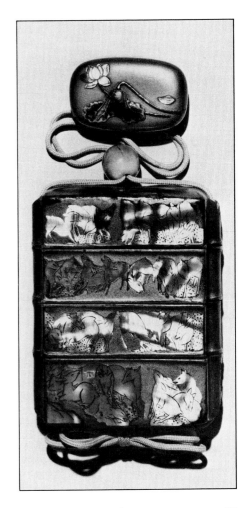

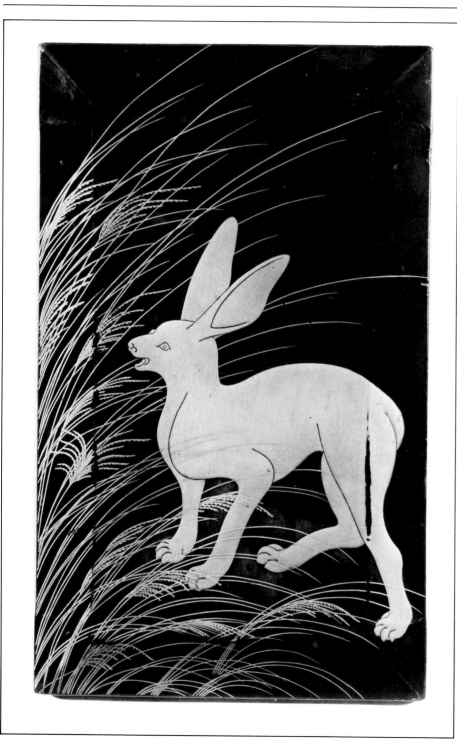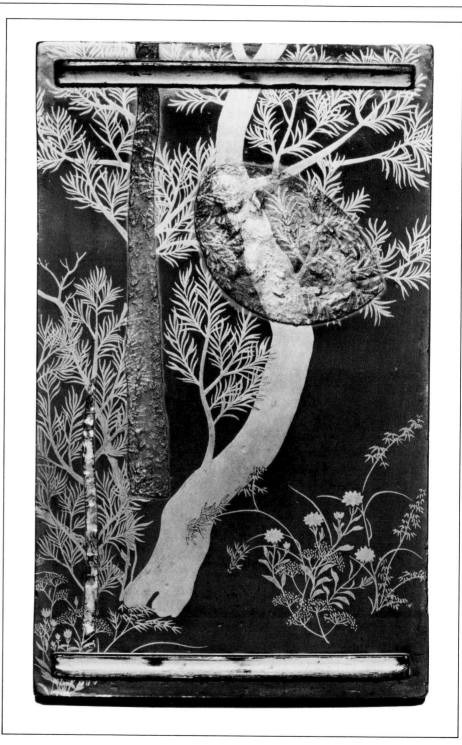

flute case in theme and technique, lacks the intensity of its design. The deer are constrained by the borders of their pewter-rimmed cases and look very much alike.

A more striking comparison can be made between the rabbit writing box no. 52 and a writing box with a bamboo design attributed to Kōetsu and in the collection of the Atami Art Museum, Atami. These boxes are the same shape and size and have the same type of inkstone and water dropper. On the underside of the lid of the Atami box is a rabbit in autumn grasses with his head turned up to the sky (Fig. 64); under the lid of box no. 52 is the autumn moon that the rabbit watches (Fig. 62). Each box uses only a small amount of inlaid shell, has areas of rough texture and metal inlay, and has an unusual ground inside: large flakes of silver *hirameji* (flat flake ground) in the Atami box (Fig. 65), red lacquer in box no. 52. A significant difference between the two boxes is the position of their inkstones. All writing boxes attributed to Kōetsu have an inkstone on the left side. Because of its centrally positioned inkstone and looser design, box no. 52 was probably not designed by Kōetsu himself, but it may be by the same lacquerer or shop that made the Atami box.

Did Kōetsu make the Atami writing box? His biography claims he made lacquer, and later generations prized Kōetsu lacquers. A record from 1714 shows that Kōetsu writing boxes were appraised from four to eight times more highly than writing boxes made by his outstanding follower, Ogata Kōrin.[44] Kōetsu's skill at pottery and sword polishing suggests that he would have been a capable lacquer

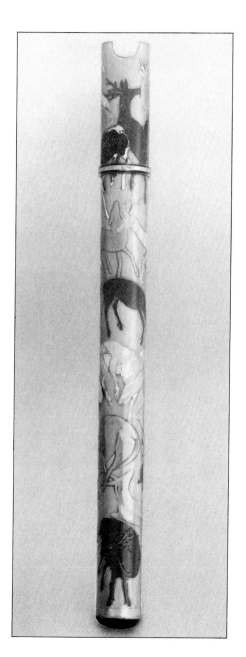

worker, but he need not have actually handled the material in order to gain high reputation as a lacquer artist. All important lacquerers worked with numerous assistants and disciples who did the more tedious work. Kōetsu probably functioned largely as designer and manager. The works attributed to him differ so widely that their execution may well have been carried out by a number of lacquer artists. Kōetsu had close connections with such Igarashi family lacquerers as Igarashi Dōho, a fellow Nichiren Buddhist, and Igarashi Tarōbei, who has been suggested as the maker of the Atami box.[45]

Kōetsu probably worked closely with these professional artists, supplying them with ideas, suggestions, and rough sketches. In a letter to a client, he wrote: "The gold inlay is nearly finished. I will show it to you. Would it be all right to do this drawing in gold powder? Write me to let me know what you think. Also tell me if I may add more leaves; they are too few. In the area with gold inlay the leaves are long. Make ink marks on the places you dislike and I will make those leaves shorter."[46]

The tradition of Rimpa lacquer design was continued by Tsuchida Sōetsu, who worked in the late seventeenth century. Although details of his life are not known, his name suggests that he considered himself a follower of Kōetsu, with whom he may have worked. A map of the Takagamine community shows a man named Tsuchida Ryōzaemon and one named Tsuchida Sōzawa living near Kōetsu. Tsuchida Sōetsu might have belonged to the family of one of these men.

An *inrō* by Sōetsu in the Greenfield Collection, no. 53 (Fig. 66), illustrates the "battle of the carriages," a scene from the *Aoi* chapter of *The Tale of Genji*, where both Genji's wife and his mistress arrive in their carriages to watch him march by in a ceremonial procession and their retainers fight over the best viewing position. The scene, executed in raised lacquer, is abbreviated and abstracted from its surroundings for the sake of the design.

Ogata Kōrin was born into a family of textile designers. Originally named Ichinojō, he took the *kō* in Kōetsu for his own name to show his respect for the tradition of Kōetsu. Their families were related, and although Kōrin was born twenty-one years after Kōetsu died, he undoubtedly heard many stories about him. When his father died, Kōrin's eldest brother took over the textile business and the thirty-year-old Kōrin was left to enjoy his considerable inheritance. This he did with great style and enthusiasm, leading a very active social life and spending freely. In the early 1690s he ran into financial difficulties, partly as a result of loans made to feudal lords. In order to maintain his high standard of living, Kōrin was forced to part with some treasured possessions. A letter he sent to his pawnbroker in 1694 still survives:

One writing box with deer by Kōetsu (including inkstone and water dropper), one Shigaraki ware water jar with lacquer lid. Since I need money for an emergency I am turning in these two items for seven *ryō* with a monthly interest of ten percent which I will borrow from you until the third month of next year. Let it be clear that on the deadline I will pay both principal and interest

Fig. 64. Writing box with rabbit viewing moon, attributed to Hon'ami Kōetsu (1558–1637), under lid. Seventeenth century. 28.2 x 17.0 x 5.4 cm. Atami Art Museum, Atami

Fig. 65. Writing box with rabbit viewing moon, inside . Atami Art Museum, Atami

Fig. 66. Inrō no. 53 with carriage fight, by Tsuchida Sōetsu. Late seventeenth century. 5.6 x 6.1 x 1.7 cm.

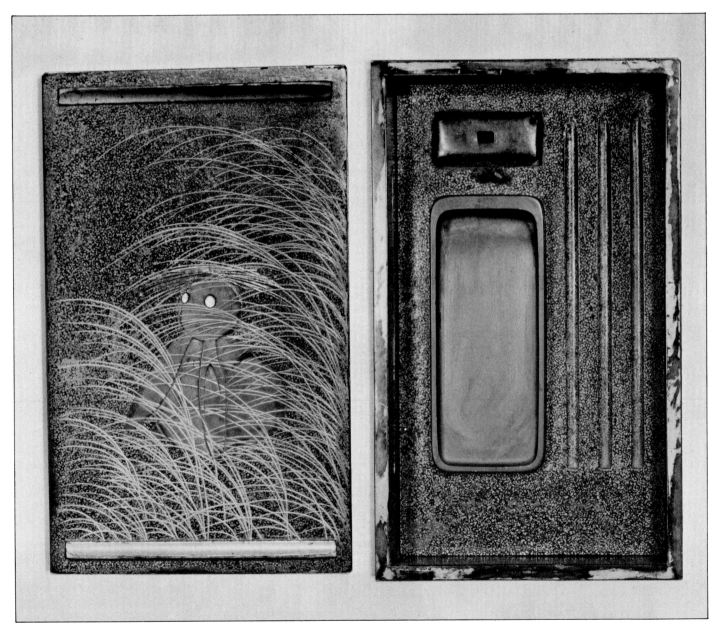

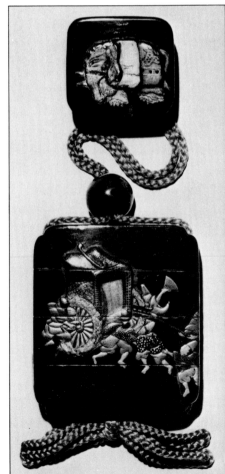

Fig. 67. Deer writing box no. 55. Eighteenth century. 19.2 x 25.9 x 4.8 cm.

and take back these two items. If I miss by even one day you may sell them or keep them, whatever you wish. I will not protest. Both of these things have been in my family for generations and have not been purchased from outside. In the event of fire or theft both of us will lose.[47]

Kōrin turned to art to make a living. He designed some textiles; for a short period he decorated his brother Kenzan's pottery; and he was successful as a painter and a lacquer artist. Well trained in the use of the brush and the fundamentals of textile design, Kōrin came naturally to lacquer design. It is possible that he did the actual lacquer drawing on some of his boxes, although most of the work would have been done by others under his supervision. Nonetheless he continued to live beyond his means. About 1697, he wrote in a letter: "I have received an order from Edo for a writing box but I'm late with it and don't think I'll get the money this year. The middleman refused to give it to me. Since this is a pressing problem I would like to receive a small advance.

Please discuss this with the people near you and forgive the trouble I'm causing you."[48] Kōrin was awarded the honorific title of *hokkyō* in 1701 and went to Edo in 1704, where lucrative commissions were available. Seven years later, he returned to Kyoto, apparently convinced that it was better to be poor there than overworked in Edo. He died famous but impoverished.

Kōrin specialized in *inrō* and writing boxes. The Greenfield Collection contains a work of each type, both bearing his name: the *inrō* no. 54 with double-petaled bellflowers and buds on each side (colorplate 10), and the writing box no. 55 (Fig. 67). On the front of *inrō* no. 54, the flowers and buds are inlaid shell; on the back they are pewter. Some leaves are indicated by outlines while others are inlaid. The signature is incised on the underside of the lid and is followed by a *kaō* (personal cipher; Fig. 68). Similar signatures appear on a number of extant *inrō* with shell and pewter decoration against a background of powdered gold with larger gold flakes.

A good comparison to no. 54 is the Sumi Bay writing box in the Seikadō

59

Fig. 68. Detail, signature and kaō, bell-flower inrō no. 54

Fig. 69. Sumi Bay writing box by Ogata Kōrin (1658–1716). Early eighteenth century. 25.8 x 23.0 x 10.0 cm. Registered Important Cultural Property, Seikadō Collection, Tokyo

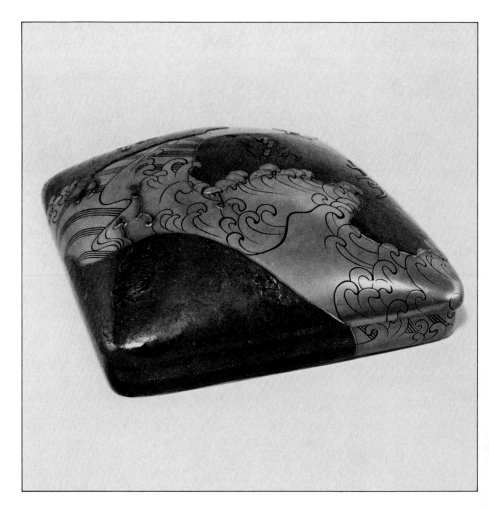

Collection, Tokyo. This striking lacquer (Fig. 69) is contained in a larger box with an inscription by Kōrin identifying it as a copy of a Kōetsu writing box and including Kōrin's signature and *kaō*. This is one of the verified works by Kōrin; on the basis of the inscription calligraphy, it is dated to the last years of his life. The pewter is relatively smooth and skillfully applied and the lines of the waves are even and sure. The *kaō* on the box is similar to that of the *inrō* but not the same.

The signature on the writing box no. 55 with deer and moon includes yet another Kōrin *kaō*. This extraordinary box was formed by splitting a single thick slab of wood, and hollowing out a space to hold the inkstone. A simple but effective design of a deer and moon on the outside was balanced by a partial view of three pines on the inside. The inkstone is decorated with a shrine gateway and the water dropper was once silverplated.

A number of sketches and related materials from Kōrin's hand still survive, among them forty-seven ink drawings probably intended as *inrō* designs. In most of them the front and

back designs are closely related, and in one example the design even continues onto the lid.[49] There are several scenes based on *The Tale of Genji*.

The *inrō* no. 56 with a courtier and a woman in a boat (Fig. 70) is not signed, but in composition, theme, and technique it is very close to Kōrin's work. The subject is taken from the last part of *The Tale of Genji*. The man, Prince Niou, has seduced the lonely Ukifune and is taking her across the Uji River to a secluded hideaway. As they are crossing they exchange poems on their love and fate.

Kōrin's lacquer was in great demand and inspired countless related designs such as the bridge *inrō* no. 57 (Fig. 71; colorplate 11). Inside the single compartment sits a small tray. The *inrō* is in the shape *Rikyū gata* ("Rikyū style"), a form traditionally said to have been favored by the tea master Sen no Rikyū (1522–91). The bridge is beautifully suited to the curve of the *inrō* and the brown ground matches the color of the shell better than black would.

Some later lacquers in the Kōrin style were deliberately aged to make them appear to be works of Kōrin's time. The incense container no. 58 with two deer is such a piece (Fig. 72). Great pains were taken by the late nineteenth-century artist to make this small box seem like an early eighteenth-century work. The background is a light brown similar to that found on such eighteenth-century boxes as no. 57; gold flakes were made somewhat clumsily in an older style for the ground; the box interior and the rim were intentionally darkened and stained; and the bottom corners were sanded to make them appear worn.

Fig. 70. Inrō *no. 56 with Ukifune and Prince Niou. Eighteenth century. 6.7 x 6.4 x 2.1 cm.*

Fig. 71. Inrō *no. 57 with bridge and plovers. Eighteenth century. 8.0 x 5.7 x 2.4 cm.*

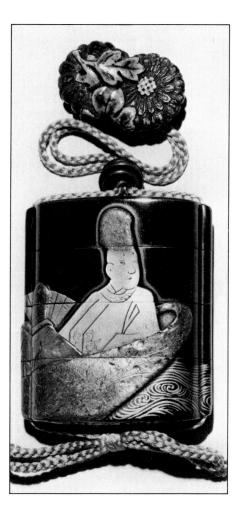

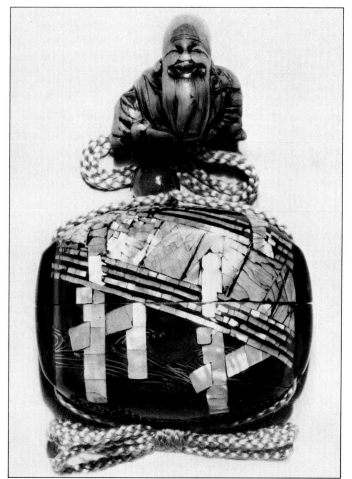

The artist was more successful with these technical details than with the choice of shell, the shape of the deer, or the drawing of the *ominaeshi* (a type of autumn flower).

Such deceptions and imitations have a long history in Japanese lacquer. During the Edo period many lacquerers, conscious of family traditions, strove to imitate their ancestors. For some, this was an honest emulation brought about by an admiration of old styles. One early eighteenth-century lacquerer wrote of his recent ancestor: "Ryōsei was single-minded and talented, and above all he wanted to preserve the old techniques. He painted in a single style and did not like his powdered gold to shine brightly. He restrained himself and in his interior designs he added one-fourth copper; in his rocks and trees or his brushwood fences he used inkstick powder. His aventurine was irregularly arranged and he darkened the flakes....He preserved the rules of his ancestors but never made forgeries."[50]

Those who did deliberately forge lacquer were looked down on:

> There was an artist of sprinkled designs by the name of Igarashi Dōho. Since old works of lacquer were scarce, he did many imitations. But because he seemed not to know about the old types of gold, although his works were relatively popular among buyers and sellers of old lacquers, people gradually realized what these works were and afterwards called them "fakes by Dōho." Then no one sought them anymore and Dōho failed.
>
> When he imitated old aventurine he rubbed in lampblack,

then added a coat of lacquer which he wiped away completely. He wiped powdered charcoal in the crevices of the raised areas so that some was left behind. He added lead to the silver and gold ... and he deliberately aged it. He would place a cover over the piece and smoke it with burning straw.

The ordinary sprinkled-design artists were unaware of these aging techniques and certified these works as truly old. But gradually, through experience, even the lowliest itinerant lacquerers learned to recognize the methods of these works called "Dōho fakes." But when the pieces turned up in increasing numbers on the shelves of antique dealers, in public markets, and even with the junk on street stalls, their connection with Dōho was forgotten.[51]

The next great Rimpa artist after Kōrin was Sakai Hōitsu (1761–1828), a wealthy samurai who became a Buddhist priest and a professional artist. Learning Kōrin's work through the Sakai family's extensive collection, Hōitsu took Kōrin as his artistic model. Hōitsu did not make lacquer, but his drawings were often used as lacquer designs by Hara Yōyūsai (1772–1845), his contemporary. The silver *inrō* no. 59 by Yōyūsai (Fig. 73) illustrates the theme of snow, moon, and flowers and includes Hōitsu's signature as part of the composition. Yōyūsai also followed a Hōitsu painting with a simple bamboo design in no. 60 (Fig. 74). Smaller containers such as this one were called *otoshi* ("dangling") rather than *inrō*. They were not hung at the waist, but were attached to

Fig. 72. Incense container no. 58 with two deer. Late nineteenth century. 6.8 x 6.8 x 2.5 cm.

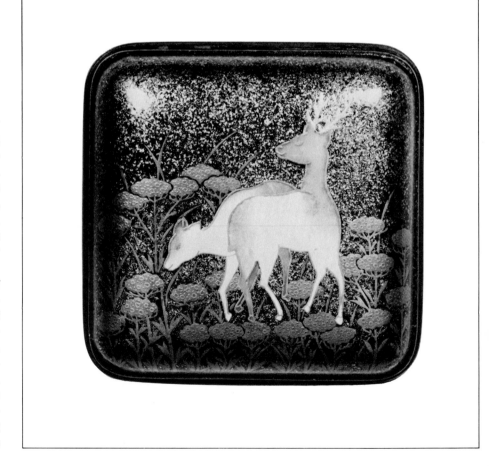

a purse carried inside the front fold of the kimono.

An album of drawings used by Yōyūsai for *inrō* is now preserved in the Museum of Fine Arts, Boston. It includes the underdrawing (Fig. 75) for Yōyūsai's *inrō* no. 61 with violets, ferns, and rushes (Fig. 76). Still visible on the back of the thin paper are the lines Yōyūsai traced in red lacquer to transfer them to the surface of the *inrō*.

Unlike most lacquer or painting schools, the Rimpa style was not passed from father to son. Scattered in time, Rimpa artists were drawn to the style by their admiration for its manner of expression. The three major figures —Sōtatsu, Kōetsu, and Kōrin—all had backgrounds in the crafts, and Kōetsu and Kōrin were capable of working in various media. Their common interest was good design.

Both Kōetsu and Kōrin used classical literary themes on their lacquer boxes, but only Kōetsu referred to specific poems in the manner of other literary-inspired lacquers of the period. On the whole, the subjects used in Rimpa style were chosen for a general literary aura and for their ready conversion into agreeable designs. Flowers, in particular, were favored because they were literary but nonspecific, colorful but varied. Drawn close up and in isolation from detailed surroundings, their carefully composed shapes are emphasized. Rimpa designs, which work well in painting, are even better suited to lacquer, where contrasts in texture, material, and shape add new dimensions to the subtle arrangements of form.

Fig. 73. Inrō *no. 59 with snow, moon, and flowers, by Hara Yōyūsai (1772–1845). 7.8 x 7.0 x 2.0 cm.*

Fig. 74. Bamboo otoshi *no. 60 by Hara Yōyūsai (1772–1845). 5.1 x 5.1 x 2.0 cm.*

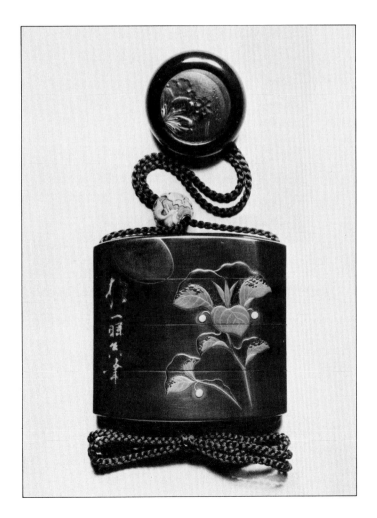

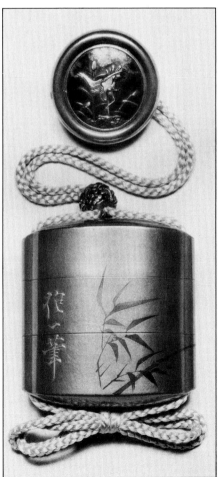

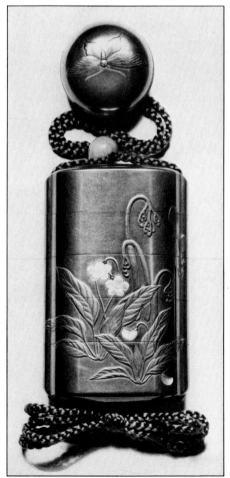

1. Rectangular box no. 1 with bamboo, peony-rose, and crests. Ca. 1647. 19 x 22.7 x 12.1 cm.

2. *Writing box no. 2 with carriage design.*
Second half seventeenth century. 16.9 x
18.5 x 3.8 cm.

3. Inrō no. 8 with dragon and waves.
Seventeenth–early eighteenth century.
5.8 x 6.5 x 2.1 cm.

4. Inrō no. 14 with chrysanthemums by
fence. Seventeenth century. 5.0 x 5.6 x
2.0 cm.

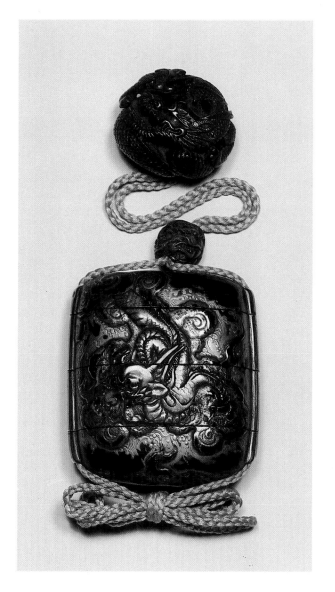

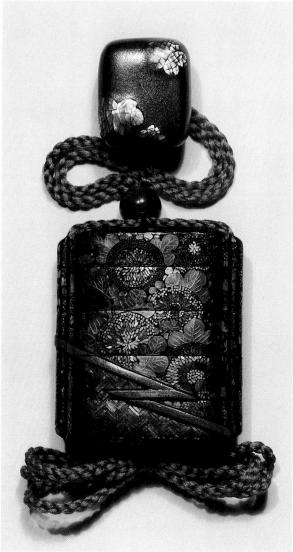

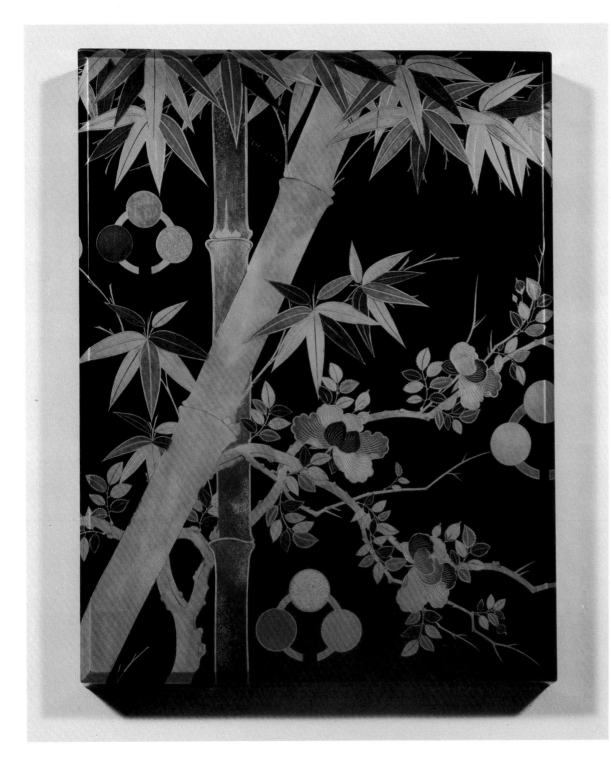

5. *Stationery box no. 27. Eighteenth century. 30.3 x 38.9 x 12.0 cm.*

6. *Stationery box no. 27, under lid*

RIGHT: 7. Incense ceremony set box no. 23. Eighteenth century. 25.0 x 16.8 x 20.0 cm.

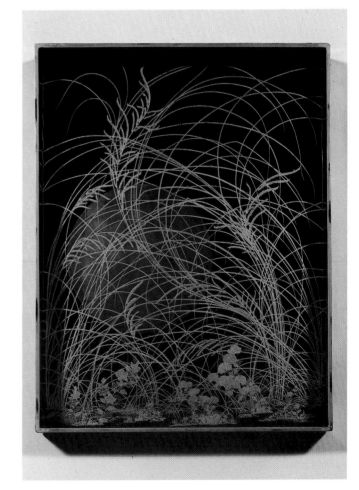

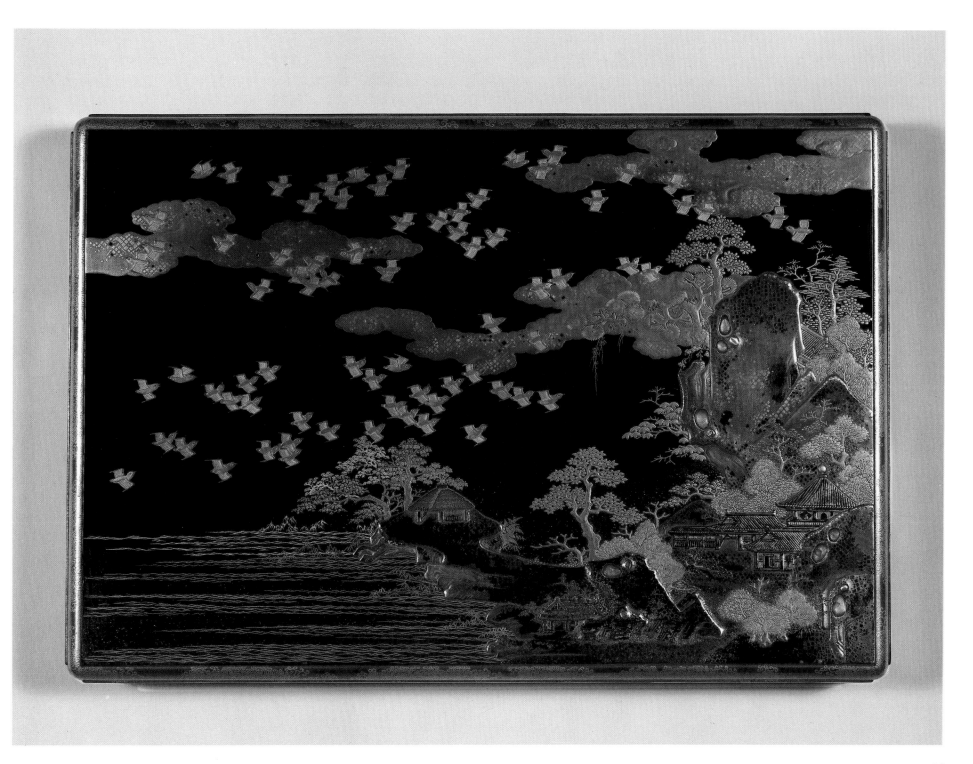

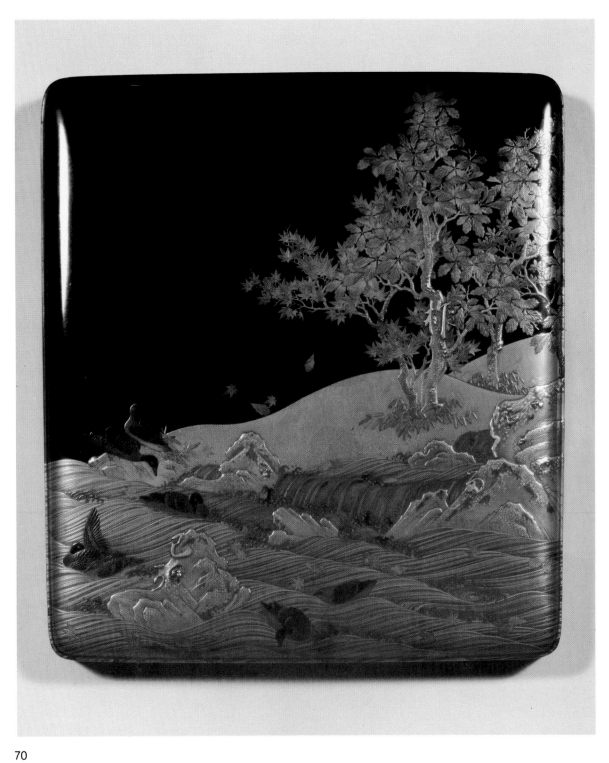

8. Writing box no. 16 with ducks and oak tree. Eighteenth century. 22.4 x 24.2 x 4.3 cm.

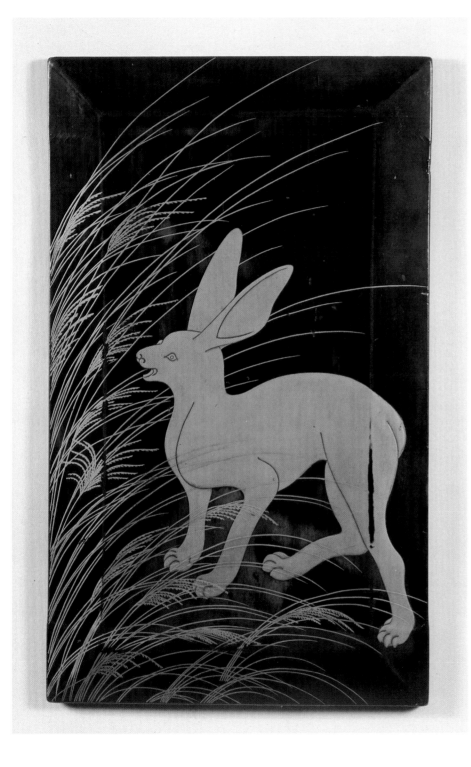

9. Rabbit writing box no. 52. Early seventeenth century. 17.0 x 28.0 x 5.1 cm.

10. Bellflower inrō no. 54. Eighteenth century. 5.4 x 5.9 x 1.6 cm.

11. Inrō no. 57 with bridge. Eighteenth century. 8.0 x 5.7 x 2.4 cm.

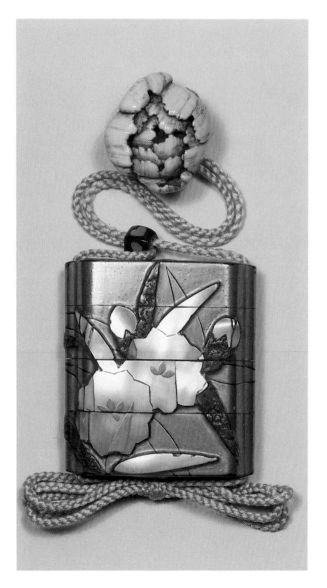

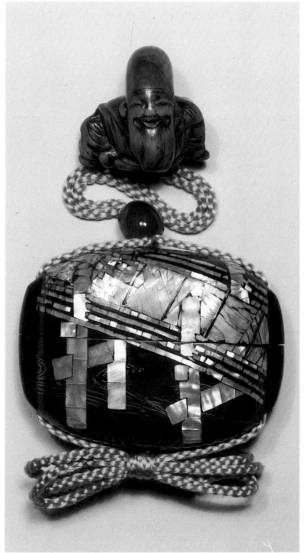

12. Inrō *no. 88 with painted shells, by Koma Kyūhaku (died 1715?). 6.1 x 9.1 x 1.6 cm.*

13. *Owl* inrō *no. 66 by Ogawa Haritsu (1663–1747). 7.1 x 6.6 x 2.7 cm.*

14. Inrō *no. 63 with* bugaku *helmet, by Ogawa Haritsu (1663–1747). 4.4 x 6.5 x 2.5 cm.*

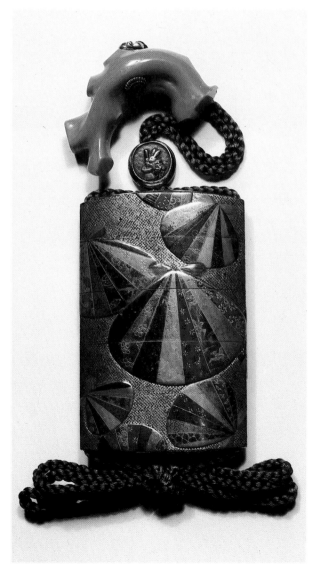

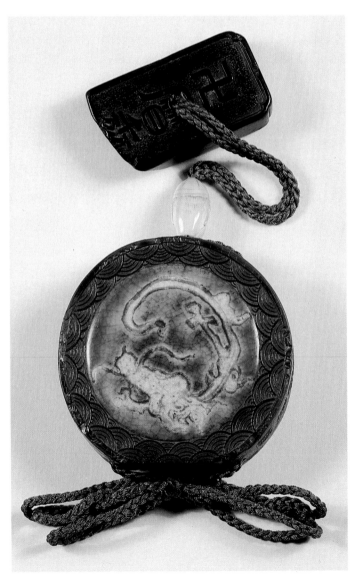

15. Sheath inrō no. 64 with phoenix, by
Ogawa Haritsu (1663–1747). D. 7.6, H. 1.6 cm.

16. Reverse of sheath inrō no. 64, with
dragon

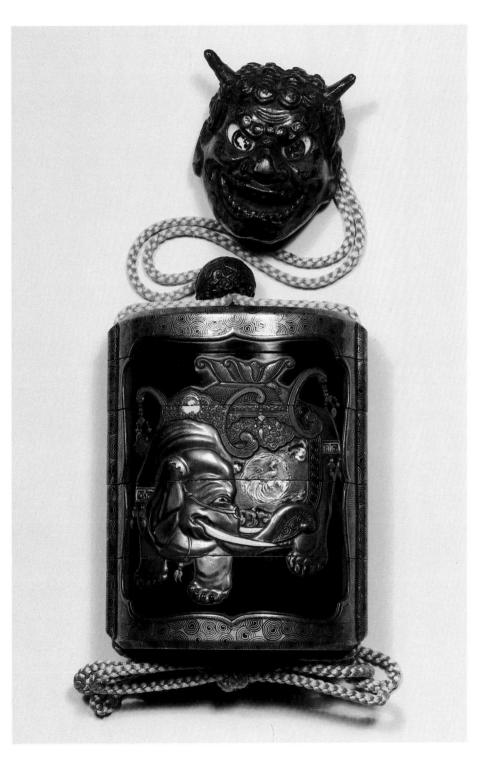

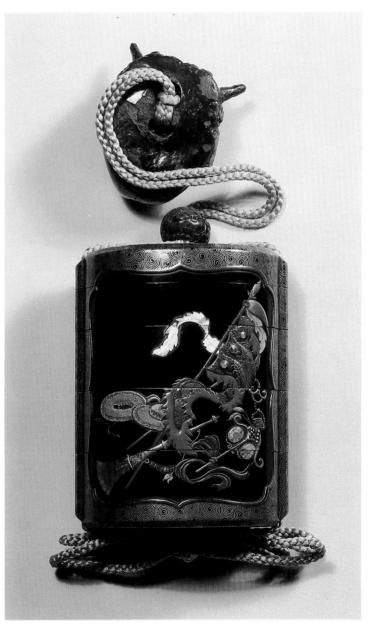

17. Elephant inrō *no. 65 by Ogawa Haritsu
(1663–1747). 10.3 x 12.9 x 3.8 cm.*

18. *Reverse of elephant* inrō *no. 65, with
instruments and pennant*

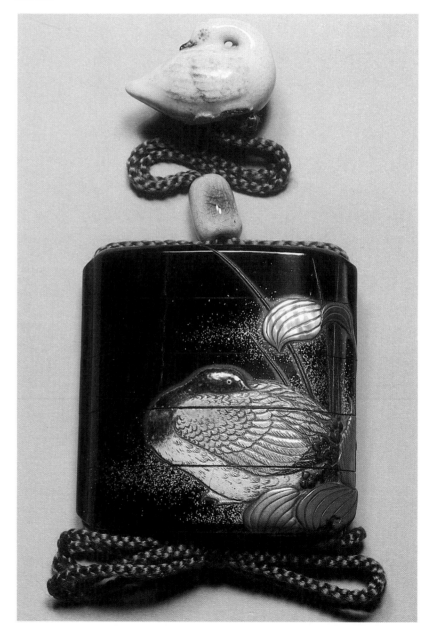

19. Inrō no. 67 with Chinese ship, by Ogawa Haritsu (1663–1747). 9.0 x 11.2 x 3.0 cm.

20. Goose inrō no. 70 by Mochizuki Hanzan. Mid-eighteenth century. 7.6 x 7.6 x 2.2 cm.

21. Writing box no. 69 with quail and millet, by Mochizuki Hanzan. Mid-eighteenth century. 20.6 x 24.3 x 4.7 cm.

22. *Writing box no. 37 with spitting courtesan. Eighteenth – early nineteenth century. 20.9 x 25.1 x 6.3 cm.*

23. Inrō *no. 30 with persimmons and
leaves. Late eighteenth century. 6.8 x 9.8 x
2.2 cm.*

24. *Double* inrō *no. 112 by Shiomi
Masanari (1647–ca. 1722). 6.0 x 8.7 x
3.4 cm.*

25. Inrō *no. 113 with ox and herdsboy.
Eighteenth–nineteenth century. 6.9 x
7.8 x 2.9 cm.*

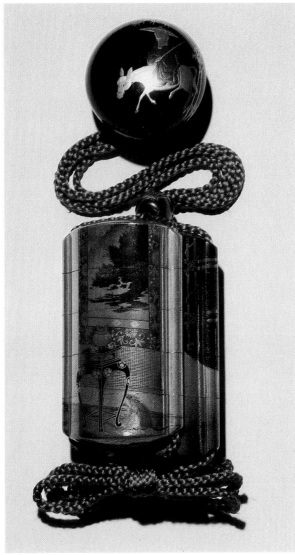

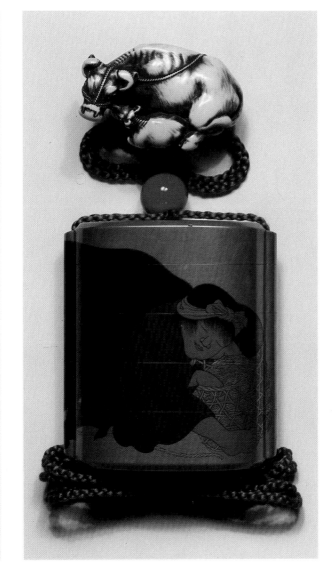

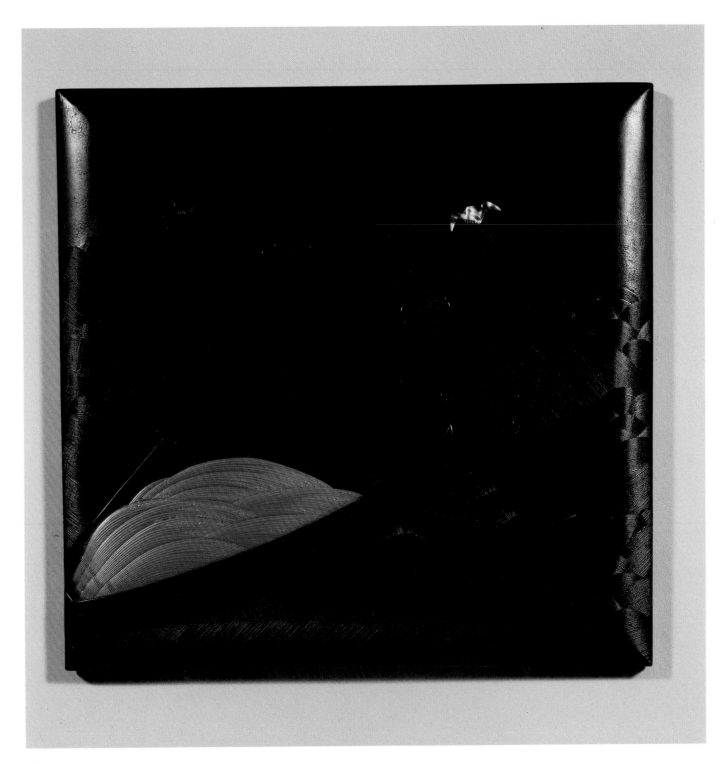

26. *Lid of layered food box no. 78 with boat and plovers, by Shibata Zeshin (1807–91). 24.4 x 22.9 x 1.7 cm.*

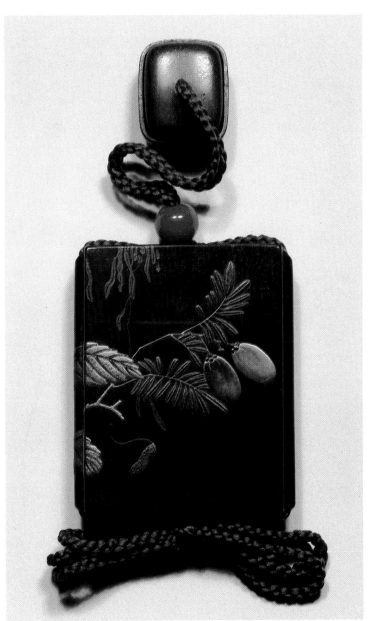

27. Inrō *no. 76 with chestnuts and ever-green, by Shibata Zeshin (1807–91). 6.7 x 7.9 x 1.8 cm.*

28. *Reverse of inrō no. 76*

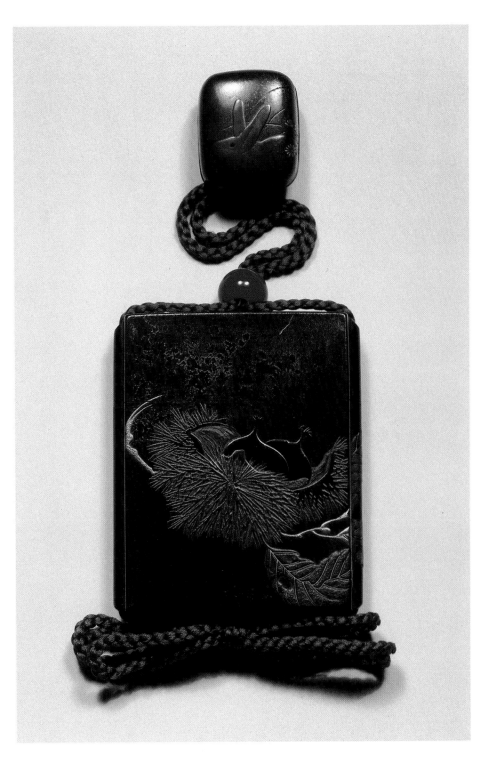

29. Inrō no. 125 with plum, pine, and bamboo, by Tsuishu Yōsei. Eighteenth century. 5.6 x 7.4 x 2.2 cm.

30. Prawn inrō no. 136 by Onko Chōkan Nagasato. Early eighteenth century. 7.9 x 5.7 x 2.4 cm.

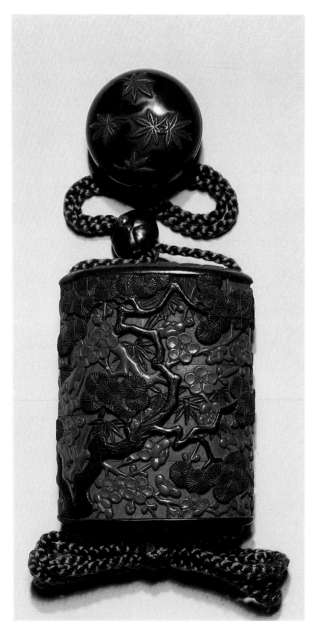

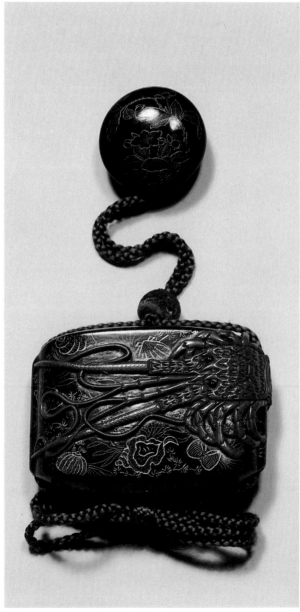

31. Inrō no. 123 with peaches and peonies, by Tatsuke Hisahide (1756–1829). 5.7 x 7.2 x 2.0 cm.

32. Bamboo inrō no. 49 by Shirayama Shōsai (1853–1923). 3.8 x 7.5 x 1.8 cm.

33. Inrō no. 137 with birds by shore. Eighteenth century. 4.7 x 6.3 x 1.6 cm.

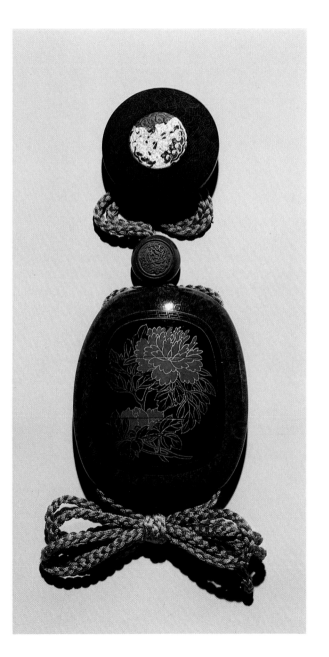

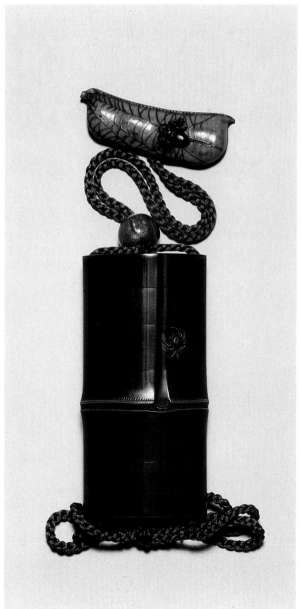

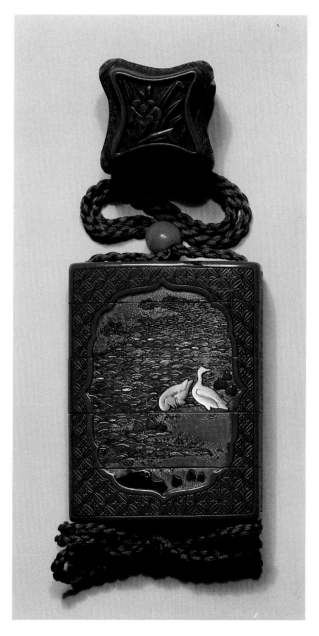

In the history of lacquer, Ogawa Haritsu (1663–1747) and Shibata Zeshin (1807–91) stand apart from simple classification by school or family tradition. They were individuals of great skill who continued to create innovative pieces throughout their lives.

OGAWA HARITSU

Haritsu grew up in the samurai Ogawa family in Ise province. Nothing is known of his early years, but legend tells that he was expelled from the family because of his profligate behavior. Poor and friendless, Haritsu traveled to the bustling metropolis of Edo to make his fortune. In Edo, he began a career as a haiku poet, and married the daughter of his teacher, the senior poet Fukuda Rogen (1630–91). When Rogen died in 1691, Haritsu became the student of the great poet Matsuo Bashō (1644–94). Haritsu's two closest friends were Bashō's leading disciples: Takarai Kikaku (1661–1707) and Hattori Ransetsu (1654–1707). Most of Haritsu's poems appear in *Zoku Minashi-guri,* an anthology edited by Kikaku in 1687. Some of the legends describing Haritsu's early years are based on interpretations of these poems. The earliest poem to which Haritsu gave an explanatory headnote in the anthology is thought to refer to his initial journey to Edo. Haritsu compares himself to one of the roadside stone statues of the Bodhisattva Jizō:

> Written at night when I was wandering through the mountains of Kai province with no place to stay:

> Wearing a sword
> A ragged, frost-covered Jizō.[52]

The experience of his early, impoverished years seems to have impressed

him deeply; his chosen art name, Haritsu, means "torn bamboo hat." Haritsu used the name Kan when he signed his earliest lacquer works. It is not known when Haritsu first turned to lacquer or how he learned its techniques, but a poem published in 1690 implies that he was involved in artistic endeavors at the age of twenty-seven:

> Even as I draw it
> The morning glory withers.[53]

The Greenfield Collection includes an *inrō* made by Haritsu during his first period, before 1712. This *inrō,* no. 63 (Fig. 77; colorplate 14), can be approximately dated on the basis of its restrained design and the red lacquer seal reading *Kan.* On the front is a helmet of the sort used in *bugaku* (an ancient form of court dance), and on the back is a flute and drum used for the accompanying music. This small, exquisite lacquer has a simple and restrained design but touches of Haritsu's original genius are shown in the gold-sprinkled cord channels and the delicate inlay on the helmet. Haritsu is thought to have been the first to inlay ceramics in lacquer; on no. 63 the helmet band contains tiny, low-fired ceramic pieces that were modeled and glazed especially for this purpose. Haritsu's most impressive talent was his complete control of detail. No matter how small the lines are drawn, they always flow evenly.

Within this first period of twenty years or more, Haritsu developed his successful style. By the age of fifty most lacquer workers would have left their best years behind them. Decorating lacquer is a tremendous strain on the eyes, particularly when the objects are small, like *inrō,* and when the drawing is

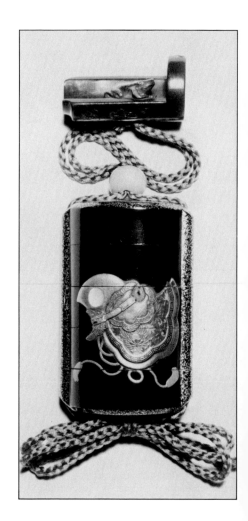

Fig. 77. Inrō no. 63 with bugaku *helmet and instruments, by Ogawa Haritsu (1663–1747). 4.4 x 6.5 x 2.5 cm.*

as delicate and precise as Haritsu's. At this age, a master's carefully trained students usually begin to take over the more taxing details. But Haritsu seems to have become stronger with age. A painting in the Mary and Jackson Burke Collection, New York, which he drew at the age of seventy-nine, attests to his unfailing eye and steady hand.

In 1712, when he entered what is traditionally considered old age, Haritsu adopted the art name Ritsuō, meaning "bamboo hat old man." He generally used this name together with his familiar Kan seal. Haritsu signed with this combination of names on the extraordinary sheath *inrō* no. 64, which imitates a round Chinese inkstick (Fig. 78; colorplate 15). It is called a sheath *inrō* because the three layered compartments slip into the middle of an outer container. A hole in the bottom of the outer container enables the wearer to push up the core. It seems that Haritsu had a flair for such Chinese exotica, perhaps through the influence of his friend Kikaku, who was conversant with Chinese culture and loved to use obscure allusions in his poetry. The netsuke for this round *inrō* was carved by Haritsu out of ebony, and also imitates a used inkstick.

Old inksticks by famous craftsmen were treasured artifacts in China. Haritsu had access to Chinese books illustrating renowned inksticks and was intrigued by the possibilities of reproducing their colors and texture in lacquer.[54] The techniques he invented for the purpose were very effective. The ground of the *inrō,* behind the phoenix and around the sides, is intentionally rough and crackled. Gold powder was lightly applied to the feathers of the phoenix to make it appear as if most of

Fig. 78. Sheath inrō *no. 64 by Ogawa Haritsu (1663–1747). D. 7.6, H. 1.6 cm.*

Fig. 79. Writing box with old Chinese inksticks, by Ogawa Haritsu (1663–1747). 1720. 23.3 x 21.1 x 5.2 cm. Tokyo National Museum, Tokyo

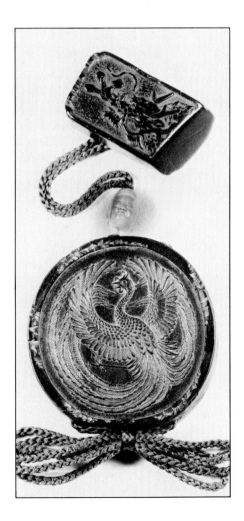

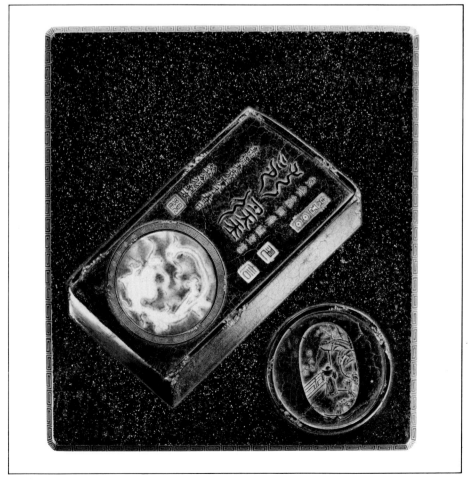

Fig. 80. Elephant inrō no. 65 by Ogawa Haritsu (1663–1747). 10.3 x 12.9 x 3.8 cm.

Fig. 81. Detail, signature and seal, elephant inrō no. 65

the gold had rubbed off with handling. The circular rim was made with realistic chips and cracks. The *inrō* looks worn and old but is in fact in excellent condition.

Haritsu's ability as an artist goes far beyond technical facility. The swirling feathers of the phoenix seem to be only temporarily constrained by the round border. The bird is tense with contained energy: its leg, the only straight line in the design, expresses this latent force.

The back of *inrō* no. 64 (colorplate 16) features a large ceramic disk encircled by waves. On the disk is a dragon in white against a green ground. The outline and details of the dragon's face were drawn in gold which has partially rubbed off. A disk very similar to this one is incorporated in a writing box by Haritsu now in the Tokyo National Museum (Fig. 79). There, too, the disk is inlaid within an imitation of an old inkstick. The *inrō* is dated 1716; the Tokyo writing box is dated 1720.

Because of its unusual thickness, the foundation of the sheath of this *inrō* is probably wood, but the three interior compartments are made of lacquer applied to a leather base. This base is

clearly visible through a crack in the surface. In the early eighteenth century, *inrō* were still used to carry medicines and it was important for them to be airtight. The *inrō* makers were aware of something mysteriously fine about the preservative powers of leather *inrō*. The highest-grade *inrō* used bases made of translucent oxhide.[55] Thick leather was used for the outside walls while thinner pieces were used for the risers inside. The flat bottom of each compartment was made of wood. The leather parts were shaped by wrapping them around wooden forms and coating them with lacquer. When the lacquer hardened the leather was slipped from the wooden cores; the thicker outside rings, thinner inside rings, and flat bases were then joined with glue. It took considerable skill to fit these parts together precisely. Subsequent layers of lacquer covered all the joints. Medium-grade *inrō* had outsides made of paper-thin strips of pinewood and insides of thin leather. The lowest-grade *inrō* were made entirely of thin wooden strips and were not considered appropriate for medicines. Present-day *inrō* makers use paper

soaked in lacquer instead of leather or wood.

Haritsu was obviously an extremely versatile craftsman. According to a story first recorded in 1768, twenty years after his death, Haritsu's talent caused quite a stir in Yoshiwara, the pleasure district of Edo:

There was a successful courtesan named Tamagiku. She gave generous tips not only to the teahouses she frequented, but also to other houses, and so there wasn't a person in the neighborhood who wasn't fond of her. One summer she didn't feel well and took to her bed. As the days passed her illness grew worse and in the beginning of the seventh month she died. For the sake of her soul the teahouses all lit faceted lanterns with streamers and hung them out front. Because business prospered, in 1728 the teahouses got together and put out Shimano lanterns. The famous craftsman Haritsu skillfully devised a mechanical lantern. When he sent it to a certain

teahouse, crowds of people came to marvel at it. From that time on, such lanterns became the custom and various interesting types appeared. Even today they are the epitome of beauty and draw mountains of sightseers.[56]

Haritsu's personality and range of ability is best seen in the oversized elephant inrō no. 65 (Fig. 80; colorplates 17, 18). Elephants were known to the Japanese only through pictures brought from China and the West. The first elephant arrived in Edo in 1724. As if to reflect the visual impact of this huge animal, Haritsu made an immense inrō.[57] Collectors traditionally assume that such large inrō were made for sumo wrestlers; in view of Haritsu's connection to Yoshiwara and the popular world of Edo, this is not implausible. Whoever the client, the true purpose of this inrō was to be as exotic as possible. The side with the elephant is inlaid with all types of materials, especially brightly colored ceramics, and the back shows a Chinese banner and foreign instruments: horn, cymbals, and drum. The gold border is decorated with freehand spirals in brown and black lacquer. Haritsu's signature is placed in a foreign-inspired scrollwork frame (Fig. 81). The inside is as astonishing as the outside. On a very fine gold aventurine ground float small, plantlike designs in silver, and each riser is covered on the outside with delicate drawings.

Everything about this inrō would have stirred wonder in the eyes of an eighteenth-century man of Edo, from the carved red saddle to the elephant's eye. The traditional lacquer master was a specialist who relied on other craftsmen to supply the basic materials for his conservative designs. Haritsu used materials that only he knew how to make, and he applied them in new ways to designs of his own invention. No wonder, then, that Haritsu was the most popular lacquerer of his time. In the 1720s Haritsu lacquer ware was cited as one of the most famous products of Edo.[58]

Many talented craftsmen must have felt the temptation similarly to abandon tradition and strike out in new directions. They were lured by the potential for fame and wealth. A story, first printed in Osaka in 1774, was written to warn craftsmen who were so inclined. Its moral is that craftsmen, unlike merchants, should not make too much money or be too much in demand, but should simply work steadily and quietly for the sake of the generations that will follow in their tradition. By way of illustration, the author relates the story of a skilled Kyoto copper worker who specialized in sword fittings. The portrait of this craftsman vividly illustrates the world in which Haritsu worked:

He was naturally talented and a skilled copper worker. He had many disciples and lower craftsmen who worked with him, but he did all the final touches himself. If the final result did not please him he threw it away, whether or not it pleased others. Because of this sense of professional pride he became famous as a skilled master.

Despite his many orders he amused himself by making netsuke for a hobby. They were so well received that he turned to the making of pillow clocks, Dutch magnets, and such things as a carving of the eight views of Ōmi on the face of a pearl bead [ojime]. Gradually his original craft became uninteresting to him. From untimely orders came untimely profits. He gained a reputation in Kyoto as a strange fellow.

Thinking that he would demonstrate his mastery, he carved a sign that read "I do all kinds of copper work." The edges of this sign were done with inlaid green shell depicting not only the famous places and ancient sites inside and outside the capital, but also the crowds of people at the prosperous theaters of the various districts. The minuteness and freshness of his carving and inlay were such that it was actually quite hard to see clearly. As a way of boasting about his work he put a sign near it that read "magnifying glasses available for rent to older people." Young people, too, realized the carving and inlay work were almost invisible without the glass, and so they would suddenly pretend to be old and would claim their eyes were weak because of sexual overindulgence. Others claimed they could only see at night and hence needed the glass.

Nowadays crowds of sightseers run about Kyoto, the way they do in Osaka, going to places that are free. When they came to look at the copper worker's sign he would sit inside his shop and listen to them talk of his reputation. He would laugh to himself with delight and put out sake and snacks, and drink from morning to night as he feasted with his praisers. Work came to a halt as a result of this constant visiting, and the district got together and complained to the elders that it was impossible to do business because of the crowds in the neighborhood. The copper worker was told to move or put away his sign before there was a fight. And so he took it down but still would show it on request from time to time.[59]

Fortunately, Haritsu remained a professional lacquerer and tempered his talent with a sense of restraint. In the inrō no. 66 with owl and clappers (Fig. 82; colorplate 13), his finesse is illustrated by the soft, feathery painting on the body of the bird and the expertly inlaid green-shell eyes and white-shell claws. The rest of the inrō follows a notably simpler style and may even have been executed by an assistant.

Sometime after 1710, Haritsu's work caught the eye of a wealthy lord from northern Japan, Tsugaru Nobuhisa (1669–1747), who hired Haritsu as his official lacquerer. From that time until 1731, when Nobuhisa retired, most of Haritsu's output went to the Tsugaru family. A firsthand report of a meeting during those years tells us more of Haritsu's personality:

Once a traveler from Sendai was talking to an innkeeper. He had heard of a craftsman named Sōha [one of Haritsu's art names] and he wanted the innkeeper to act as his go-between. When word was conveyed to Sōha he replied that at the moment he was in the direct employ of the lord

Fig. 82. Owl inrō no. 66 by Ogawa Haritsu (1663–1747). 7.1 x 6.6 x 2.7 cm.

Fig. 83. Inrō no. 67 with Chinese ship and falcon, by Ogawa Haritsu (1663–1747). 9.0 x 11.2 x 3.0 cm.

Fig. 84. Detail, signature and seal, inrō no. 67

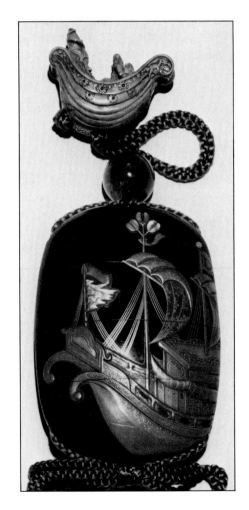

and would not do work for anyone else. But since the traveler had come so far just to place an order he felt a sense of obligation. He said that he could not meet the traveler until a certain distant date.

When that date arrived the innkeeper led the traveler to Sōha's residence and after the traveler presented the customary gift he was brought into the main room. There someone presented him with a cup of tea and a tobacco tray in a very proper manner and after a while Sōha himself appeared. He was dressed in a layered kimono with a padded sash. His wide-sleeved outer coat was decorated with checks and stripes, and he wore a purple hat. He was attended on either side by girls fifteen or sixteen years old and was in every way so elaborately perfect in appearance that he took off his hat at the entrance to the room.

He said that when he had heard that the traveler was a man of high station he had been deter-

Fig. 85. Inrō no. 68 with Chinese ship and musical instruments, by Mochizuki Hanzan. Mid-eighteenth century. 7.1 x 7.8 x 2.5 cm.

Fig. 86. Detail, signature, inrō no. 68

mined to greet him properly and from now on it would be possible to fill some orders for him.[60]

In 1724 the cyclical date, a year designation that repeats every sixty years, was the same as the year Haritsu was born. It was probably in this year that he devised the name Ukanshi by adding part of the name of the cyclical year to his name Kan. Works he signed with that name, such as the ship inrō no. 67, show the complete maturity of his style (Figs. 83, 84; colorplate 19). Slightly oversized, this inrō is in the ovoid shape of contemporary gold pieces. The decoration and detailing is rich but controlled. The expert inlay is subtly worked into the design; whether the green shell on the railing or the white shell underneath the gold lattice of the stern, it seems a natural part of the overall picture. On the back, a falcon sits impatiently on his perch, which looks exactly like inlaid rosewood but is in fact lacquer.

The best way to appreciate this work is to compare the ship design to a copy made by Haritsu's pupil and principal follower, Mochizuki Hanzan (flourished

mid-eighteenth century), on inrō no. 68 (Figs. 85, 86). The most obvious difference is that the square corners of the Hanzan inrō conflict with the many curves of the design of the ship and its sails. Haritsu's design is simpler, with clearer and more effective lines, and it is complemented by the curved shape of the inrō. Haritsu's sculptural ship reflects a greater investment of time, for the creation of raised lacquer is a slow process. Hanzan seems to have worked quickly. He did not use enough layers of black in the ground, so it turned unevenly brown as the lacquer grew more transparent. Some of the time Hanzan saved in the raised lacquer and ground was spent inlaying a pattern of shells only on the top and bottom of his inrō. Hanzan's drawing is expert and seems a bit stiff only when compared to Haritsu's. On the back, Hanzan copied a simplified version of the exotic instruments on Haritsu's elephant inrō.

Haritsu had two sons who worked with him, Sōri (dates unknown) and Eiha (born 1712), and at least one other important disciple, Karitsu, who assisted him when he was working for

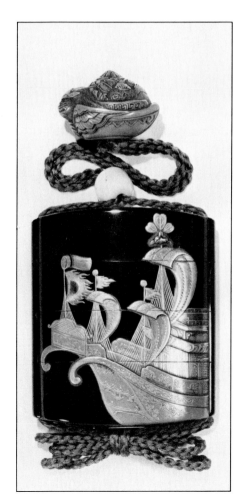

Fig. 87. Writing box no. 69 with quail
and millet, by Mochizuki Hanzan. Mid-
eighteenth century. 20.6 x 24.3 x 4.7 cm.

Fig. 88. Goose inrō no. 70 by Mochizuki
Hanzan. Mid-eighteenth century. 7.6 x 7.6
x 2.2 cm.

Tsugaru Nobuhisa. Hanzan, his princi-
pal follower, was called "the second
Haritsu," and is said to have worked in
the 1750s and 1760s. Possibly Hanzan
was accepted as Haritsu's student
between 1731, when Haritsu stopped
working for Nobuhisa, and 1747, the
year of Haritsu's death. Haritsu was still
active late in life. Two years before he
died he wrote:

The yearly market—
How I'd like to sell fifty or
sixty of my years.[61]

Hanzan maintained Haritsu's tradi-
tion of inlay and design. On the quail
writing box no. 69 (Fig. 87; colorplate
21) he comes close to his teacher in the
ease with which he has incorporated
different inlays into the freely flowing
leaves of the millet stalks. The box inte-
rior, covered with a black ground that
has turned brown in places, shows a
few clouds of aventurine and a design
of bamboo clappers similar to the one
on the owl inrō no. 66. It is signed with a
pottery seal reading Hanzan.

The inrō no. 70 with a goose (Fig. 88;
colorplate 20) clearly shows that Han-
zan also used the Kan seal of his mas-
ter, a common practice for artists not

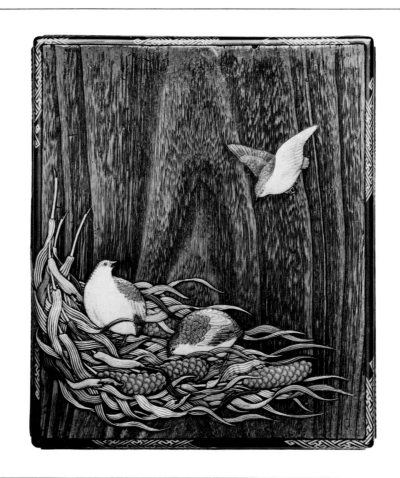

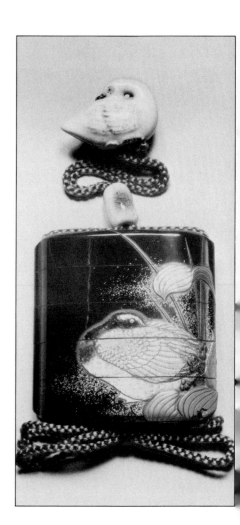

Fig. 89. Inrō no. 71 with mice and peppers, by Sakai Chūbei (1736–1802). 4.5 x 8.7 x 2.1 cm.

Fig. 90. Inrō no. 72 with Chinese inksticks, by Shibata Zeshin (1807–91). 5.8 x 7.9 x 2.1 cm.

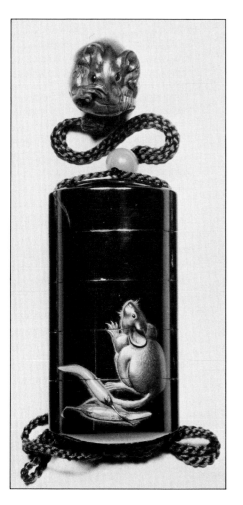

yet established independently. We can recognize *inrō* no. 70 as the work of Hanzan from its marked similarities to the writing box no. 69. The feathers of the goose, for example, are carved into the ceramic in exactly the same way as those of the quail, noticeably different from the soft feathers of Haritsu's owl. Other details, such as the inlay of the water plants, the gold flakes, and the brown areas of the ground, confirm this as the work of Hanzan.

The Haritsu tradition continued only one generation beyond Hanzan. The third Haritsu was Sakai Chūbei (1736–1802), who took the art name Ritsusō or Rissō.[62] The *inrō* no. 71 with mice and peppers (Fig. 89) seems even closer to Haritsu's work than Hanzan's. The design is clever: one mouse looks up to the left where the tail of the second mouse is visible, and on the back the second animal looks down toward the first one around the corner. The careful arrangement of the red and green inlay and the expressive faces and feet of the animals are worthy of Haritsu. Ritsusō spared no effort, glazing the tips of the green peppers yellow in the interests of realism.

SHIBATA ZESHIN

Strictly speaking, Ritsusō was the last follower of Haritsu, but the lacquerer and painter Shibata Zeshin (1807–91) was inspired by Haritsu and copied many of his designs. Zeshin began his lacquer-making career at the age of eleven and worked the next eight years for Koma Kansai (1767–1835). The Koma family were among the oldest traditional lacquer makers; Zeshin sometimes called himself Koma Zeshin. His work, however, is original and seems to owe more to Haritsu's tradition than to the Koma family. But the Koma family taught him well, and with that knowledge Zeshin's innovative mind enabled him to rediscover old processes as well as to devise new ones. Part of his interest in Haritsu undoubtedly stemmed from a desire to learn how to produce the spectacular textures and colors that Haritsu alone had created.

Zeshin's admiration of Haritsu is directly expressed in the *inrō* no. 72 with a design of old inksticks (Fig. 90). On the round inkstick in front a Chinese inscription is copied with only minor variations from the inkstick on the Haritsu box in the Tokyo National

Museum (Fig. 79). The inkstick on the back is inscribed in gold characters with Haritsu's alternate name, Ritsuō, followed by part of a Chinese poem. The implication is that Ritsuō is the name of a Chinese inkstick maker. It is a clever allusion and an accomplished imitation, but somehow less convincing than Haritsu's own works. Although he tried to copy Haritsu's technique, Zeshin had trouble approximating the subtle texture of an old inkstick. The difference between their work can best be seen by comparing the Haritsu *inrō* no. 73 with the Zeshin box no. 74, both with the subject of a tiger in a bamboo grove; Zeshin's tiger is simplified and not as lively as Haritsu's (Figs. 91, 92).

Zeshin's exercises in imitating Haritsu were most useful as experience in creating unusual grounds. The small box no. 75 with an autumnal design of *ominaeshi* flowers by a fence (Fig. 93) uses a rough greenish black lacquer not only for the background but also for the flowers. These flowers were not covered with the usual sprinklings of metal or colored powders. As a result, the design is elegant and understated. The fence motif, inlaid in the usual way with lead and shell, is restricted to the side of the box where it can stand upright. There is no decoration inside.

An even more impressive work is the chestnut *inrō* no. 76 (Figs. 94, 95; color-plates 27, 28), surely one of Zeshin's masterpieces. A branch of chestnut on the front and a branch of *kaya* (an evergreen) on the back are set against a textured olive-colored background. The season is late autumn. The husk of the chestnut has opened and one kernel falls through the air.

The first impression one has upon holding this *inrō* is of the variety of sur-

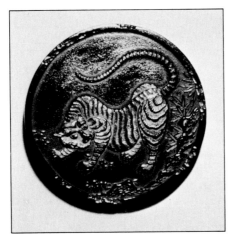

Fig. 91. Incense container no. 74 imitating Chinese inkstick, by Shibata Zeshin (1807–91). D. 7.2, H. 1.9 cm.

Fig. 92. Inrō no. 73 imitating Chinese ink-stick, by Ogawa Haritsu (1663–1747). 5.1 x 8.2 x 2.8 cm.

Fig. 93. Box no. 75 with ominaeshi flowers and fence, by Shibata Zeshin (1807–91). 9.0 x 12.6 x 5.3 cm.

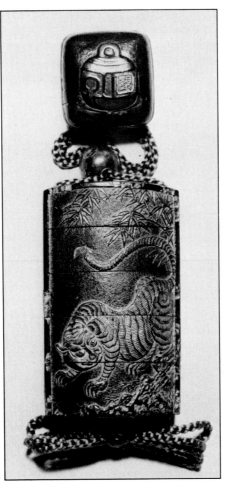

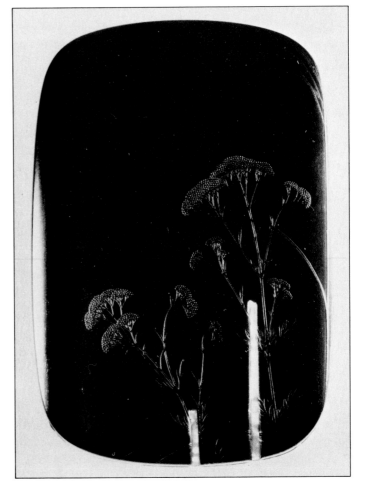

Fig. 94. Inrō *no. 76 with chestnuts and evergreen, by Shibata Zeshin (1807–91). 6.7 x 7.9 x 1.8 cm.*

Fig. 95. *Reverse of inrō no. 76*

Fig. 96. Inrō *no. 77 with hanging bag and firefly, by Shibata Zeshin (1807–91). 5.3 x 7.3 x 1.6 cm.*

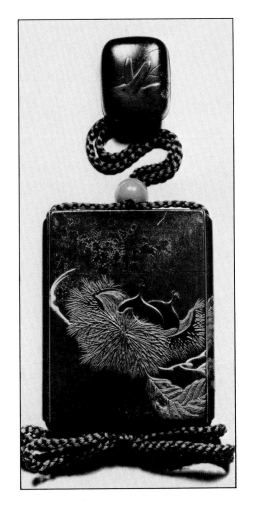

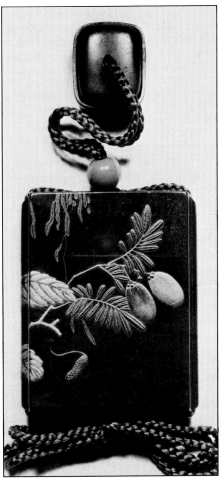

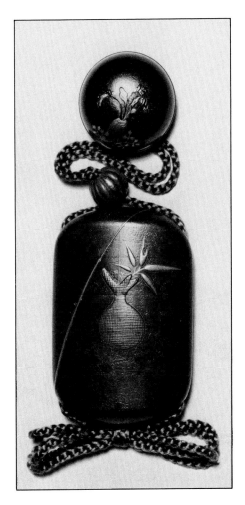

face textures. Some are realistic, such as the smooth brown of the chestnuts or the prickly black of the husk. Others are rich sprinkled designs, such as the branches and leaves. The lowest chestnut leaf blends two styles, its veins sprinkled gold, but its surface rough and dark. A hanging vine on the back is carved into the ground.

But the real genius of the *inrō* lies in its design. On both sides, the branches that hang suspended in space without reference to a tree convey distinct moods. The branch on the front nestles the chestnuts. Upward bending curves of branch, husk, and leaf give a sense of enclosure and rest. On the back, everything is falling. The chestnut flies through the air, the two *kaya* nuts swing out as if they too are about to fall, and the long stringy vine points down. Rarely have the two sides of an *inrō* been so effectively opposed. Through his skillful drawing and placement, Zeshin was able to evoke the fundamental dichotomy of rest and impermanence by this pair of simple images from nature.

Like Haritsu, Zeshin was a master of detailed drawing. The hanging red bag

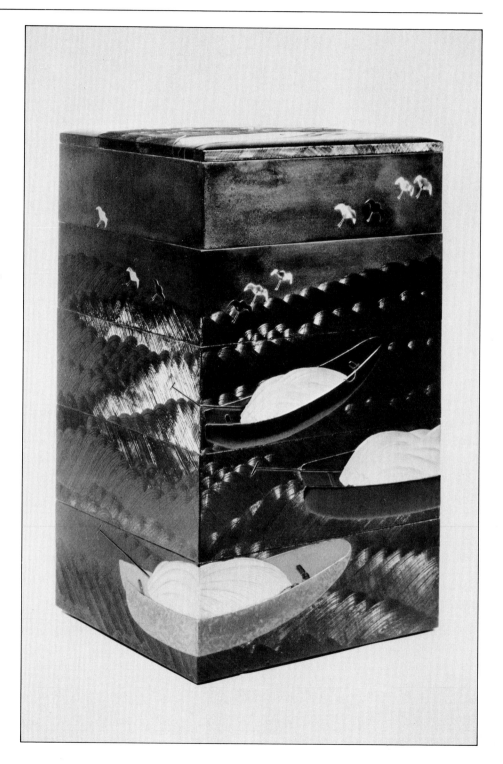

Fig. 97. Layered food box no. 78 with grain-laden boats and plovers, by Shibata Zeshin (1807–91). 24.4 x 22.9 x 40.9 cm.

on the small rounded *inrō* no. 77 (Fig. 96) is presumably filled with fireflies, one of which crawls along the pole. On the reverse, a hole in the wall and a spider web suggest the poverty of the famous fourth-century Chinese scholar Ch'e Yin (Shain in Japanese) who, because he could not afford oil for a lamp, studied long into the summer night by the light of bags of fireflies.

The layered box set no. 78 (Fig. 97; lid colorplate 26) was made to hold food prepared for special occasions. These boxes could be taken to a picnic site for a festival such as the annual cherry-blossom viewing, brought to a neighbor's house for a wedding or funeral, or used at home, as at New Year's. Large, layered food boxes first became popular about 1600 and, as in no. 78, their interiors were usually lacquered red. Zeshin made an extra lid for this set so that it could be divided into two smaller layered boxes, in connection with the custom of exchanging foods. The rice-laden boats are an auspicious theme. They float unnaturally on a stylized sea, drawn by combing wet lacquer. Even with its many different materials and techniques, the decora-

tion appears quiet because of its dark tones and limited use of gold and shell. The mood changes suddenly when the lid is removed and the brilliant red interior is revealed.

Zeshin was a prolific artist whose hunger for novelty is often apparent. The *inrō* no. 79 with barred windows (Fig. 98) is an unusual type of sheath *inrō* with a side that opens to allow removal of the lidded container within. On one side of this inner container is a devil and on the other is his adversary Shōki, the Japanese name for a legendary Chinese figure, Chung K'uei. Shōki destroys devils and those spirits that make people poor. His portrait is traditionally hung in the fifth month to express a wish for happiness, health, and success. When the container is in place, Shōki can be seen through the shell bars of his window and the devil is seen through the metal bars of a cage. An *inrō* by Zeshin with the same design, belonging to the Nezu Art Museum, Tokyo, is dated 1886.

Another legend is represented on the *inrō* no. 80, which bears a devil-woman who haunted the Rashōmon gate at the southern entrance to Kyoto (Fig. 99).

94

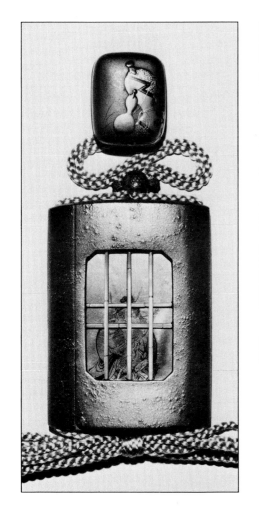

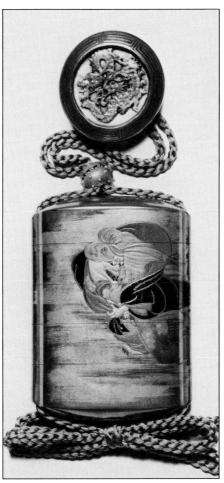

The warrior Watanabe no Tsuna (953–1024) is said to have confronted her and cut off her arm. The next day she came to his house disguised as an old woman and stole her arm back. On the *inrō* she is shown in flight, clutching her dismembered limb. Zeshin first achieved renown at the age of thirty-three as a result of a large painting he made of this subject.

Zeshin was recognized by his contemporaries for his masterly command of lacquer, and he was lionized in the West after his works appeared in the 1873 Vienna Exposition. He was still an active artist when the Western collectors discovered Japanese lacquer. They found his technique and cleverness congenial. Zeshin's originality also affected his fellow artists. Thanks to exhibits held during his lifetime in Ueno Park, Tokyo, at what is now the Tokyo National Museum, young lacquerers were able to see and study his technical innovations.

KŌAMI

Most of the important lacquerers between 1600 and 1900 viewed their art as a family profession. Pride of craftsmanship extended over generations, and the quality of one's work was a reflection on the skill of one's ancestors.

In 1720, Kōami Nagasuku (1661–1723) wrote an essay of instructions for his descendants in which he outlined the behavior expected of a Kōami lacquerer. The Kōami family was the oldest and most prestigious of lacquer families; Nagasuku was the twelfth generation. From the beginning, the Kōami family had been patronized by military rulers. The first to fifth generations worked for the Ashikaga shoguns in the fifteenth and sixteenth centuries. The sixth and seventh generations were employed by Hideyoshi, the warrior who unified Japan, and from the eighth generation on they were lacquerers for the Tokugawa shoguns. However, they were not the only Tokugawa lacquer artists. Until the middle of the eighteenth century the shogun supplied stipends to twenty-five official lacquerers; later, there were ten to fifteen lacquerers on their payrolls. In return for the yearly allowance these artists supplied the needs of the Tokugawa family and worked on special projects. Kōami Nagasuku, for example, made furniture for the wedding of the shogun Tsunayoshi's daughter and was in charge of the lacquerers for the mausoleum at Nikkō in 1689.

Nagasuku's essay vividly expresses the attitude of a traditional lacquerer in the early eighteenth century:

Not even for a moment can I forget my gratitude to my lord, and I am always thankful for my ancestral family and for the great benevolence of my parents. It is a rare opportunity and a great blessing to have been born in this reign. I revere and worship heaven for its favors and the Buddhist and Shinto gods for their protection. To my great relief, I have been given a regular stipend and a place to live. In addition to my parents, I have older and younger brothers, and a sufficient number of relatives and relations, as well as enough apprentices and subordinates.

When you are the head of a family your behavior is very important. Do not imitate the lowly. Act without anger or arrogance and maintain a generous frame of mind. Be courageous but not overbearing. In everything you do, be compassionate and correct. Act with humility but in such a way that you will not be despised by others. Never forget the saying: "Be a townsman with the spirit of a samurai." Although you may have the ambition of a king, remember to be humble and modest.

Always practice your family profession and aspire to being the head of the family. You must never forget that when it comes to sprinkled designs we are the best. But do not boast, not even a little. In our profession of lacquer and sprinkled designs there is no one in all of Japan whom you need fear. With this in mind study diligently. In this profession there are those who are talented, those who are skilled, and those who are worldly. Some are very good with small details, others are inventive or intuitive, and others are very knowledgeable. Beware of all of them. Restrain yourself and concentrate on your own work. Don't forget the saying: "We all have faults." Never despise others, always humble yourself and be very polite, but do not humiliate yourself except under extreme circumstances.

When you walk, walk quietly. When you sit, be sure to keep one knee down. Even if it is only for a moment, sit respectfully. Do not tuck your hands inside your kimono and don't expose your shoulder or your knees. Don't doze or yawn. Train your mind so that nothing will tire you, and be relaxed.

Be alert in all things, so that even if you were playing with children you would still be able to hear a whisper. But under no circumstance should you eavesdrop or spy on others. Be thoughtful and do not interfere. At all of your meals eat quietly what is set before you and do not display your likes and dislikes.

Do not handle money, but train your mind to remember everything. Learn to remember intuitively the sizes of lacquers and sprinkled designs; the gold that is to be applied; the type of lacquer; the number of laborers; the wages for detail work; the weight and quantity of the colors that are used; the rice, salt, bean paste, firewood, and everything else that you need.

Read books, remember your etiquette, practice your calligra-

phy, and be able to write. In general, learn through practice, and other things will follow on their own.

Everything in the universe is depicted in sprinkled designs: the dynamic and the static aspects of heaven, earth, and man; the shells and fish; mountains and rivers; a thousand grasses and ten thousand trees; the materials of a house; miscellaneous utensils; all tools; jewelry; the arts; incense; the tea ceremony; cooking; karma; mental impressions. If there is a single one of these things that you do not know you will have difficulty. The profession of lacquerer or sprinkled-design artist is such that you must practice and train yourself all the time, sitting or lying down, twenty-four hours a day, without a break, if you are to mature and to gain fame. There is no point in boasting and thinking yourself skilled and talented. It is essential that other people call you a great artist. If you do not know everything you will have difficulty, and if you stop studying you will forget.

Whenever you receive an order you must be particularly persevering. One cannot expect a younger man to know all that an older one does. If he did, the knowledge of a sixty-year-old would be the same as that of an eleven-year-old. Gradually you will learn all the details, and as you do, the memory of your lessons will quickly fade. In all things you must make an effort.

You should not be short-tempered or fond of complaining, but it isn't good to be too stiff, either. Take care in all that you do.[63]

These instructions, modeled on those handed down in military families, may have been written for Nagasuku's grandson, who was probably about eleven when Nagasuku wrote this at age sixty. The dates of Nagasuku's son Masamine and of later generations are not known precisely, partly because they used the same public name, Kōami Inaba. Only their art names differed.

The inrō no. 82 with butterflies (Fig. 100) was made by Kōami Masamine and shows the quality of design and craftsmanship that his father so desired to preserve. Two generations later, Kōami Nagayoshi, the fifteenth-generation Kōami, made the inrō no. 83 with children at play (Fig. 101). Both inrō are straightforward in style. Adhering to the injunctions of their ancestor, the artists executed their conservative designs with great care while avoiding any flashy display of technical ability. In addition to a signature, each applied his personal kaō.

Thanks to the Kōami family documents preserved by Shibata Zeshin, we know the names and some history of the nineteen generations of Kōami lacquerers. However, these individuals are only the heads of the main family, representing a fraction of the total number of lacquer artists who claimed this prestigious lineage. Besides the one chosen to be the new family head, other sons in the family were often skilled lacquerers, who sought independent careers, leading to the establishment of many branches of the family.

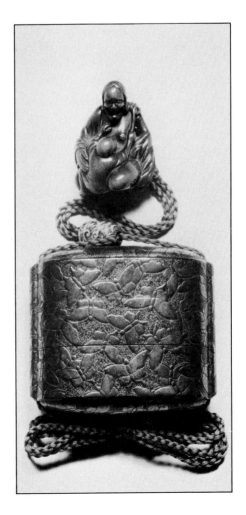

Fig. 100. Butterfly inrō *no. 82 by Kōami Masamine. Early eighteenth century. 8.0 x 6.3 x 3.2 cm.*

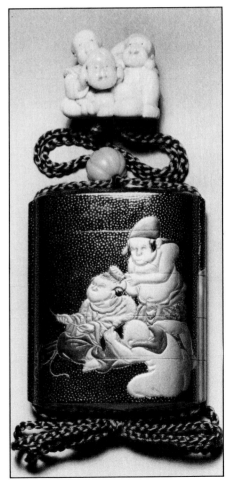

Fig. 101. Inrō *no. 83 with children and screen, by Kōami Nagayoshi. Mid-eighteenth century. 6.2 x 7.5 x 2.2 cm.*

In 1687, for example, Kōami Nagasuku was one of the leading lacquer artists in Edo. He was also known as Kōami Iyo or Yosanbei. At the same time three other Kōamis were working in Edo: Kōami Seijirō, Kōami Matagorō, and Kōami Rizaemon. A lacquerer in Kyoto, who called himself simply Kōami (with a different character for *kō*), may also have been related.[64] Although we know little about these lacquerers, certainly they would have taken their illustrious heritage as seriously as did the main branch of the family.

One of these Kōami family members is probably the man whom we now know only as the lay priest Nagasada. Although a contemporary of Nagasuku, Nagasada counts himself as a thirteenth-generation Kōami through a branch line. He, too, left written instructions to his descendants. But while Nagasuku's advice was mainly philosophical, Nagasada's was technical. He claimed to be writing secret instructions, previously transmitted only orally, because he feared the teaching would be lost "because of a foolish descendant or one whose life is cut short." He is clearly frightened by the idea of recording this precious information, his professional inheritance, and the reader is repeatedly cautioned to guard the text from outsiders. Nagasada, like any Kōami, believed his ancestry a blessing, but it undeniably limited him. The innovations of an independent-minded Haritsu were out of the question for a Kōami. Nagasada explains:

In the work of our present generation we are maintaining the old methods and although we are responsive to circum-stances, the preservation of the old methods comes first. We never leave out any steps. We follow the old manner without regard for how much gold is needed, and we work at our skills to the best of our ability. For designs, choose what catches your interest, but leave out anything that is particularly excessive or deliberately crude.[65]

The two Kōami *inrō* nos. 82 and 83 reflect this conservative interest in technical quality. The same conscious tradition that preserved and advanced lacquering skills also threatened to restrict creativity, and only the best lacquerers could rise above their weighty heritage.

YAMADA

In a sense, the Yamada family is the perfect example of a hereditary lacquer tradition. It seems that there was never more than one lacquerer at a time named Yamada and each generation used the same name, Jōka or Jōkasai. The first Yamada Jōka was appointed official *inrō* maker to the shogun in the late seventeenth century. The family continued alone in that position through the Edo period, using no other names and with an unknown number of generations during that time.

The *inrō* no. 84 with rope curtain and leaves (Fig. 102) may well have been made by the founder of the Yamada family. It has an unusually long inscription: "Made by Yamada Jōka. According to the record of Kamo Shrine, this design was originated by the priest of imperial blood, Aodare." The leaves on the design are from a mountain plant called *aoi* that has long been associ-

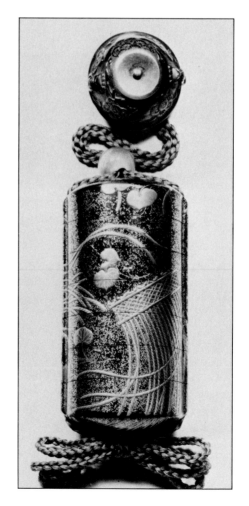

ated with the Kamo Shrine festival. The same leaves are also the basis for the Tokugawa family crest, and this *inrō* might well have been made for one of Jōka's Tokugawa patrons. It is a spirited design, more active and original than those of the Kōami *inrō*.

Works by later members of the family can sometimes be dated by the source of the design. The creator of the design for the *inrō* no. 85 with butterflies (Fig. 103) is identified as the famous artist Hanabusa Itchō (1652–1724). This name was used by Itchō between 1709 and 1724, so the *inrō* was probably made during that period. The design suits the lacquer medium so well that it seems to have been drawn specifically for that purpose.

The *inrō* no. 86 with a dragon and waves (Fig. 104) is another example of lacquer imitating ink painting (see *inrō* no. 31). The painting on the *inrō* is signed *Hōgen Jotekisai*, a name used by Kanō Hidenobu (1717–63), the eleventh-generation Kanō painter. *Hōgen* ("perception of the law") was an honorary title bestowed on senior artists, and so we can assume that the painting dates near the end of the

Fig. 103. Butterfly inrō no. 85 by Yamada Jōka. Early eighteenth century. 6.3 x 9.7 x 2.8 cm.

Fig. 104. Inrō no. 86 imitating ink painting, by Yamada Jōka. Mid-eighteenth century. 7.8 x 8.5 x 2.0 cm.

painter's career. The *inrō* is presumably from the same period.

KOMA

Another great lacquer tradition that began in Edo under the Tokugawa shoguns was that of the Koma family. The Koma lineage, however, is confused and uncertain. The first, Koma Kyūi, is said to have been made an official lacquerer in 1636 and to have died in 1663. According to the surviving versions of the geneology, his son, Koma Kyūhaku or Kyūzō, is supposed to have become the second head of the family in 1681 and to have died in 1715. Either a generation is missing between them, or else the dates are wrong. The Kōami family records list a Koma Kyūi active in 1680, perhaps referring to the founder just before his son took over, but only Koma Kyūi is listed as active in Edo in 1687 and 1692, and the name Koma is written differently. Signed works by Koma artists can be attributed to specific individuals only with great caution.

The *inrō* no. 88 with painted shells (Fig. 105; colorplate 12) is signed *Koma Yasutada,* generally acknowl-

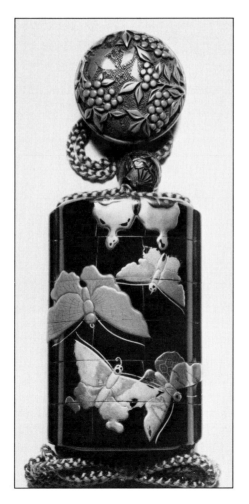

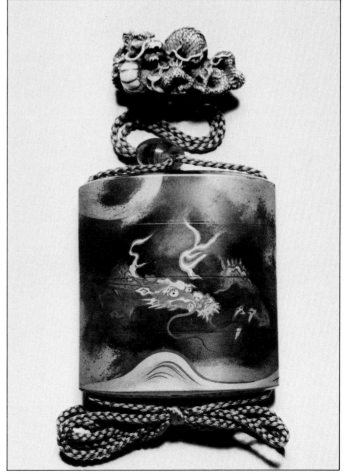

Fig. 105. Inrō *no. 88 with painted shells, by Koma Kyūhaku (died 1715?). 6.1 x 9.1 x 1.6 cm.*

Fig. 106. Inrō *no. 89 with horseback rider. Eighteenth–nineteenth century. 6.2 x 9.1 x 1.9 cm.*

Fig. 107. *Lizard* inrō *no. 91 by Koma Kyūhaku (died 1732). 7.6 x 5.8 x 2.4 cm.*

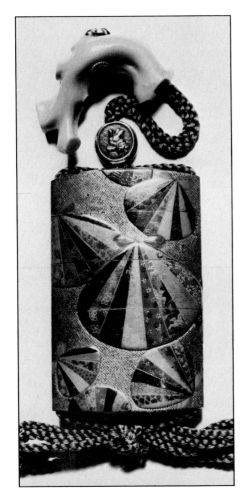

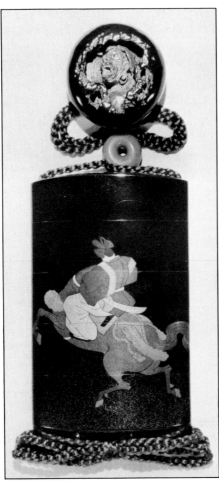

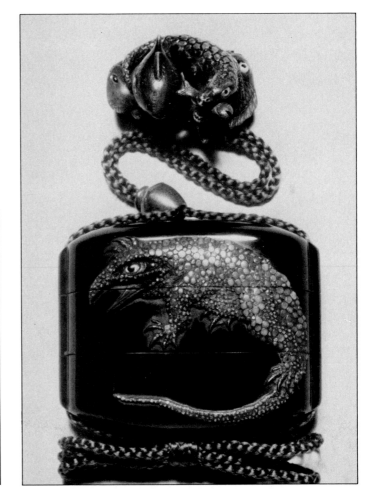

edged to be the youthful name of Kyūhaku. The unusual shape of this thin *inrō* with hidden cord channels is the same as that of the *inrō* no. 89 with a horseback rider (Fig. 106), which is also signed *Koma Yasutada,* although it cannot be attributed to the same artist. The shell *inrō* is lighter in weight than the horseman *inrō,* and the calligraphy of the signatures differs. But the most telling difference between them is the style of the design. The largest shell in no. 88 is upright while those around it vary in size and position. The background, made up of a mosaic of tiny gold squares, is rich and vibrant. Despite the simplicity of the subject the design seems lively and active. The designs on the shells closely resemble those on the sails of ships painted by Haritsu and Hanzan in the early eighteenth century (*inrō* nos. 67 and 68). Presumably, the shell *inrō* is the work of Koma Kyūhaku, the second-generation Koma whose family tradition was short enough to encourage creativity. The horse and rider of no. 89, on the other hand, seem much closer to designs of the late eighteenth and early nineteenth centuries.

Members of the Koma family were fond of using the names of their ancestors. Yasutada's public name, Kyūhaku, was used by at least three later generations. The lizard *inrō* no. 91 (Fig. 107) is signed by Koma Yasuaki (died 1732), Yasutada's heir and the second to bear the name Koma Kyūhaku. The reverse of the lizard *inrō* shows a sprinkled design of waves and bears no relation to the front.

The fifth-generation Koma, like the first, second, and third, called himself Kyūhaku. He died in 1794, two years after the death of the print artist Katsukawa Shunshō (1726–92), whose design he used on the red *inrō* no. 93 (Fig. 108). The drawing shows Ichikawa Danjūrō V (1741–1806), a Kabuki actor, dressed for Shibaraku, one of his famous roles. The nested squares on his sleeve are his family crest, which reappears inside the *inrō* on the risers for each case. The print that Koma Kyūhaku copied was probably made during the peak of Shunshō's activity in the 1780s. The *inrō,* then, would have been made about the same time, in the last fourteen years of Kyūhaku's life. A partially visible flower design under the red lacquer on the back of this *inrō* remains from an earlier decoration. Because of the time involved in making an *inrō* form, makers traditionally recycled worn or damaged *inrō* by scraping off the old design and adding a new one. When this *inrō* was first made the red lacquer ground was darker and the old traces invisible.

Through Koma Koryū, a student of the fifth-generation Koma, a branch tradition of the Koma family developed and extended into the nineteenth century. Koryū's disciple Koma Kansai (died 1792) had a son (1767–1835) and a grandson (dates unknown) who both used the name Kansai. The second Koma Kansai was the teacher of Shibata Zeshin, who sometimes called himself Koma Zeshin. Three *inrō* signed with the name Kansai, nos. 96, 97, and 98 (Figs. 109–111), are so different that it would be futile to attribute any one to a particular Koma Kansai. No two are signed alike, but at least two of the three generations are represented.

Fig. 108. Inrō no. 93 with actor Ichikawa Danjūrō V, by Koma Kyūhaku (died 1794). 5.5 x 8.0 x 2.4 cm.

Fig. 109. Chrysanthemum inrō no. 96 by Koma Kansai. Nineteenth century. 5.4 x 9.5 x 2.3 cm.

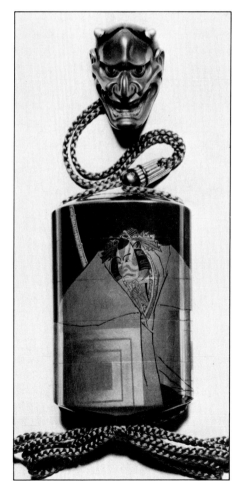

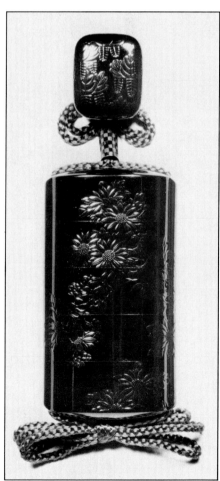

Fig. 110. Inrō no. 97 with scene from story of forty-seven rōnin, by Koma Kansai. Nineteenth century. D. 10.7, H. 3.4 cm.

Fig. 111. Iris inrō no. 98 by Koma Kansai. Nineteenth century. 6.9 x 7.0 x 2.0 cm.

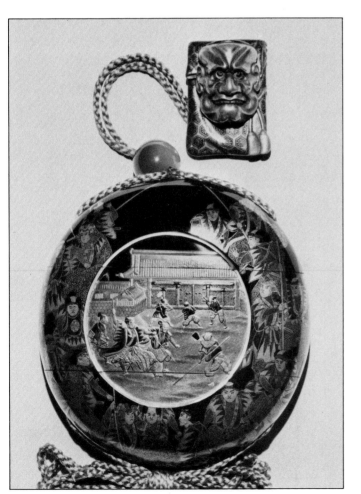

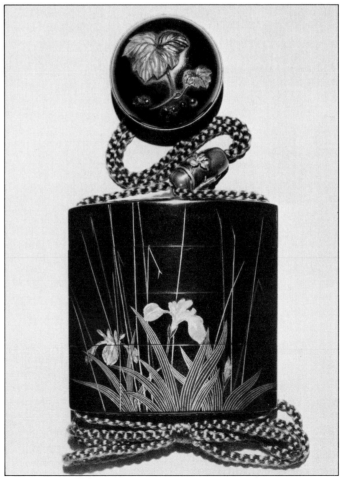

EN'AMI

The En'ami family were official lacquerers to the shogun almost as long as the Koma family, but works signed by them are much rarer. The inrō no. 99 with a bean vine (Fig. 112) is signed *En'ami* and has a seal reading *Shigemune*. The En'ami genealogy is unknown, but the design on this inrō suggests that its lacquerer worked in the eighteenth century. The strong, compelling form easily surpasses all but the earliest of Koma inrō. The drawing favors neither front nor back. The vine wraps around the inrō as if it were naturally seeking the light. One blossom seems to reach to the left while the other points right. A large leaf and a tendril move left while two other leaves and the bean pod lean right. These movements and countermovements keep the design taut, while the heavy gold sprinkling and wavy surface add a sculptural dimension.

KAJIKAWA

In the world of *inrō*, works signed by the Kajikawa family are as numerous as those of the En'ami are scarce. The Kajikawa were official lacquerers to

Fig. 112. Inrō *no. 99 with bean vine, by
En'ami Shigemune. Eighteenth century.
5.5 x 7.9 x 3.4 cm.*

Fig. 113. Inrō *no. 100 with bands of
designs, by Kajikawa Bunryūsai. Late sev-
enteenth century. 5.5 x 7.4 x 2.0 cm.*

Fig. 114. Inrō *no. 101 with* kusudama *and*
buriburi *toy. Eighteenth century. 5.8 x 7.9 x
2.2 cm.*

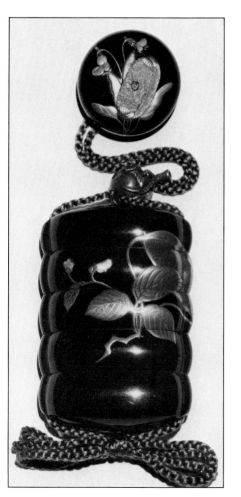

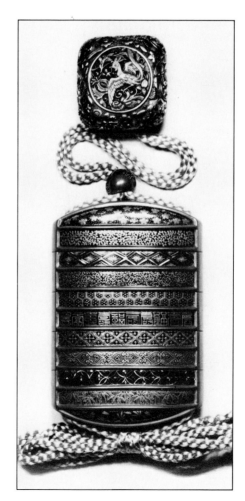

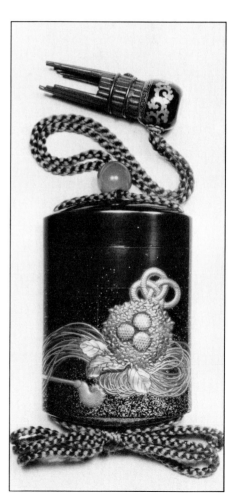

the shogun from the early seventeenth century to the end of the Edo period in the mid-nineteenth century. Almost all of their works are simply signed *Kajikawa* with a red jar-shaped seal, so that, as in the Yamada family, the individual generations remain anonymous. Kajikawa pieces vary widely in quality, and problems of connoisseurship are exacerbated by the large number of twentieth-century forgeries. Of the few Kajikawa artists who used their full names, several called themselves Kajikawa Bunryūsai. This signature appears on the *inrō* no. 100 with decorated bands (Fig. 113). In front of his name the artist wrote "official craftsman" and after it he added a seal much different from the usual Kajikawa seal. The decoration is skilled but essentially modest, and judging by its size, design, and interior aventurine, it seems to have been made in the late seventeenth century.

The earliest of the three other Kajikawa *inrō* in the Greenfield Collection is *inrō* no. 101 with a *kusudama* on one side and a *buriburi* toy on the other (Fig. 114). The *kusudama* is a bag filled with various fragrant incenses,

Fig. 115. Inrō *no. 102 with rope curtain and* swallows. *Early nineteenth century. 5.9 x 8.1 x 2.4 cm.*

Fig. 116. Snake inrō *no. 103. Early nineteenth century. 7.3 x 7.1 x 2.1 cm.*

decorated on the outside with felicitous plants, flowers, and five-colored string. These fancy bags were hung in houses during the festival of the fifth day of the fifth month to keep away evil influences and extend life. The *buri-buri* toy was also a decoration and a protection against malevolent spirits. The drawing and technique of the *inrō* are close to that of Hanzan; it was probably made in the mid-eighteenth century. The rope curtain *inrō* no. 102 (Fig. 115) and the snake *inrō* no. 103 (Fig. 116) are both Kajikawa works from the early nineteenth century.

SHUNSHŌ

Not all of the great lacquer families were employed by the shogun. Yamamoto Shunshō (1610–82), a founder of one of the most distinguished lacquer traditions of the Edo period, lived in Kyoto and started his career as a poet and scholar. Deeply immersed in the world of classical Japanese literature, he compiled a thirty-four-volume index of poems from ancient anthologies and fictional literature, which was published in 1666. He was well versed in Chinese literature and a friend of the

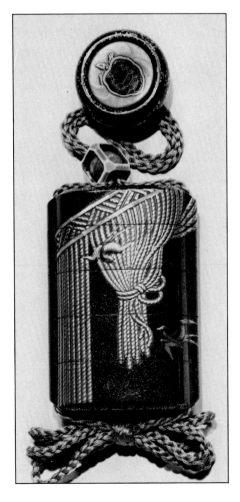

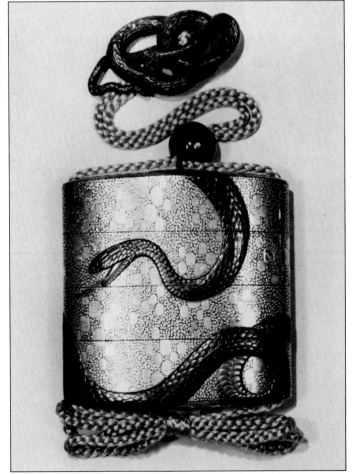

Fig. 117. Ferry inrō no. 104 attributed to Yamamoto Shunshō. Seventeenth–eighteenth century. 5.9 x 8.1 x 2.4 cm.

Fig. 118. Inrō no. 105 with death of Buddha. Eighteenth–nineteenth century. 7.5 x 7.5 x 2.2 cm.

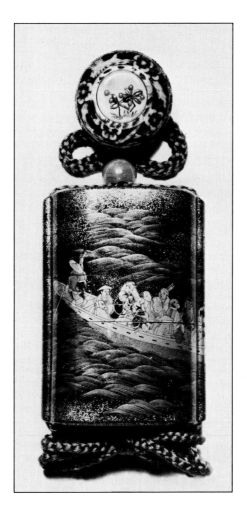

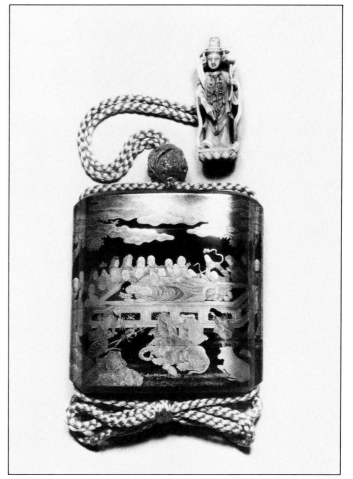

Confucian scholar Itō Jinsai (1627–1705). His skill as an illustrator can be seen in the charming drawings he made for a 1650 edition of *The Tale of Genji*. But above all he was renowned as a lacquerer, especially in the difficult technique of flattened sprinkled design, as in *inrō* no. 104 (Fig. 117).

The generations after Yamamoto Shunshō took his first name as their family name and continued to specialize in flattened sprinkled designs. The *inrō* no. 105 showing the death of the Buddha (Fig. 118) is probably the work of his eldest son, Shunshō Keishō (1651–1707). The scene of the Buddha surrounded by disciples and the mourning animal kingdom was a well-known theme in Buddhist painting. In traditional versions the dignified calm of the recumbent Buddha, finally gaining complete release from the cycle of birth and death, is contrasted with the agitated expressions of the mourners. On this *inrō* everyone seems reasonably composed.

Although the succession in a professional family was usually from father to son, the continuation of tradition within the family was more important than

details of birth. If suitable sons were not available, then relatives, sons-in-law, or promising disciples would be adopted into the family. Keishō, who left no children, was succeeded by his younger brother Seikatsu (1654– 1740).

The Shunshō family continued to the end of the nineteenth century. The *inrō* no. 107 with a courtesan (Fig. 119), the work of the sixth-generation Shunshō Seishi (1774–1831), is based on a drawing by the well-known ukiyo-e artist Hosoda Eishi (1756–1815). Seishi and later generations of the Shunshō family worked in Nagoya, where Shunshō Seirei (1734–1803), Seishi's father, moved after the great Kyoto fire of 1788.

To found a family dynasty of this sort must have been the dream of many a lacquer worker in the Edo period. The first Shunshō, an exceptionally talented man from an old samurai family, probably had enough friends and money to establish his workshop without great sacrifice. But for most craftsmen the route from apprentice to family head was long and hard.

Lacquer apprentices usually became indentured between the ages of eleven and thirteen. Unlike hereditary servants of earlier times, an apprentice was bound by a verbal or written contract. In return for ten years of service in the home of a teacher he was provided with summer and winter clothes and a little money. An apprentice was given only two days off per year, New Year's day and the sixteenth day of the seventh month, and the average work day was eight hours long, beginning at six in the morning. At the end of the ten-year training period the apprentice became inde-

pendent, receiving a license and the permission of his master to practice what he had learned. Without this permission it was impossible to pursue his craft. An apprentice could find himself helpless before an unreasonable teacher.

SHIOMI

In Kyoto at the end of the seventeenth century, an extraordinarily skilled lacquerer named Shiomi Masanari (1647– ca. 1722) challenged the primacy of the Shunshō family in their specialty of flattened sprinkled designs. Masanari probably began his artistic career as a painter. There is a record that he made a painting of an ox at a shrine in Kii province in 1688.[66] Masanari was apparently renowned for his ox paintings. He probably turned to lacquer near the end of the seventeenth century.

The *inrō* no. 108 with rice fields (Fig. 120) is in the typical style of the late seventeenth century and bears a seal reading *Shiomi Masanari*. Masanari and his descendants, most of whom also called themselves Shiomi Masanari, generally signed their *inrō* with small red seals of this type. Since the Shiomi school appears to have retained a very high level of technical ability throughout the eighteenth century, and since the small Shiomi seal is easily traced and copied, it is very difficult to distinguish generations or to identify non-Shiomi works that received Shiomi seals at a later date.[67] On the basis of its style and quality it seems reasonable to accept no. 108 as an early work of the first Shiomi Masanari.

Another Masanari work that can be approximately dated is *inrō* no. 109 with travelers taking shelter from the

Fig.119. Inrō no. 107 with writing courtesan, by Shunshō Seishi (1774–1831). 5.8 x 8.5 x 1.4 cm.

Fig. 120. Inrō no. 108 with fields, shed, and scarecrow, by Shiomi Masanari (1647–ca. 1722). Late seventeenth century. 6.0 x 7.7 x 2.3 cm.

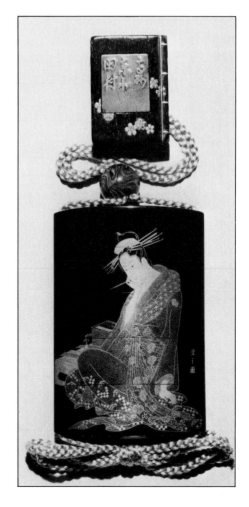

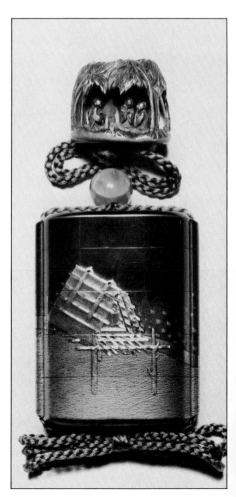

Fig. 121. Inrō no. 109 with travelers taking shelter from rain, by Shiomi Masanari (1647–ca. 1722). 8.3 x 7.2 x 2.0 cm.

Fig. 122. Dragonfly inrō no. 110 by Shiomi Masanari (1647–ca. 1722). 5.9 x 6.9 x 2.5 cm.

rain (Fig. 121). This *inrō* is based on a painting by Hanabusa Itchō in a Japanese collection.[68] Itchō signed this painting with a name and a seal that he used during the period of his exile (1699–1709). The lacquerer excluded that signature from his copy, so it is likely that the *inrō* was made before late 1709, when Itchō was allowed to return to Edo.

The inscription on *inrō* no. 110 (Fig. 122) identifies it as a work of 1716, near the end of Masanari's life. Although it is somewhat conservative in design, it illustrates Masanari's subtle mastery of flattened sprinkled design in the wings of the dragonfly, where a delicate network of lines is faintly visible. Masanari was so renowned for his mastery of the flattened technique that his contemporaries called it *Shiomi makie* ("Shiomi sprinkled designs").

The *inrō* no.111 (Fig. 123) by Masanari's follower Shiomi Masakage also uses a dragonfly design and is no less skillful than Masanari's *inrō*. Because of the asymmetrical composition and strong contrasts, Masakage's design is more dynamic and direct, despite such impressive technical flourishes as the

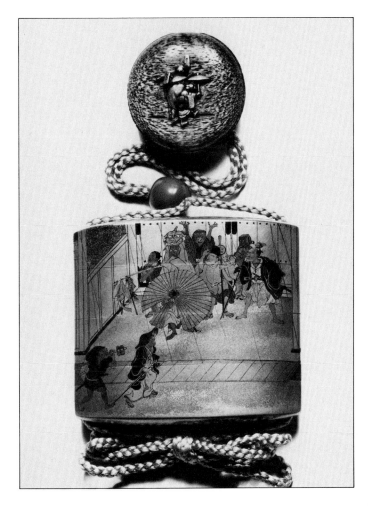

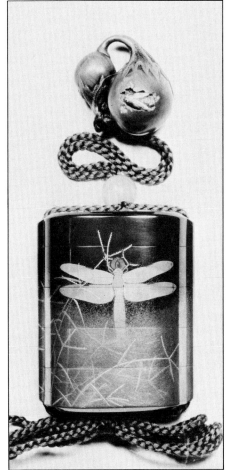

Fig. 123. Dragonfly inrō no. 111 by Shiomi
Masakage. Eighteenth century. 6.1 x 7.6 x
2.4 cm.

Fig. 124. Double inrō no. 112 by Shiomi
Masanari (1647–ca. 1722). 6.0 x 8.7 x
3.4 cm.

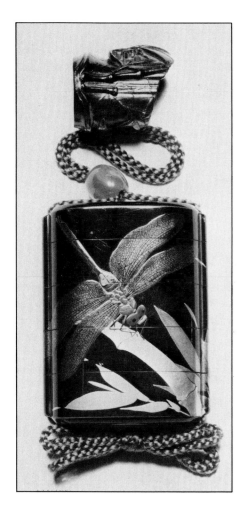

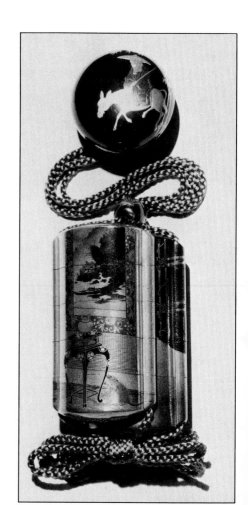

realistic gossamer wings. Masakage's signature appears in written form inside the lid.

These four inrō, nos. 108–111, establish a standard for the works of Masanari and Masakage. Against them can be set two exceptional inrō, the double inrō no. 112 (Fig. 124; colorplate 24) and inrō no. 113 with an ox and a sleeping boy (colorplate 25). The unique shape of the double inrō represents two inrō joined. This shape must have been very difficult to construct out of thin leather strips and wooden pieces, and it is matched by an equally complex pair of drawings. A cat on the back looks in the window and sees a mouse who, on the front, looks up at a hanging scroll. There are three seals on the inrō, one reading Shiomi Masanari, one with the name Shiomi, and one with Masakage. The name Masakage is written differently from the signature on inrō no. 111 by Masanari's follower. On that inrō the kage in Masakage is written with a character meaning "scene." Here it is written with a character meaning "shade, dark." According to one scholar this form of Masakage on the dou-

ble inrō was used by Masanari himself as an alternate name,[69] an appropriate one for Masanari to have used in his later years. The double inrō was probably made by Masanari in his old age. The style and execution are consistent with inrō no. 109 with travelers and the dragonfly inrō no. 110. The cleverness of the design and the eccentric shape also bring to mind the innovative works of Haritsu; possibly Masanari was responding to the trends in popular taste that brought Haritsu such fame in the 1720s.

The inrō no. 113 with a boy and ox demonstrates extraordinary control of the lacquer medium. Under a microscope the precision of the sprinkling is incredible. Every line is perfect; not a speck of powder is out of place. The written signature and the unusual seal zu ("drawing") suggest that Shiomi Masanari is being identified as the source of the drawing rather than as the lacquerer. The flat, carefully colored design is much closer to painting than lacquer works of the early eighteenth century, and the drawing itself seems like a work of the second half of the eighteenth century. This inrō

Fig. 125. Inrō no. 114 with Hatakeyama Shigetada. Eighteenth century. 6.2 x 8.4 x 2.6 cm.

Fig. 126. Inrō no. 115 with Takasago legend and cranes, by Iizuka Tōyō. Mid–late eighteenth century. 5.5 x 8.3 x 2.0 cm.

Fig. 127. Detail, signature, inrō no. 115

was probably made by a talented follower of Masanari, perhaps on the inspiration of one of Masanari's well-known ox paintings.

The equally accomplished *inrō* no. 114 (Fig. 125) is said to illustrate a legend based on the life of Taira no Kagekiyo (died 1196). The warrior Kagekiyo was famous for his bravery; fictional stories of his prowess were popular subjects in the Edo theater. This *inrō* shows the dramatic moment when his attempt to assassinate the general Minamoto no Yoritomo (1147–99) was foiled by Yoritomo's retainer Hatakeyama Shigetada (1164–1205).

TŌYŌ

Iizuka Tōyō was a renowned lacquerer active in Edo in the 1760s and 1770s. He is said to have caught the attention of Hachisuka Shigeyoshi (1738–1801), lord of Tokushima, who asked him to apply sprinkled designs to a pair of lacquer clogs. The proud Tōyō refused, saying, "I have chosen to make *inrō* and furniture for a living and do not want to make anything used for feet even if you were the one to use it." Impressed by this attitude, Shigeyoshi

gave Tōyō a generous stipend to work for him as his personal lacquerer. When he again asked for lacquered footwear, Shigeyoshi was not denied. Tōyō's descendants continued to work for the Hachisuka family.[70]

The Tōyō *inrō* no. 115 with an old man and woman (Figs. 126, 127) illustrates the legend of Takasago, a story made famous by a Nō play of the same name written by Zeami (1363–1443). The old couple who rake and sweep pine needles underneath the pines of Takasago Bay are in fact the spirits of pine trees at Takasago and Sumiyoshi, coastal beauty spots. The pines of these locales are said to be united despite their distance, even as this happy couple is. Their images, symbolic of conjugal fidelity and long life, are reinforced by the stylized crane design on the back, but the techniques used on front and back are surprisingly disparate. The old man and woman are deftly carved into the lacquer in imitation of metalwork, while the cranes are a flattened sprinkled design of gold on a black ground. Tōyō was aiming for novelty. The inside of this *inrō* is painstakingly decorated with tiny flowers.

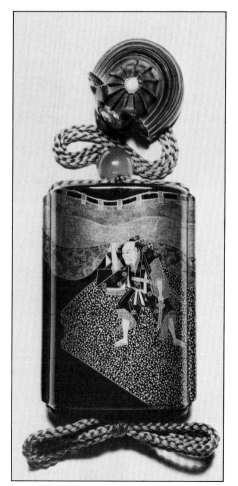

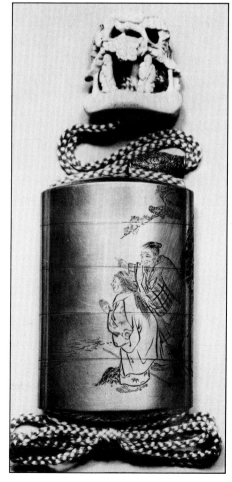

A more successfully original design is his incense container no.116 with caged birds on the lid (Fig. 128). The multicolored birds are realistically trapped between the gold background and the woven lead cage. On the bottom of the box a rough lacquer is beautifully modeled to resemble a lotus pod. It is signed with Tōyō's art name, Kanshōsai.

The pheasant on a plum tree in the snow of inrō no. 117 (Fig. 129) is identified on the back as a painting by Hōgen Eisen-in Michinobu. The painter Kanō Michinobu (1730–90) held the title hōgen from 1762 until 1780, so the painting this inrō follows was made during that period. Many of Tōyō's inrō are said to be based on drawings by Michinobu, but the Tōyō who signed this work was probably not the original Tōyō. The calligraphy of the signature and the kaō differ markedly from Tōyō's standard.[71] Designs such as this were often handed down in a family and realized by different generations. An inrō with the same decoration, once in the Tomkinson collection, was signed Tōka, presumably by a follower of Tōyō.[72]

TATSUKE

The Tatsuke family continued a lacquer tradition in Kyoto from the mid-seventeenth to the nineteenth century. Each generation used different names, but the artists are little known. One of the most intriguing Tatsuke works is the inrō no. 121 with a man in Chinese garb (Fig. 130). An inscription on the back reads Tatsuke Kōkyō ("Tatsuke the mirror maker"), beside a very large seal that reads Tokufū ("wind of virtue"). This conspicuous signature is probably humorous since the gray sprinkled ground of the inrō and the modeling of the dour-featured gentleman look convincingly like metalwork. The oversized seal might be that of the author of the design. The painter Shitomi Sekigyū (died 1743) used Tokufū as his art name; this design may follow his drawing of Shōki hunting demons.

It is also possible, however, that the large seal is meant subtly to identify an obscure subject. A Confucian scholar would know that "wind of virtue" is part of the line "the wind of virtue subdues the frontier bandits" from a poem by Sung Ching (663–737).[73] Sung Ching

110

Fig. 129. Inrō *no. 117 with pheasant in plum tree. Late eighteenth century. 4.6 x 7.7 x 2.3 cm.*

Fig. 130. Inrō *no. 121 with Chinese figure. Eighteenth century. 5.2 x 6.6 x 2.2 cm.*

was a T'ang dynasty minister noted for his wisdom and virtue as well as his stern demeanor. Whether this *inrō* depicts Shōki or Sung Ching, it was certainly worn by someone who admired purposeful resolve.

One of the last Tatsuke family members was Tatsuke Hisahide (1756–1829), who specialized in *inrō* but was fond of Japanese literature, comic poetry, and painting.[74] In the *inrō* no. 123 with peaches and peonies (colorplate 31) he also reveals an interest in Chinese things. The peaches and peonies, suggesting wealth, abundance, and fertility, and the predominant red color are meant to resemble carved Chinese lacquer. But instead of carving, Hisahide used the Japanese techique of flattened sprinkled design.

5 Carving and Inlay

Lacquerers who considered themselves specialists in certain decorative techniques used different terms to describe their professions. Those artists discussed previously were lacquerers (*nushi*), sprinkled-design artists (*makieshi*), or *inrō* artists (*inrōshi*), flexible categories that overlapped to a great extent. But two specialties were distinct from these: lacquer carvers (*tsuishushi*) and inlay artists (*aogaishi*).

The idea of carving lacquer first became popular in China during the Sung dynasty (960–1279). Sung lacquer was imported to Japan during the Muromachi period (1333–1573) and particularly fine examples were treasured by the Japanese. The Japanese made no imitations of these pieces until the late fifteenth century because lacquer carving was so difficult and time-consuming.

In order to achieve a carvable thickness, from one hundred to three hundred coats of lacquer were applied to the wood and lacquer base. Each layer had to dry and be lightly polished before the next could be added. Since lacquer hardens slowly, only one layer could be added a day, except at the height of the summer rainy season. After all the layers were applied, the artist could at last draw his design and begin carving.

These difficult techniques became the special preserve of a family whose members each took the name Tsuishu Yōsei. *Tsuishu* ("layered red") describes carved lacquer, which is usually red, and *Yōsei* combines the names of two Chinese lacquer carvers famous in Japan, Yōmo (Yang Mao) and Chōsei (Chang Ch'eng). The family continued for twenty generations,

from the fifteenth to the twentieth century, working first for the Ashikaga shoguns and then for the Tokugawa. Not until the late eighteenth century did they begin to share with the Nomura family the official title of "inlay artist and carved lacquer artist to the shogun."

The continuing importance of the Tsuishu family in the manufacture of carved lacquer for more than twenty generations must have required a good deal of political effort. In 1666 an influential figure at court wrote in his diary: "Tsuishu Yōsei came with two folding fans. We had tea and sake and he expressed his great desire of becoming a *hokkyō*,"[75] the title given by the court as a sign of high recognition. It is not known whether this Yōsei or any other Tsuishu family member ever became a *hokkyō,* since detailed histories of the individual generations are not available.

The round incense container no. 124 (Fig. 131) is a typical Japanese adaptation of Chinese lacquer carving. Layer after layer of red lacquer was applied and then carved away to leave the plum tree in relief against a fretted background. Compared to Chinese designs the single plum tree on the lid is extremely restrained. There is no sense of crowding or excess, and the plum blossoms are shown from many angles, as they would be in a sprinkled design. The background design, the regular pattern on the side, and the shape of the box closely follow Chinese prototypes. The box is unsigned and was most likely made by someone outside of the Tsuishu family, in the seventeenth or early eighteenth century.

The *inrō* no. 125 with plum, pine, and bamboo (colorplate 29) is closer in the density of its design to the spirit of Chi-

nese carved lacquer. Such combinations of carved red and green were given the special name *kōka ryokuyō* ("red flowers green leaves"), and were made by applying layers of green lacquer on top of layers of red. All of the green lacquer on no. 125 has been carved away except for the pine, bamboo, and half of the checkerboard pattern on top and bottom. To set off the red plum and to know how deep to carve, the artist applied a layer of light brown lacquer between the red layers and the base. The plum and pine are carefully intertwined and the carved surfaces smoothly finished. The Yōsei signature on the bottom belongs to an eighteenth-century member of the Tsuishu family.

The Tsuishu Yōsei who made *inrō* no. 126 (Fig. 132) used a wider range of colors in an attempt to obtain the effects of the inlay produced by such artists as Haritsu. As in eighteenth-century sprinkled designs, this carved lacquer has marvelous details, especially in the weave of the basket. The subject, a flower basket, would immediately have been recognized as Chinese, the popular attribute of the Taoist immortal Lan Ts'ai-ho, who, although he might forget one shoe and wear ragged clothes, was never without a beautiful basket of flowers.

The *inrō* no. 127 with praying mantis and wheel (Fig. 133) also uses colored lacquer in a Chinese-inspired design. The sage Chuang Tzu mentioned the self-confidence of the praying mantis who stood before a carriage and tried to stop it by waving his front legs threateningly.[76] The image appealed to Japanese samurai as a symbol of valor beyond reason. In this *inrō* the militaristic theme has been softened by the

Fig.131. Incense container no. 124 with blossoming plum. Late seventeenth– eighteenth century. D. 9.5, H. 3.5 cm.

Fig. 132. Inrō no. 126 with flowers in basket, by Tsuishu Yōsei. Eighteenth century. 5.6 x 9.4 x 2.5 cm.

Fig. 133. Inrō no. 127 with praying mantis and wheel. Early nineteenth century. 6.0 x 7.6 x 2.5 cm.

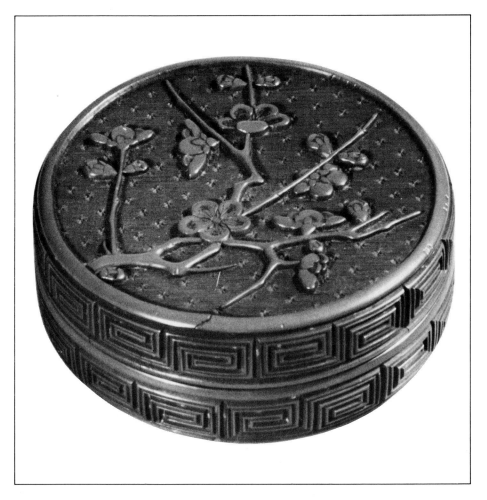

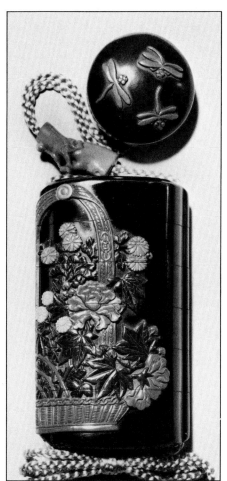

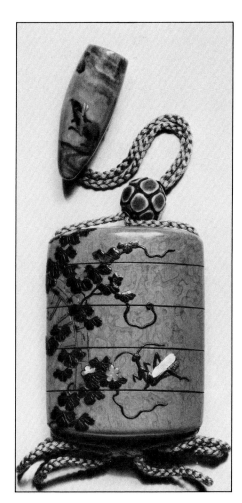

Fig. 134. Inrō no. 128 with tea ceremony utensils. Eighteenth century. 8.1 x 5.5 x 2.7 cm.

Fig. 135. Detail, signature, inrō no. 128

blossoming vine and the apparent age of the broken carriage wheel. The unusual ground was created by applying lacquer layers in different shades of brown to an irregular surface. When the ground was polished smooth, areas of the lower layers were selectively uncovered.

A completely Japanese carved lacquer is the *inrō* no. 128 with tea ceremony utensils (Fig. 134). On the front is a charcoal basket, tongs, rings, and a feather, equipment used during the tea ceremony to start or replenish the charcoal fire in the hearth. The back of the *inrō* shows a plum tree through the round bamboo window of the tearoom. The short, wide *inrō*, with only one compartment and a tiny suspended tray, is in the shape favored by the great tea master Sen no Rikyū. This was the *inrō* of a true man of tea. The signature on the bottom can be read *Yōsei* but the character for *yō* is not the usual one (Fig. 135). Presumably the artist was a member of a branch of the Tsuishu family in the eighteenth century.

Tamakaji Zōkoku (1806–69) was the most famous lacquer carver of the nineteenth century. He lived in Taka-matsu, on the island of Shikoku, and learned his craft from his father who specialized in making lacquer sword sheaths for the local rulers, the Matsudaira family. Zōkoku quickly distinguished himself with his originality and skill in both lacquer and pottery. Matsudaira Yorihiro (1798–1842) rewarded Zōkoku with samurai status in 1835 in recognition of his impressive work and gave him the name Tamakaji in 1839. About 1840, Zōkoku is said to have made an *inrō* whose carved design included 55 plants, 30 flowers, 2 rocks, 343 turtles, 433 crabs, 41 fish, 27 snails, 24 dragonflies, 9 flies, 4 wasps, 26 butterflies, 3 beetles, 4 grasshoppers, 4 leeches, 4 crickets, 4 praying mantises, 18 spiders, 5 centipedes, 19 sparrows, 7 herons, 10 kingfishers, 3 geese, and 1 swallow.[77] Of course, most of this virtuosity was invisible to the naked eye.

The carved red lacquer incense container no. 130 (Fig. 136) was made by Zōkoku's son, who also used the name Zōkoku but wrote it with different characters. The carving is expert enough to be by the master even though the conservative design

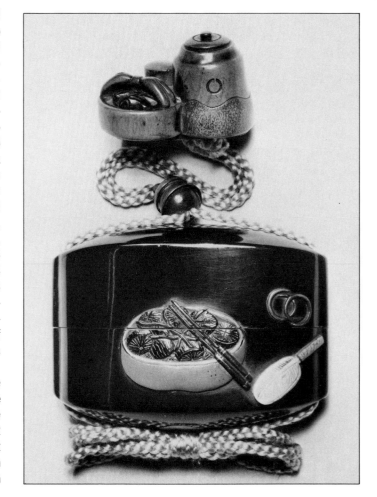

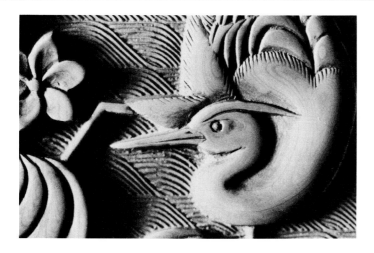

Fig. 136. Heron incense container no. 130 by Tamakaji Zōkoku. Late nineteenth century. D. 7.2, H. 2.7 cm.

Fig. 137. Detail, heron incense container no. 130

Fig.138. Chrysanthemum inrō no. 131. Late eighteenth–nineteenth century. 4.7 x 7.7 x 2.4 cm.

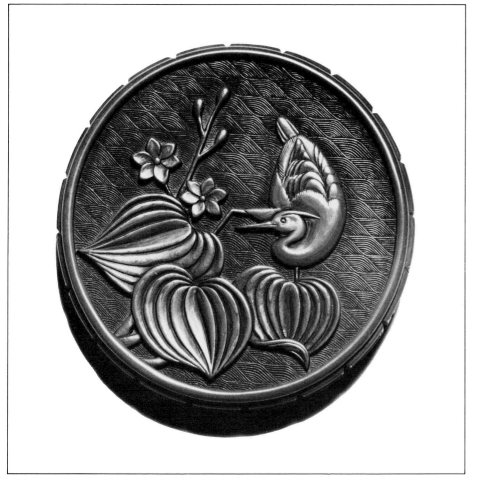

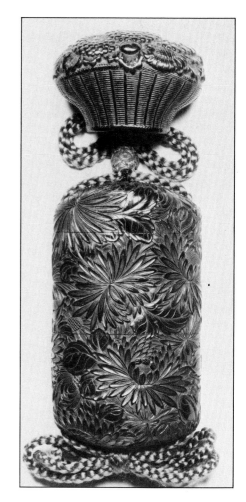

avoids reproducing nature's variety. Like the plum blossoms on the incense container no. 124, the heron and water plant on no. 130 are carefully composed and separate from the patterned background. The wood-grain pattern on the back of the heron is caused by slight color variations in the many layers of red (Fig. 137). A layer of black lacquer was used beneath the red layers as a guide for the carver.

Entirely black carved lacquers such as no. 131 (Fig. 138) are called *tsui-koku* ("layered black") rather than *tsuishu*. Still others are all yellow and are called *tsuiō* ("layered yellow"). In *guri,* one of the most traditional types of Chinese lacquer, red, black, and yellow lacquers, sometimes with green and brown, were applied in alternate layers and deeply carved in a symmetrical pattern. *Guri,* too, was copied in Japan.

On the carved incense container no. 132, where the deep V-shaped carving has exposed the inner layers, we can see three or more sequences of yellow, green, red, and black lacquer (Fig. 139). In order for the carved lines to be even, each layer of lacquer had

to be applied in the same thickness. The inside of this box, in contrast to the outside, looks crackled and worn. This appearance was probably deliberately induced to give the impression of an ancient Chinese work.

When *guri* was applied to *inrō* no. 133 (Fig. 140), the artist had the additional problem of smoothly continuing his design across the joints between the compartments. In this case, the inside makes no concession to the Chinese-inspired outside and is decorated with aventurine, as in *inrō* with sprinkled designs.

In another Chinese engraving technique, thinly incised lines are colored in a contrasting shade, usually gold. An unusual example of this decorative method, called *chinkin* ("sunken gold"), is the tall thin *inrō* no. 134 with a gourd vine (Fig. 141). The simple, flowing design was freely scratched into the black lacquer with a pointed instrument. A thin covering of lacquer was wiped over the body of the *inrō* and allowed to remain inside the carved lines. Red powder was applied to those lines and remained there when the sticky lacquer hardened. According to the seal on the reverse, this *inrō* was the work of Tsuigyokushi, a name that can be translated "maker of carved precious things." The name is meant to sound Chinese but may refer to a member of the Tsuishu family. The long thin shape of the *inrō* went out of fashion later in the seventeenth century.

As the eighteenth-century *inrō* no. 135 with a flower basket (Fig. 142) illustrates, subtle variations in the thickness and depth of the carved lines alter the brightness of the incised design. The wisteria that cleverly rises out of the basket and extends onto the back

Fig. 139. Guri incense container no. 132. Eighteenth–nineteenth century. D. 7.7, H. 2.7 cm.

Fig. 140. Inrō no. 133 with scroll pattern. Nineteenth century. 5.3 x 6.8 x 2.5 cm.

Fig. 141. Inrō no. 134 with gourd vine. Early seventeenth century. 3.1 x 13.7 x 1.6 cm.

Fig. 142. Inrō no. 135 with flowers in basket. Eighteenth century. 3.8 x 9.9 x 1.9 cm.

Fig. 143. Inrō no. 137 with birds by shore. Eighteenth century. 4.7 x 6.3 x 1.6 cm.

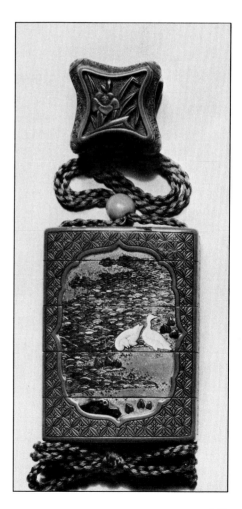

of the *inrō* is carved with broader lines to distinguish it from the cut flowers. The *inrō* is signed *Chin'ei,* literally "rare splendor." The sound *chin* in the artist's chosen name suggests that he specialized in this *chinkin* technique.

Proper preparation of the ground is as important to shallow incising as it is to the deep-carving methods. The black ground of the gourd-vine *inrō* no. 134 appears to have resisted the engraving tool. Red lacquer seems naturally softer and easier to carve than black in the rare cases where they appear together, such as the prawn *inrō* no. 136 (colorplate 30). The prawn *inrō* was made by Onko Chōkan Nagasato, one of a number of lacquer carvers in the eighteenth century who used the rather odd name Onko Chōkan. The family name, Onko, is the first half of a famous saying from the *Confucian Analects:* "By appreciating the old understand the new" (*onko chishin*). Presumably, the family viewed themselves as the preservers of an authentic Chinese tradition of lacquer carving. The netsuke with this *inrō* is signed by another member of the family, Onko Chōkan Takenaga.

Carved lacquer was also used in conjunction with inlay, as in the *inrō* no. 137 with birds by the shore (Fig. 143; colorplate 33). The red lacquer is an exotic frame for a realistic scene whose specialty is the shell inlay of the waves. The patience of the inlay artist is hard to imagine. Each tiny sliver of shell had to be cut and filed to a precise curve, set in lacquer, and covered with additional coats of lacquer that were then polished away from the surface of the shell.

Inlay specialists who worked in shell were called *aogaishi* ("green-shell artists") because most of the difficult shell inlays used thin greenish fragments of abalone shell. In the *inrō* no. 138 with textile patterns (Fig. 144), tiny squares of green shell are used together with matching pieces of gold leaf. Both the gold and the shell were made thin so that they could be easily cut into regular squares; the polishing had to be done carefully to avoid damaging the design with the charcoal polishing sticks.

Some lacquer artists commissioned metalworkers to make details that could be inlaid into the lacquer, such as the miniature gold and silver cherry blossoms in the *inrō* no. 139 (Fig. 145), depicting the spring scene in the mountains of Yoshino, south of Nara. Larger metalwork was used for the figures of Minamoto no Yoshitsune (1159–89) and his retainer Benkei (died 1189) which were inlaid in sprinkled design on *inrō* no. 140 (Fig. 146) by Hara Yōyūsai. The scene describes the legendary first meeting and fight between the aristocratic Yoshitsune and the fierce Benkei on the Gojō Bridge in Kyoto. According to the Nō drama *Hashi Benkei* ("Benkei on the

Bridge"), Yoshitsune kicked Benkei's lance when Benkei mistook him for a woman. In the ensuing fight Benkei was beaten and swore fealty to Yoshitsune.

The delicate carved inlay found in the *inrō* no. 141 with birds and flowers (Fig. 147) is called Shibayama after the family that produced it. Their techniques of coloring and carving ivory and shell for inlay are said to have originated in the late eighteenth century, but they reached the peak of their popularity in the late nineteenth century, when large numbers of lacquers in the Shibayama style were made at Yokohama for export.

The use of *inrō* declined rapidly in the second half of the nineteenth century. With the advent of the Meiji period, Western styles of dress became popular and *inrō* were no longer an appropriate accessory. Although the *inrō* had served a functional purpose as a medicine container in the beginning of its history, it had always been more important as an ornament. The traditional kimono included capacious storage areas in the front fold and in the sleeves; throughout the Edo period gentlemen regularly carried walletlike holders of paper and other essentials inside their kimono. The contents of the tiny *inrō* could easily have been carried in the same way, but the true purpose of the *inrō* was to display discretely wealth and taste.

The feudal government of the Edo period had closely restricted all evidence of monetary success distinct from rank. When social position determined even the types of fabrics that could be worn, wealthy men developed elaborate systems of fashion. Only the products of certain stores were considered suitable to a man of

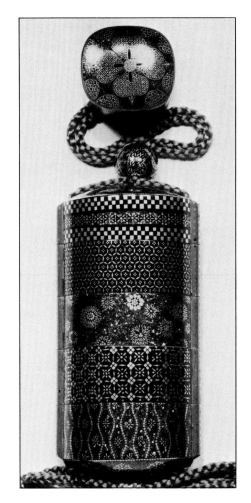

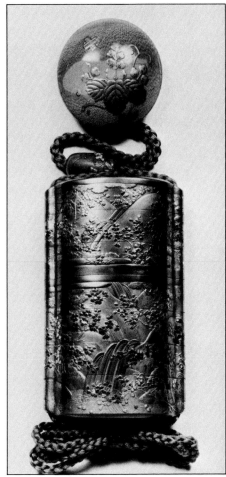

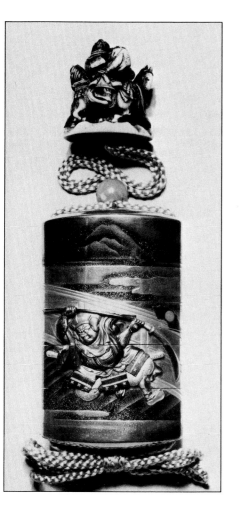

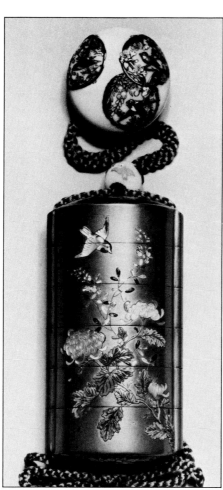

Fig. 146. Inrō no. 140 with Benkei, by Hara Yōyūsai (1774–1845). 5.8 x 9.0 x 2.2 cm.

Fig. 147. Inrō no. 141 with birds and flowers. Nineteenth century. 5.2 x 9.5 x 3.1 cm.

taste. Displays of luxury included such items as *inrō* and netsuke, too small and everyday to be subject to regulation, yet easily visible. When feudal restrictions were lifted this psychological support for the use of *inrō* vanished. Compared to pocket watches, *inrō* seemed hopelessly old-fashioned to the Japanese of the Meiji period.

But to the Westerners who were discovering Japanese art in the late nineteenth century, *inrō* were particularly enchanting. Like the great jewelry of nineteenth-century Europe, *inrō* combined rich materials with perfectly executed detail. For the first European and American collectors, the superior craftsmanship of Japanese lacquers was an important part of their appreciation.

A few twentieth-century lacquerers continued to work in such obsolete forms as *inrō*, but most of them concentrated on boxes, cabinets, or tea wares that could be used as well as admired in a modern home. There are no mechanical aids to ease the work of the lacquerer. For quality, lacquer must still be applied, polished, and decorated by hand. Such commercial shortcuts as sprayed substitutes for lacquer and printed designs are easily recognizable.

Lacquerers of this century have been much more conscious of their role as artists. Such nonfunctional lacquers as framed panels and pieces with independent, innovative designs are common. But modern lacquer artists still uphold the ideals of craftsmanship developed and articulated between 1600 and 1900, and their creativity continues to be matched by their extraordinary patience and concern for technical quality.

Notes

1. Kurokawa, 1878, p. 313.

2. The lacquer tree (*urushi no ki*) is *Rhus vernicifera DC* or *Rhus verniciflua Stokes*. The English word "lacquer" comes from the word used in India to refer to shellac, a distillate of gum produced by the secretion of innumerable shell lice on certain trees (Huth, 1971, p. 20). In Europe lacquer was first called "japan," just as porcelain was called "china." For a summary of the chemical content and behavior of lacquer, see Weintraub, 1979, pp. 40–41; Itō, 1979, pp. 61–84.

3. For colorplates of some of these early lacquered objects, see Saitō, 1970, pls. 28–33. Among the earliest known lacquered objects are combs (illus. in Tokyo, 1978, pp. 37, 57) and pottery fragments (Itō, 1979, pl. 1).

4. Sawaguchi, 1966, pp. 34–35.

5. The Kōami family at this time were in the official employ of the shogun Iemitsu and received an annual stipend of 200 *koku* of rice per year. One *koku*, 5.2 bushels, was supposed to be enough rice to support an individual for a year. Kōami, 1683, p. 500.

6. Fukuoka, 1978, p. 19.

7. Wakamori, 1971, p. 268.

8. Ōe no Masafusa (1041–1111), poem no. 1703, *Shinkokinwakashū* [New Collection of Ancient and Modern Poetry], 1206, in Matsushita, 1903.

9. Izumi Shikibu (born ca. 976), poem no. 1714, *Shinkokinwakashū* [New Collection of Ancient and Modern Poetry], 1206, in Matsushita, 1903.

10. Fujiwara no Teishi (976–1000), poem no. 1715, *Shinkokinwakashū* [New Collection of Ancient and Modern Poetry], 1206, in Matsushita, 1903.

11. Anonymous, poem no. 671, *Kokinwakashū* [Collection of Ancient and Modern Poetry], ca. 905, in Matsushita, 1903.

12. Tanaka, 1779, pp. 5–7.

13. Kokushō, 1937, pp. 62–63. This passage was written between 1723 and 1727.

14. Ise (1717–84), n.d., vol. 18, p. 293.

15. Sōami, 1523, p. 675. As early as the T'ang dynasty (618–907), the Chinese stored some seals in special boxes and wore others suspended on their persons; see Ssu-ma, 1084, vol. 4, p. 2231. At a tea ceremony in 1640, the *tokonoma* (display alcove) was decorated with a painting of the West Lake by Sesshū Tōyō (1420–1506); a flower container with a pair of mandarin ducks in gold, set on a carved red lacquer table; a blue and white ceramic incense burner; a scoop; fire tongs; an incense container with sprinkled design; and a carved red lacquer *inrō*. The last four items were arranged on a long carved red lacquer tray. All the carved lacquers were imports from China. See Takuan, 1629–40, vol. 6, p. 167.

16. This source quoted in Kitamura, 1830, p. 250.

17. Hōrin, 1636–68, vol. 5, p. 587. The word I have translated as "layered boxes" is *jūrō* ("layered towers"), almost certainly referring to an *inrō*. The term *inrō*, though used colloquially, was not yet standard, since those conversant with Chinese things realized that *inrō* properly referred to a larger layered box used to contain seals.

18. Andō, 1961, pp. 41–49.

19. Hōrin, 1636–68, vol. 1, pp. 547, 550. On the lid of the third compartment of the Greenfield dragon *inrō* no. 7 is written *sokōen*, an unidentified medicine.

20. Nihon Gakushiin, 1957, p. 286.

21. Takuan, 1629–40, vol. 6, p. 93.

22. Anonymous, poem no. 397, *Gosenwakashū* [Collection of Poetry Selected Later], ca. 951, in Matsushita, 1903.

23. Uchida, 1964, vol. 2, p. 629.

24. Ki no Tsurayuki (ca. 868–945 or 946), poem no. 1532, *Fūgawakashū* [Poetry Collection of Elegance], ca. 1345, in Matsushita, 1903.

25. Fujita, 1690, vol. 4, p. 117. The same names appeared in *Yorozu Kaimono Chōhōki*, 1692.

26. Nagasada, ca. 1700–23, introduction.

27. Fujiwara Koreie (1048–84), poem no. 267, *Kinyōwakashū* [Poetry Collection of Golden Leaves], ca. 1127, in Matsushita, 1903.

28. Matsuda, 1964, pp. 94–96.

29. Sakanoue Korenori (flourished early 10th century), poem no. 302, *Kokinwakashū* [Collection of Ancient and Modern Poetry], in Matsushita, 1903.

30. Fujiwara Ietaka (1158–1237), in *Minishū* (anthology of his poems), ca. 1237, Matsushita, 1925–26, poem no. 13,724.

31. Mukōyama, 1838–56, vol. 9, pp. 206–207.

32. Sanada, ca. 1596–1623, pp. 314–315.

33. Kanenishiki, 1773, n.p.

34. Inaba, 1781, vol. 6, n.p.

35. Yoshida, 1971, pp. 108–111.

36. Rokkaku, 1932, p. 221.

37. Craftsmen, including lacquerers, in the employ of the shogun were frequently listed in the *bukan*, an annual record of retainers. For a modern edition, see Hashimoto, 1965.

38. Takebe, 1957, vol. 1, p. 52.

39. Inoue, 1705, vol. 1, n.p.

40. De Bary, 1972, p. 380.

41. Tanaka, 1964, pp. 323–324.

42. Yoshida, 1971, p. 122.

43. Yoshida, 1971, pp. 100–101.

44. "Ginza Shodōgu Rakusatsu," 1714, nos. 2, 4.

45. Okada, 1978, p. 218.

46. Okada, 1978, p. 207.

47. Yamane, 1965, p. 19.

48. Yamane, 1965, p. 19.

49. The size, format, and composition of these drawings indicate that they were meant for *inrō*; see Yamane, 1962, nos. 50, 54, 55, 59, 62, 70, 73, and 82. Unified designs that sweep across both sides of an *inrō* can be related to contemporary textile designs; see Nagata, 1705, for illustrations.

50. Nagasada, ca. 1700–23, n.p.

51. Nagasada, ca. 1700–23, n.p.

52. Yasui, 1972, vol. 9, pp. 143–144.

53. Yasui, 1972, vol. 9, pp. 143–144.

54. Washington, D.C. 1979, pp. 76–77.

55. Miyake, 1732, pp. 97–98.

56. Ringyōya, 1768, p. 108. This text records Tamagiku's death date as 1716. Later sources agree this is an error, saying that she died in 1726 and that the lanterns were first put out in 1728. See, e.g., Shūsanjin, 1844, p. 324; Keijun, 1814, vol. 7, p. 347.

57. Haritsu is also known to have made a set of shrine doors with a design of elephants. See Keijun, 1814, vol. 7, p. 147.

58. Saitō, 1849–50, vol. 1, p. 221.

59. Sōken'ō, 1774, pp. 147–149.

60. Aomori, 1958, p. 482.

61. Yasui, 1972, vol. 9, p. 144.

62. Many writers on lacquer seem unaware of Ritsusō's dates, given clearly in Saitō, 1849–50, vol. 2, p. 22. The entry for the third month, second day, of *Kyōwa* 2 (1802) states that Ritsusō was the student of Hanzan, who was in turn the student of Ogawa Haritsu. This entry also helps to clarify Hanzan's dates. Japanese sources claim that Hanzan was active in the 1750s and 1760s. Such Western works as Jahss, 1971, p. 401, usually offer 1743–90 as his dates, in which case Hanzan was likely to be neither Haritsu's pupil nor Ritsusō's teacher. As far as I can determine, the unlikely 1743–90 dates originated in the listing given by Captain F. Brinkley, *Japan: Its History, Arts, and Literature* (Boston and Tokyo: J. B. Millet, 1902), vol. 7, pp. 360–363.

63. Kōami, 1718, p. 105. In translating from the Kōami documents I have compared this edition with the 1934 manuscript on which it was based, in the Tokyo National Research Institute of Cultural Properties.

64. Fujita, 1687, p. 269; *Yorozu Kaimono Chōhōki*, 1692, p. 47.

65. Nagasada, ca. 1700–23, n.p.

66. Asaoka, 1850, vol. 2, pp. 998–999.

67. In the collection of the Tokyo National University of Fine Arts is a manuscript titled *Harumasa Shitae* (no. 11-11) of drawings for lacquer designs apparently used by the Shunshō school in the Edo period. It includes a much used transfer of a Shiomi Masanari seal.

68. Kobayashi, 1978, no. 71; for more complex versions of this theme in screen format, painted after Itchō's return from exile, see Kobayashi, 1978, nos. 47, 48; Murase, 1977, p. 292.

69. Takagi, 1912, p. 26.

70. Asaoka, 1850, vol. 2, p. 1070.

71. The first Tōyō's best-known work is a set of stationery box and writing box belonging to the Imperial Household Agency, Tokyo; seal and *kaō* illustrated in Arawaka, 1978, p. 97.

72. Tomkinson, 1898, vol. 1, no. 310. The subject of pheasant in winter was inspired by poetry. The artist Tani Bunchō (1763–1840) recorded a painting almost identical to Michinobu's. Bunchō's sketch attributes the pheasant painting to Hokkyō Toshinori in his seventy-second year; two poems inscribed on the painting focus on the pheasant's long tail. See Tani, ca. 1794–1829, p. 191.

73. Ts'ao, 1960, vol. 2, p. 750.

74. Hisahide's name is sometimes read Toshihide or Nagahide.

75. Hōrin, 1636–68, vol. 6, p. 192.

76. Chuang Tzu, 1968, p. 62.

77. Gempūan, 1930, pp. 22–23.

Appendix 1

MUME GA E SUZURIBAKO NIKKI (DIARY OF THE MAKING OF A WRITING BOX WITH A PLUM-BRANCH DESIGN)

In 1718, Kōami Nagasuku or Iyo (1661–1723), twelfth-generation head of the prestigious Kōami family, was asked to make a copy of a lacquer writing box owned by the shogun Tokugawa Yoshimune (1684–1751). The box had been made over two hundred years earlier by Nagasuku's ancestor, Kōami Michikiyo or Dōsei (1432–1500), the second-generation head of the Kōami family. Nagasuku was so impressed by the importance of this commission that he kept a diary of fifty-eight entries, covering more than three months of the four-month project. Nagasuku's son Masamine added a note in 1741, implying that the diary was assembled and transmitted by Masamine. This record, marred only by some copying errors and obscure terminology, offers a unique glimpse into the world of an important lacquer artist of the Edo period.

The most striking revelation of the diary is that Nagasuku shared a surprisingly large portion of the work with hired specialists, who account for one third of the total cost of production. For the wooden core of the box, he called in Jūbei, a professional maker of lacquer bases. For the gold powders and drawing of the design he relied on the specialists Denbei, Seigorō, and, as time grew short, Kihachi. Not until the project was a month overdue did Nagasuku himself become so deeply involved that he no longer had time for his diary. As manager of the project, Nagasuku dealt with the shogunate and supervised the workers, extending to them his advice and expertise. With this division of responsibility, the work proceeded very quickly; four months is a short time for such a difficult job. Yet, judging by the award Nagasuku received at last, the work was done very well.

The diary also illustrates how highly the original lacquer box was valued. The shogunate officials did not let Nagasuku keep the original a moment longer than neces-

sary. Special precautions were taken against fire and officials debated the danger of a typhoon. It was clearly a privilege just to see the box; a number of visitors called on Nagasuku for that purpose while it was at his home.

We owe the survival of this extraordinary document to Shibata Zeshin who copied the text in 1855. For my translation I have used a copy of this text made in 1934 for the Tokyo National Research Institute of Cultural Properties together with the edited version published in Kōami , 1718, pp. 101–104.

Third year of *Kyōhō* [1718]

Fourth month

4.28. I was summoned by the artisan office [*saikujo*] and met with Okada Shōgorō and Yada Horibeidaiyū. I went to the attendant's office [*konando*] in the early afternoon. There I met the chamberlain, Lord Arima, governor of Hyōgo, and the attendant, Kuwahara Gonzaemon. I was ordered to authenticate a corner rack, a writing box[1] with a design of partly submerged wheels, a writing box with mulberry leaves on a black background, and a writing box with a plum-branch design on an aventurine ground. I will report back to them with my opinions.

4.29. I was summoned to [Edo] castle just before evening and met Lord Arima. He asked me if the sprinkled designs might be copies of old ones. I told him that the writing box with a plum-branch design, which I examined yesterday, was a famous one that had belonged to Ashikaga Yoshimasa.[2] I said that it had been made by my ancestor Kōami Michikiyo.

[Fifth month]

5.2. I was called to the castle and met Ginnotani Hyōemon; after a while I went inside and met the elder Yashiro Kyūkan. I had with me a handscroll by Nagayasu[3] authenticating the plum-branch writing box as a famous lacquer and I gave this to them. Lord Arima looked at it and took it.

5.7. I went to the castle and met Okada Shōgorō and Kōrai Yahachi, who were accompanied by the receptionist Ieda Hyōzaemon. After a while we went in. Through the elder Michitake I was given an order from Lord Arima. I was requested to give an estimate of how much it would cost to make a copy of the writing box with the plum-branch design that I had seen the other day. When I asked if this meant using gold powders and flakes of the same quality as those used in old times, he said yes. He told me to give him the estimate on the day after tomorrow, and I agreed.

5.9. I went to the castle and met Kamiya Hyōzaemon. Itō Gozaemon and Tōbori Gorō came along and after a while we went in. I turned over my estimate to the elder Michitake. This is what I wrote:

> Memorandum: One writing box with a design of a plum branch.
> Everything to be done as in the original.
> Estimate:
>
> 3 *ryō* 1 *bu*[4] For lacquer, labor, and miscellaneous materials, to build the box from the base wood to the middle layers of lacquer.
>
> 8 *ryō* For labor and materials to draw the sprinkled design.
>
> 27 *ryō* For powdered gold, gold flakes, and cut gold to make all designs in the same grade as in old times.
>
> 5 *ryō* 2 *bu* For skilled workers [*saikunin*], their meals, and miscellaneous expenses.
>
> 2 *ryō* 2 *bu* For polishing charcoal, Yoshino paper, lacquer, and cinnabar to be used for all the designs and small parts [*komamono*].
> Total: 53 *ryō*[5]

The above will require ninety days to complete. Unless the lower layers and sprinkled designs are dried gradually and well, it will be hard to

imitate the original. Hence, this much time is required.

> Fifth month, ninth day
> Kōami Iyo

In addition to this estimate I wrote the following on a separate piece of paper:

> Since this is to be a copy of a lacquer made by my ancestor, I humbly request that you allow me to execute the commission. In view of your generous patronage, I myself need receive no pay for this work and I have left my own needs out of this estimate.
>
> Fifth month, ninth day
> Kōami Iyo

5.11. I went to the castle and met Yada Horibeidaiyū. I told him that it was impossible for me to lower the estimate for the lacquer writing box. He said that he would have a reply for me tomorrow, and we parted in front of the office. I heard that although the order had not yet been decided upon by Lord Arima, Iyo [not the author] had been called in to examine the box.

5.12. Today I went to the castle as soon as they opened the gates. Saitō Yasuzaemon and Hagiwara Matahachiro came and were ordered by Ieda Hyōzaemon to examine my estimate with care. They left the following note:

> Since gold powders and flakes, as well as the labor of various professionals and the colors, are now very expensive, it would be difficult for the artisan office to copy the box at this price. Nonetheless, we feel that you should have it done for 49 *ryō*.

5.16. I received from Kamiya Hyōzaemon, at the office of Lord Arima, the order to make a copy of the writing box with the plum-branch design, which would not differ from the original in the slightest way.

I left the original writing box at the office. I was told that in view of the danger of fire in the neighborhood my craftsmen were not to use lamps after dark and that the writing box must be removed whenever there is a

sudden fire in the area. In such a case I should stop everything and bring it back to the office. My group must be made aware of this.

5.17. Today I brought the writing box to my house and summoned Jūbei, the base-maker [*kijiya*]. I let him handle the box and I ordered the new wooden core from him. Until the wood comes the box will be kept at the office. One of the men who serves in the inner chamber will take the box and deliver it. I summoned the powder makers [*konaya*] Denbei and Seigorō to look at it. Kōrai Yahachi, Hori Godaiyū, and Kurozawa Seijirō came to look at the writing box.

The elders Yashiro Kyūi, Michitake, Chōho, and Kaboku conveyed their concern that a typhoon might arise while the box was here.

5.21. I went to the castle and met Hyōzaemon, Hyōdaiyū, Gouemon, and Shōzaemon. I asked to take the writing box home with me. I told them I needed to compare the new wooden core and to make the sample boards [*teita*].[6] The messenger Taira Daiyū brought the box. Since I am keeping it for the moment, I sent a receipt to the office. I addressed it to Kōrai Shōzaemon. It read as follows:

Memorandum to the artisan office:
One writing box with a plum-branch design.
 I have taken the above box and am holding it temporarily. In the event of fire in the neighborhood I will immediately return it to the office.
 Fifth month, twenty-first day
 Kōami Iyo

The other day, on the nineteenth, a document was sent from the office to Lord Okubo, governor of Sado, giving me official approval to approach the castle. It read as follows:

Memorandum to the four heads of the gates:
 In the event of a fire nearby, even in the middle of the night, let Kōami Iyo and five others come in and go out of any gate from Oite to Na-

gaya, and from Sakurada to Nagaya, and let them go as far as the gate reception area.
 Fifth month

Upon receiving this message, Lord Okubo immediately gave us approval to approach the castle.

Since the wooden core was finished today, I took out the writing box to compare with it. Upon examination, I called the basemaker Jūbei at the end of the day and had him make some changes.

5.22. Kōrai Shōzaemon was off duty and I heard from the head gatekeeper Hyōzaemon about the order relating to the writing box.

I summoned Denbei and Seigorō and ordered them to start making the sample boards.

Last night there was a fire in the Sarugaku district. It was quickly controlled. On that occasion the head of the office's night watch, Kōrai Shōzaemon, came because the writing box was here. After meeting with me he returned immediately. The inner-chamber messenger, Taira Daiyū, together with four people, also came from the office.

Today I received the wooden core from Tarōbei and ordered work on the underlayers of lacquer to begin tonight.

5.23. Denbei came and worked on sample boards.

5.24. Denbei and Seigorō made sample boards.

Today the office returned the scroll and papers relating to famous writing boxes, documents that I had given to Lord Arima on the second of this month.

5.25. Denbei came alone and copied the design on the original.

5.27. Denbei came alone and copied the design on the original.

Toyota Jūbei, Uchida Tomoemon, Ōuchi Matashirō, and Minamoto Hachirō came to see the writing box.

5.28. Once again Denbei came and made copies.

5.29. Denbei and Seigorō made sample boards.

[Sixth month]
6.1. Denbei and Seigorō came and made a facsimile sample board of the writing box [*makoto shitate teita*].[7]
6.2. Denbei came and did the final tracing [*kime no gogaki*] for the writing box.

6.3. Denbei and Seigorō came and made sample boards, which they are working on while the original is still here. They also kept trying to improve the rock design on their sample board. This time they also changed powders and, in order to make it appear authentic, they tried sprinkling them.

6.4. Denbei and Seigorō are on vacation.
6.5. Denbei did tracings and Seigorō made sample boards.
6.6. Denbei did tracings.
6.7. Seigorō came and made sample boards.
6.8. I saw the sample boards with underpainting. A middle layer of lacquer on the writing box was completed. Tarōbei brought the box and we compared it with the original. They were exactly alike. I told him to add the next layer [? *jitsuke*] and to polish it in.
6.9. Denbei worked on sample boards. My old friend Kihachi stopped by.
6.10. Denbei came.
6.11. Seigorō came.
6.13. A middle layer of lacquer on the writing box was completed and Tarōbei brought the box for comparison. It was fine.
6.14. Denbei and Seigorō came.
6.19. A middle layer of lacquer on the writing box was completed and the surface improved.
6.20. The middle layers of lacquer were finished and Denbei came.
6.21. I spoke to Seigorō about the surface and the writing box as a whole. We compared every detail of the original tracing and the small pattern pieces [*honshi to kirikata*]. The application of raised lacquer was improved.
6.22. Denbei and Seigorō came and made more improvements.
6.23. Seigorō came and improved the lower layer of raised lacquer.

6.24. Today he also touched up the middle layer of lacquer on the sample boards.
6.25. We started this morning with the detailed underdrawing for the back of the lid. Both Denbei and Seigorō went home.
6.27. Seigorō worked on the detailed painting and on pasting cut gold pieces. Both of them finished just before 1:00 P.M. This completes the sample boards. Before 3:00 P.M. I visited the artisan office. I asked on the fifth day [..]
6.29. After 3:00 P.M. I went to the castle. At 4:00 P.M. I took Lord Arima samples of some materials that we would be using: underdrawings, sample boards, stone areas [*iwa no tokoro*],[8] the three colors of gold flakes, the plum tree, and the flowers. I showed them to him one by one. When he asked about the quality of the gold color, I informed him that this was AA powder, fortieth grade. One hundred *momme* [about 1/8 oz.] of gold nuggets, which had come from the mountains, were burned inside salt. Shavings of forty *momme* of those that were burned were mixed on the sample boards with over thirty-eight *momme* of the original grade of gold. Since about thirty-seven *momme* were just right, we did it again and made the gold flakes for aventurine, too. With these as a base we put flat gold foil [*kanagai*] on top.

There are many ways to make the ancient color of the gold on the plum tree. I took everything to show. The gold on the original writing box naturally looked old. What can a lacquerer do in such a case? Fortunately there are some secret traditions in this area for which I am grateful to the protection and blessings of generations of my ancestors.

6.30. I expressed my gratitude to my ancestors and the gods. I sent Jinbei to the monk Ennyū of the Ennichi Cloister at Yanaka. I sent messages to Jōshin Temple and Shuen Temple.

[Seventh month]
7.1. I went to the castle. The receptionist, Hori Gobei, had overheard the attendants

talking to the lord's personal staff. They said that they had heard of some unskilled Kōami who had been given an order by Lord Arima. But when they had seen what he had done they spoke of him as a skilled and famous man, with an exceptionally fine reputation. I heard Hori Gobei discussing this with the other receptionist, Taira Zaemon. I was very grateful, because in our profession this is the highest honor one can ask.

The shape of the water dropper to be put inside the copy of the plum-branch writing box should be exquisite. I ordered a hole to be cut in the inkstone board to hold the water dropper. When that was finished I fitted the brush tray[s] and lacquered [them]. I had inquired about these steps and received permission from Lord Arima in the artisan office.

7.2. I finished the middle layers of lacquer on the container for the writing box [*kake no onsuzuribako*]. Today Denbei and Kihachi came and traced the design onto it.

7.3. Seigorō, Denbei, and Kihachi came and fixed the corners on the middle layers of lacquer on the container.

7.4. Seigorō attached the gold-foil moon to the writing box [*moto ni dekiru onsuzuribako*].

7.5. Seigorō came.

7.8. Seigorō applied the cut gold. Since craftsmen do not work during the Obon Festival, I was asked to return the original writing box and the copy to the artisan office. Since two personal retainers came, I sent it off with Bunzaemon. Bunzaemon met Hyōzō and gave it to him. The official witness also participated. They put it in the [. .] and returned.

7.18. I went to the artisan office, met Hyōzaemon, and asked to receive again the original writing box and the copy. Two of the personal retainers gave them to me. Gorōemon [. .]

[Eighth month]

8.8. Seigorō and Denbei came and once again we polished the gold foil.

8.10. Both of them came and drew the clouds inside the lid and sprinkled the aventurine.

8.11. In the same way, they sprinkled the aventurine within the base of the box.

8.12. The aventurine was lacquered over.

8.16. In the same way, the rocks, shore, and clouds on the outside were painted. Denbei and the two others came.

8.17. The aventurine for the rock design was sprinkled. Kihachi and the two others came.

8.19. The aventurine was lacquered over.

8.20. Aventurine.

8.21. The inside aventurine was polished and lacquered. I took the writing box to the artisan office together with the following note:

I promised to finish the sprinkled designs for the copy of the plum-branch writing box within ninety days. Despite additional labor, however, it will still be impossible to finish within this month. Please give me permission to extend the time period until after the twentieth of next month.

Eighth month
Kōami Iyo

This morning Hyōzaemon immediately went and showed this note to Lord Arima, who said that we had had a long time and the box must be completed quickly, although he would allow me until the twentieth. Hyōzaemon came back and told Jinuemon that my request had been granted.

8.22. The aventurine was polished and the container fixed.

8.23. The aventurine was polished. Seigorō drew details on the container.

Memorandum by Kōami Inaba:[9]

First year of *Kampō* [1741], fifth month, twenty-eighth day. Years ago we received a bonus award from the artisan office for the writing box with a plum-branch design. Upon the request by Okada Genshichirō for further details, I wrote this note:

The plum-branch writing box.
On the fifth month, sixteenth day of *Kyōhō* 3 [1718], we received an order to make a copy and on the twentieth of the ninth month in the same year it was finished and presented. On the eleventh of the tenth month of that year Lord Okubo, governor of Sado, was ordered to pay the money for it. We received payment and there is a record of visits to the castle on the eighteenth and nineteenth of that month. On the nineteenth there was a request to come and receive a gold piece as a bonus.[10] Because a fire broke out, Lord Okuba, governor of Nagato, and Lord Okubo were ordered to leave. Takada Chūzaemon, the censor, and Kubota Hyōzō of the artisan office were witnesses. This is what I know of it.

Kōami Inaba

Copied the second year of *Ansei* [1855], tenth month, fifteenth day. In the possession of Koma Zeshin.

NOTES

1. *Kakesuzuribako* ("suspended inkstone box"), a type of writing box in which the writing implements and inkstone are kept in a tray suspended within a larger lidded box. The space underneath the tray is used to store paper.

2. The shogun Ashikaga Yoshimasa (1436–90) was a great collector and connoisseur.

3. Kōami Nagayasu or Chōan (1569–1610) was the seventh-generation Kōami family head.

4. A *ryō* is a unit of gold currency divided into 4 *bu*. In 1718, one *ryō* bought about 1.5 *koku* of rice (approximately 7.7 bushels).

5. This total is unaccountably 6 *ryō* 3 *bu* higher than the sum of the figures given.

6. These *teita* ("hand boards") were probably small boards on which different powders, flakes, and lacquers were tested for

the exact combination of materials and methods needed to approximate the appearance of the original box.

7. The meaning of this phrase is unclear. It probably refers to the attempt to reproduce actual parts of the original design on sample boards.

8. Possibly small samples of raised-lacquer rock formations similar to those in the design on the original box.

9. Kōami Inaba is the public name used by all Kōami family heads after Nagasuku. Judging by the date, this Kōami Inaba is probably Nagasuku's son Masamine.

10. See the entry for that date in Narushima, 1849, vol. 45, p. 134.

Appendix 2

Matsuura Seizan (1760–1841) was lord of the Hirado domain in northern Kyushu. *Kasshi Yawa,* his extensive journal of his activities between 1821 and 1841, is one of the most valuable historical sources for the late Edo period. In the journal Lord Matsuura describes his interest in *inrō* (Matsuura, 1821–41, p. 76):

> While I was serving in the government I began to be fond of accessories that hung from the waist and eventually I became a collector. At that time I was frequently invited to the mansions of various important people. On those occasions the attendants would tag along as I went from the entrance to the interview room and they would ask me what I was wearing from my waist that day. Many of them would follow along behind me to get a better look, trying to flatter me with their attention. My own associates would also ask me what I was wearing and when I went to the shogun's castle people looked in the same way to see what hung at my waist. Naturally it wouldn't have done for me to have worn the same things repeatedly under those circumstances. Since I was continually changing my accessories, I developed a reputation for eccentricity.
>
> After I retired these things became useless and so a lord in Higo province asked if he could have them. I was considering this request and was about to consent when, as I was idly neglecting to act, everything was lost in a fire. I had over one hundred sets of *inrō* and other accessories.

This fire destroyed Lord Matsuura's collection in 1818. He was able to remember thirty-nine of his sets and a few other individual items. Altogether he recalls and lists thirty-six *inrō* in his journal. He describes all but a few of these *inrō* as part of a complete set including *inrō, ojime,* and netsuke. The subject matter of these three parts was carefully coordinated. The themes that Lord Matsuura chose for his *inrō* sets were self-consciously clever and one can imagine the fawning attendants bent over behind him, praising his ingenious selection. One set, for example, he calls the "One, Mount Fuji; Two, Hawks *Inrō.*" The *inrō* had a sprinkled design of Mount Fuji, the *ojime* was made from a hawk bell, and the netsuke was in the shape of an eggplant. The combination alludes to the popular tradition that Tokugawa Ieyasu's three favorite things were first, Mount Fuji; second, hawks; and third, eggplant. The tradition of coordinated *inrō, ojime,* and netsuke continues among contemporary collectors. (Mr. Greenfield has also carefully matched the netsuke and *ojime* on his *inrō.*)

In addition to *inrō,* Lord Matsuura also collected *kinchaku* (money bags) and *dōran* (pouches for miscellaneous articles), which he wore together with or in place of *inrō.* When a *kinchaku* or *dōran* is thematically related to an *inrō,* he calls the whole group an ensemble. Out of the complete record of his collection I have excerpted those entries that contain an *inrō;* some descriptions of *ojime* and *kinchaku* have been abbreviated (Matsuura, 1821–41, pp. 76–83).

"OBTAINING THE JEWEL" ENSEMBLE
Netsuke: Carved ivory, with a design of women divers swimming.
Ojime: Octopus and blowfish in carved wood; made by Sengetsu.
Inrō: Jeweled pagoda amid waves, with a sprinkled design and gold leaf on a chestnut-colored ground.
Kinchaku: Large dragon design, with embroidered waves.
Cords: All of them were yellowish brown.

"THREE NO'S IN ONE MONKEY" *INRŌ*
Netsuke: Carved wooden monkey. His right hand covered both eyes, his left covered his mouth, and both feet were raised to cover his ears. This is what is called the "no sight, no sound, no speech posture."
Ojime: I have forgotten.
Inrō: Black lacquer with the four characters *kai shin kyo fu* [precepts, restraint, reverence, awe] in running-style script and grass-style script in sprinkled gold and silver, as written by Lord Matsudaira Sadanobu [1758–1829].

"RAT, OX, TIGER" ENSEMBLE
Netsuke: Carved ivory, with a design of a rat standing and eating dried chestnuts.
Ojime: In the shape of a clump of rocks.
Inrō: Black lacquer, with a sprinkled design of an ox-drawn carriage crossing a river.
Kinchaku: Tiger fur.

"OLD TEMPLE" *INRŌ*
Inrō: Black lacquer, with a palm-tree design. Its leaves and trunk were green lacquer and the rock was red lacquer—a true imitation of a palm in lacquer.
Netsuke: Ebony, in the shape of a round tile.
Ojime: Comma shape from an old tile.

"BUDDHIST NOVICE GRINDING TEA" *INRŌ*
Netsuke: Black horn, in the shape of a novice leaning against a tea grinder and sleeping.
Ojime: Stone.
Inrō: Black, old; with a vine of morning glories.

"WATER WHEEL" *INRŌ*
Netsuke: Carved wooden carp.
Ojime: Crystal.
Inrō: Long and narrow, black lacquer; with splashing waves. On both sides of the water wheel were many silver drops of water. The wheel is called a "well wheel."

"ALL OLD COINS" *INRŌ*
Inrō: Black lacquer, in the shape of various coins, from the oldest Chinese coins to old Japanese coins. The crushed pipe bowl in the middle was particularly interesting.
Ojime: Silver coin with a hole in it.
Netsuke: Ebony, mirror-shaped. On the front was a round piece of gold from Kai province. On the back was a small old coin called a "one-tenth portion." The cord ran through a hole in the coin.

"DEMON" *INRŌ*
Inrō: Black lacquer ground, with oak leaves and a demon hiding in a hole in a rock.
Ojime: Translucent jade, with gold veins.
Netsuke: Rosewood; mirror-shaped. *Shibuichi* [silver-copper alloy]. Carved by Sōyo, with a design of Shōki, the demon hunter, polishing his sword.

"DAFFODIL" *INRŌ*
Inrō: Long and narrow, with a sprinkled design of daffodils. The leaves were green lacquer and the flowers were silver; both sides had gold bamboo all over.
Ojime: White shell.
Netsuke: Carved wood, in the shape of a hat woven of bamboo skin.

"WHITE FISH" *INRŌ*
Inrō: Small and horizontal, with a milky color; several white fish made of thick shell.
Ojime: Ebony carved in the shape of a clam.
Netsuke: A soup bowl of black lacquer with a gold sprinkled design.

"THOUSAND CRANES" *INRŌ*
Inrō: Flat shape, black lacquer; with one thousand cranes in a flattened sprinkled design.
Netsuke: Carved ivory, in the shape of a turtle with two of its children on its back.
Ojime: Carved horn in the shape of a climbing turtle.

"STANDING WOMAN" *INRŌ*
Netsuke: Carved ivory in the shape of a standing farm woman. If you looked at it from below you could faintly see her pudendum between her legs.
Ojime: Carved horn.
Inrō: Chestnut-colored and horizontal with trout in a stream. Large design.

"LONG ARMS LONG LEGS" ENSEMBLE
Netsuke: Wood, in the shape of a long-legged man carrying a long-armed man.
Inrō: Black, with a lead sprinkled design of a crab.

Kinchaku: Octopus-shaped.
Ojime: I have forgotten.

"MIDWIFE" INRŌ

Netsuke: Carved ivory in the shape of a midwife sitting on a backgammon board. In front of her was a basin and she was washing a newborn baby by her feet.
Ojime: Shell, vulva-shaped.
Inrō: Black lacquer with a sprinkled design of paper dolls.

"GOLD AND SILVER PEONIES" INRŌ

Netsuke: Tagayasan mirror-shaped netsuke. The mirror is *shibuichi.* Carved by Sōmin, with a design of a lion after Sesshū Tōyō [1420–1506].
Inrō: Flat and tall, with a gold-colored incised design. Large aventurine with gold and silver flowers, cut gold, and gold leaves in a raised sprinkled technique.
Ojime: Gold-wire bead.

"PEONIES AND LION" ENSEMBLE

Netsuke: Wood in the shape of two frenzied lions.
Two *Ojime:* One was small, silver, and drum-shaped; the other was a lion carved by Sōmin. They were superb.
Inrō: Flat and tall, black lacquer; peony bushes in a gold sprinkled design on one side.
Kinchaku: From India; I have forgotten the design and the hide.

"PINE, BAMBOO, AND PLUM" ENSEMBLE

Netsuke: Green pinecone in wood; carved by Shūgetsu.
Inrō: Burnt cedarwood ground, with a gold raised sprinkled design of mushrooms [*matsutake,* a homonym of "pine and bamboo"].
Kinchaku: Ancient tea-colored silk, with a design of plum blossoms.
Ojime: Bamboo. It had a small hole.

"ONE, MOUNT FUJI; TWO, HAWKS" INRŌ

Inrō: Flat, with flowering fields, various grasses, and a silver sprinkled design of Mount Fuji.
Ojime: Hawk bell of silver.

Netsuke: Eggplant of purple wood; very realistic.

"NŌ" INRŌ

Inrō: Flat and large, with aventurine. On the front was a box for a Nō mask and a bell; on the back was a fan and an old-man mask. Cut pieces of gold and silver were used in the design.
Netsuke: Heartwood of the persimmon tree in the shape of a Nō flute.
Ojime: Carved horn in the shape of a drum.
Cord: Crimson.

"ALL MICE" ENSEMBLE

Inrō: Black lacquer, with a flattened sprinkled design of mice.
Netsuke: Carved ivory mouse; realistic.
Dōran: Long, of white mouse fur with gold fittings. Western-style painting of a mouse. The flap was *shibuichi;* the edging was silver cord.
Ojime: Seed of a *kaya* tree, in the shape of a dried chestnut.

"JARS" INRŌ

Inrō: Flat and chestnut-colored, with a raised gold design of jars.
Ojime: A scoop with silver rings.
Netsuke: Transparent buffalo horn in the shape of a medicine jar. When you opened the mouth you could see a miniature horn carving inside. When you put it in your palm it moved like a potato bug; if you threw it on the ground it stretched out like a snake. Extraordinary workmanship! All who saw it were surprised and excited. It was particularly amusing to show to women.

"DRAGONFLY" ENSEMBLE

Inrō: Black lacquer, with a swarm of dragonflies in red, brown, and various other colors.
Ojime: A fishing basket of a reddish color; it opened at the top. Divided by red, yellow, and black stripes.
Netsuke: I have forgotten.
Kinchaku: Dark blue silk with a woven design in colored thread.

"TEA UTENSILS" INRŌ

Inrō: Flat, in the shape of a tea caddy; lacquer by Sōtetsu.
Netsuke: A bamboo fishing boat, made by Fuhaku.
Ojime: Carved bamboo root in the shape of a standing tea whisk.

"RABBIT AND SCOURING RUSHES" INRŌ

Inrō: Tall, in black lacquer; with scouring rushes in green lacquer and withered leaves in gold on both sides.
Netsuke: A white rabbit with eyes of red gem. It was not huddled, but relaxed; very interesting.
Ojime: I have forgotten.

"RABBIT AND MOON" INRŌ

Inrō: Flat and horizontal, with two large rabbits in raised white shell, their fur in raised lacquer.
Netsuke: Katsura wood in the shape of a rice pestle.
Ojime: Flat crystal in the shape of a full moon.

"ORCHID PAVILION" ENSEMBLE

Inrō: Tall and rectangular; in the shape of a Chinese inkstick. There were four green cloud patterns. On the front were the two characters *gagun* [flock of geese] in the style of Wang Hsi-chih; on the back was a pair of geese.
Netsuke: Heartwood of the persimmon tree in the shape of an old Nara inkstick. The bottom was cut off at an angle as if it had been used.
Ojime: Was it a brush handle? I have forgotten.
Kinchaku: Was it from India? I have forgotten.

"BAMBOO AND TIGER" INRŌ (Was it an ensemble? I'm not sure.)

Netsuke: Carved ivory in the shape of a tiger licking his paws.
Inrō: Rectangular and long; raised-lacquer bamboo with gold raised sprinkled design of freely drawn bamboo all over.
Ojime: Tiger-eye stone? I have forgotten.

"FIREFLY" INRŌ

Inrō: Flat, in black lacquer, with irregularly scattered aventurine and a design of flying fireflies with shining green shell; realistic.
Netsuke: Carved horn in the shape of a round fan.
Ojime: Firefly lacquer. The upper part was red, the middle part was black lacquer, and the lower part was green shell; it was shiny.

ITEMS FROM ENSEMBLES THAT I HAVE FORGOTTEN:

"Chrysanthemum and Long Life" *Inrō:* Flat, black lacquer; with the character for long life sprinkled in red and the chrysanthemum flower in gold. This chrysanthemum was drawn in what is popularly called "imperial style," used on things belonging to the imperial family.

"Lily" *Inrō:* Red lacquer, with a gold sprinkled design of lily flowers; flowers and leaves on both sides.

"Autumn Grasses" *Inrō:* Black lacquer, tall; with a sprinkled design of flowers and autumn grasses on both sides. I remember that there was a poem in sprinkled silver written in the midst of them.

There were also six or seven *inrō* that had been used by my late father. He favored old and elegant things that he chose himself. Although I always looked after them carefully, I have forgotten them. Those that I occasionally recall are:

Inrō: Medium size, Okinawan brushed lacquer; with a sprinkled design of a butterfly. Was it based on a quote from Chuang Tzu?
Inrō: Small, with a lead sprinkled design. I have forgotten the subject.
Inrō: Small, with a sprinkled design of fans and inlaid shell. Both of these small *inrō* were early pieces.

It has just occurred to me that I also had a small *inrō* with the character for long life. It was black lacquer in a carved shape. On the front the character for long life was written in running style with raised sprinkled gold. On the back was a gold and silver raised sprinkled design of plum blossoms, and the character for happiness written in seal script.

This *inrō* has a tradition associated with it. After Lord Shōei retired to his original home, an actor who was famous at the time, Ichikawa Hakuen [Ichikawa Danjūrō V; see no. 93, Fig. 108], often visited Lord Shōei to keep him company. Once the lord asked, "What kind of plays are being done?" Hakuen replied, "In the middle of the Soga play we are doing what is called 'Sukeroku in Disguise.' " When Lord Shōei asked what he wore for that role, Hakuen replied, "A black brocade kimono with a design of apricot leaves and peony, a purple headband, and one small sword." Lord Shōei said, "In that case I'll give you an *inrō* to wear." Hakuen took it, bowed, and went home.

From that time on, in the song for that play, Hakuen added the phrase "one *inrō*, one step forward." (It is said that this song was sung by the first-generation Edo actor Kato and that actors, following this precedent even now in the "Sukeroku" play, still wear an *inrō* with that costume. Today it is not done unless the actor belongs to the school of Hakuen.) This is one of the *inrō* used in that play. (Because it was an old one, I had given it to the lord in Higo province before the fire and it was saved.)

There is also an *inrō* that I obtained years ago from the lord of Tokuyama. It is tall, rather large, and lacquered light red. It has a gold sprinkled design of a monkey and a rabbit in a tug-of-war. Half of it has worn off. The monkey is about to lose and he pulls while standing precariously. The rabbit sits, calm and immovable. I was very fond of this *inrō* because of its age; however, from time to time it gave me a strange feeling. For that reason I gave the *inrō* to the lord in Higo province and this one also escaped the fire. That strange feeling was a small thing not worth mentioning.

Catalogue of the Exhibition

Dimensions are given in the order width, length, and height or thickness unless noted otherwise. Publications and provenances were compiled with the assistance of Charles A. Greenfield. A *kaō* is a stylized symbol used together with a signature or in its place.

1. RECTANGULAR BOX and CYLINDRICAL CONTAINER from a set; both with bamboo, peony-rose, and crests of Kuroda and Ogasawara families
 Ca. 1647
 Raised sprinkled design (*takamakie*); box: 19 x 22.7 x 12.1 cm.; container: D. 5.6 cm., H. 4.4 cm.
 Ex collection: Edward Gilbertson, Henry Charles Clifford, Demaree and Dorothy Bess
 Box exhibited: New York, 1972, p. 123, no. 24

2. WRITING BOX with carriage design based on *Yūgao* chapter, *The Tale of Genji*
 Second half seventeenth century
 Various sprinkled techniques (*makie*); 16.9 x 18.5 x 3.8 cm.
 Ex collection: T. B. Kitson
 Exhibited: New York, 1972, p. 128, no. 50

3. WRITING BOX with chrysanthemums
 Late seventeenth century
 Flattened sprinkled design (*togidashi makie*); 21.1 x 22.9 x 5 cm.
 Ex collection: R. Matsumoto

4. INCENSE CONTAINER with two cormorants
 Late seventeenth century
 Raised sprinkled design (*takamakie*); 4.6 x 3.5 x 1.8 cm.
 Ex collection: T. Tsuruoka
 Exhibited: New York, 1972, p. 123, no. 27

5. INRŌ with horse and attendant
 Seventeenth century
 One case: raised lacquer; 5.5 x 6.8 x 2.4 cm.
 Ex collection: Louis Gonse
 Exhibited: New York, 1972, p. 43, no. 4
 NETSUKE: ivory
 OJIME: glass

6. INRŌ with horse tied to post
 Seventeenth century
 Three cases; raised sprinkled design (*takamakie*); 5.0 x 6.7 x 1.8 cm.
 Ex collection: Louis Gonse, Demaree and Dorothy Bess
 Exhibited: New York, 1972, p. 44, no. 6; Los Angeles, New York, 1976–77, no. 93
 NETSUKE: wood; signed *Minkō* [?]
 OJIME: coral

7. INRŌ with dragons
 Late seventeenth–early eighteenth century
 Four cases: raised sprinkled design (*takamakie*); 5.6 x 6.9 x 2.2 cm.
 NETSUKE: wood and metal; signed with *kaō*
 OJIME: metal

8. INRŌ with dragon and waves
 Seventeenth–early eighteenth century
 Three cases; sprinkled design (*makie*) and tortoiseshell inlay; 5.8 x 6.5 x 2.1 cm.
 NETSUKE: wood; signed *Toyomasa*
 OJIME: wood; signed *Kozan*

9. INRŌ with peasants tying rice sheaves
 Late seventeenth century
 Four cases; raised sprinkled design (*takamakie*) and shell inlay; 5.8 x 7.2 x 2.0 cm.
 Ex collection: Alexander G. Moslé
 Published: Moslé, 1933, no. 1713, pl. 111
 Exhibited: New York, 1972, p. 44, no. 7
 NETSUKE: lacquer
 OJIME: cloisonné

10. INRŌ with bamboo and spider webs
 Late seventeenth century
 Four cases; raised sprinkled design (*takamakie*); 5.3 x 6.3 x 2.2 cm.
 NETSUKE: wood; signed *Naoyuki,* with *kaō*
 OJIME: amber

11. INRŌ with sumo wrestlers
 Eighteenth century
 Four cases; raised lacquer on red ground; 5.7 x 8.7 x 2.9 cm.
 Ex collection: Jean Garié, Walter Lionel Behrens, Demaree and Dorothy Bess
 Exhibited: New York, 1972, p. 48, no. 25
 NETSUKE: wood with lacquer
 OJIME: lacquer

12. INRŌ with figure and phoenix
 Eighteenth century
 Four cases; various types of inlay; 5.8 x 7.8 x 2.3 cm.
 Ex collection: J. B. Gaskell, H. Gordon Bois, W. W. Winkworth, Demaree and Dorothy Bess
 Exhibited: London, 1916, p. 79, no. 91; New York, 1972, p. 50, no. 34
 NETSUKE: wood with lacquer and ceramic; signed *Teiji*
 OJIME: wood

13. INCENSE CONTAINER with chrysanthemums
 Seventeenth century
 Raised sprinkled design (*takamakie*); 7.7 x 7.7 x 3.2 cm.
 Exhibited: New York, 1972, p. 123, no. 26

14. INRŌ with chrysanthemums by fence
 Seventeenth century
 Four cases; pewter and shell (*aogai*) inlay; 5.0 x 5.6 x 2.0 cm.
 Ex collection: Efrem Zimbalist
 Exhibited: New York, 1972, p. 43, no. 2
 NETSUKE: lacquer; signed *Tokushin*
 OJIME: glass

15. WRITING BOX with pheasant
 Early eighteenth century
 Raised sprinkled design (*takamakie*); 21.6 x 23.2 x 4.6 cm.
 Ex collection: Thomas E. Waggaman, George D. Pratt
 Exhibited: New York, 1972, p. 131, no. 60

16. WRITING BOX with ducks and oak tree, illustrating a poem in *Kinyōwakashū* [Poetry Collection of Golden Leaves]
 Eighteenth century
 Raised sprinkled design (*takamakie*); 22.4 x 24.2 x 4.3 cm.
 Ex collection: T. B. Kitson
 Exhibited: New York, 1972, p. 130, no. 55

17. TEA CADDY with camellia
 Eighteenth century
 Various sprinkled techniques (*makie*); D. 6.5, H. 6.3 cm.
 Exhibited: New York, 1972, p. 126, no. 42

18. INCENSE CONTAINER with fan-shaped landscapes
 Eighteenth century
 Level sprinkled design (*hiramakie*); D. 5.6, H. 1.3 cm.
 Ex collection: Louis Cartier

19. INCENSE CONTAINER in shape of folded letter, with "longing grasses" (*shinobugusa*)
 Eighteenth century
 Level sprinkled design (*hiramakie*); 8.9 x 5.5 x 3.1 cm.

20. INCENSE CONTAINER with bridge
 Late seventeenth century
 Raised sprinkled design (*takamakie*); 6.7 x 6.7 x 3.3 cm.
 Ex collection: D. A. Stevens
 Exhibited: New York, 1972, p. 121, no. 14

21. INCENSE CONTAINER with maple leaves in Tatsuta River
 Eighteenth century
 Flattened sprinkled design (*togidashi makie*); 7.0 x 7.0 x 3.8 cm.

22. INCENSE CONTAINER with pines by shore
 Eighteenth century
 Various sprinkled techniques (*makie*) and shell inlay; 7.7 x 7.7 x 3.8 cm.
 Exhibited: New York, 1972, p. 121, no. 15

23. INCENSE CEREMONY SET with plovers and landscape by sea
 Eighteenth century
 Various sprinkled techniques (*makie*); box: 25.0 x 16.8 x 20.0 cm.
 Ex collection: Demaree and Dorothy Bess
 Exhibited: New York, 1972, p. 123, no. 25

24. LAYERED INCENSE CONTAINER with letter tied to maple branch
 Seventeenth century
 Two cases: raised sprinkled design (*takamakie*); 6.1 x 7.2 x 3.6 cm.
 Exhibited: New York, 1972, p. 119, no. 5

25. LAYERED INCENSE CONTAINER with swallows and blossoming cherry trees
 Eighteenth century

Three cases; level sprinkled design
(*hiramakie*) and metal, on aventurine
ground (*nashiji*); 5.6 x 7.5 x 6.5 cm.
Exhibited: New York, 1972, p. 119, no. 4

26. LAYERED INCENSE CONTAINER with
chrysanthemum crest
 Early nineteenth century
 Three cases; various sprinkled tech-
 niques (*makie*); D. 5.5, H. 6.8 cm.

27. STATIONERY BOX and WRITING BOX,
both with bamboo and peony-rose
 Eighteenth century
 Level sprinkled design (*hiramakie*);
 stationery box: 30.3 x 38.9 x 12.9 cm.;
 writing box: 22.4 x 24.3 x 5.2 cm.
 Ex collection: James Orange
 Published: Orange, 1910, pl. 4; Jahss,
 1978, pp. 68–69

28. WRITING BOX with blossoming plum
tree and three-leafed *aoi* crest
 Nineteenth century
 Lacking inkstone and trays; raised
 sprinkled design (*takamakie*); 21.6 x
 22.8 x 5.5 cm.
 Ex collection: Samuel T. Peters
 Exhibited: New York, 1972, p. 127, no.
 46; Los Angeles, New York, 1976–77,
 p. 178, no. 126

29. INRŌ with fish
 Nomura Chōbei; late eighteenth century
 Two cases: shell inlay and lacquered
 skate skin; 8.5 x 7.2 x 2.5 cm.
 Signed *Chōbei saku* [made by Chōbei];
 seal *Gai*
 Exhibited: New York, 1972, p. 61, no. 77
NETSUKE: wood; signed *Toyokazu*
OJIME: coral

30. INRŌ with persimmons, gingko leaves,
and maple leaves in basket
 Late eighteenth century
 Four cases; raised sprinkled design
 (*takamakie*), flattened sprinkled design
 (*togidashi makie*), and pewter inlay;
 6.8 x 9.8 x 2.2 cm.
 Signed *Jitokusai*
 Ex collection: G. Winthrop Brown
 Exhibited: New York, 1972, p. 53, no. 46

NETSUKE: amber
OJIME: amber

31. INRŌ imitating Chinese ink painting
with poem by Li Po (702–762)
 Seki Naotaka; late eighteenth–early
 nineteenth century
 Three cases; flattened sprinkled design
 imitating ink painting (*sumie togidashi
 makie*); 6.6 x 7.6 x 1.7 cm.
 Signed *Seki Naotaka*
 Ex collection: Louis Gonse, Demaree
 and Dorothy Bess
NETSUKE: lacquer
OJIME: metal; signed *Shōzan*

32. INRŌ with phoenix and peonies
 Eighteenth century
 Four cases; level sprinkled design
 (*hiramakie*) and carved lacquer
 (*tsuishu*) on white ground; 5.2 x 9.2 x 3.0 cm.
 Ex collection: Walter Lionel Behrens,
 Demaree and Dorothy Bess
 Exhibited: New York, 1972, p. 47, no. 19
NETSUKE: ivory
OJIME: bone

33. INRŌ with inlaid quail eggshell
 Early nineteenth century
 Three cases; inlaid quail eggshell; 6.9 x
 7.0 x 1.9 cm.
 Ex collection: Vicomte de Sartiges,
 Demaree and Dorothy Bess
 Exhibited: New York, 1972, p. 74, no. 122
NETSUKE: crystal
OJIME: crystal

34. WRITING BOX with Bodhidharma
 Eighteenth–early nineteenth century
 Flattened sprinkled design (*togidashi
 makie*); D. 15.3, H. 3.3 cm.
 Ex collection: Harry Seymour Trower,
 Victor Rienaecker, Lernihan, R. Matsu-
 moto, Demaree and Dorothy Bess
 Published: Rienaecker, 1938–39, pl. 2
 Exhibited: New York, 1972, p. 133, no. 62

35. INRŌ with Bodhidharma, courtesan,
and attendant
 Hasegawa Jūbi; late eighteenth–early
 nineteenth century
 Six cases; flattened sprinkled design

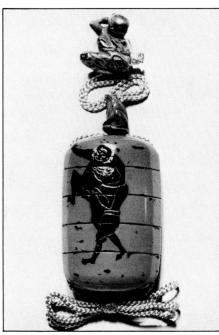

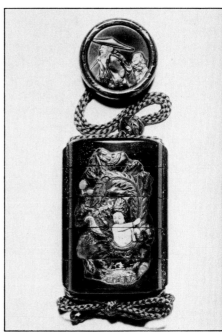

Fig. 148. Inrō *no. 11* *Fig. 149.* Inrō *no. 12*

Fig. 150. Writing box no. 28

(*togidashi makie*); 4.8 x 7.9 x 2.6 cm.
Signed *Hasegawa Jūbi saku* [made by
Hasegawa Jūbi]; seal *Chū*
Ex collection: J. B. Gaskell
Exhibited: London, 1916, p. 83, no. 147;
New York, 1972, p. 53, no. 47
NETSUKE: lacquer
OJIME: coral

36. INRŌ with kimono on rack
Eighteenth–nineteenth century
Four cases; flattened sprinkled design
(*togidashi makie*); 5.6 x 7.0 x 2.0 cm.
Ex collection: Alexander G. Moslé
Published: Moslé, 1933, no. 1725
Exhibited: New York, 1972, p. 73, no. 119
NETSUKE: wood and metal
OJIME: jade

37. WRITING BOX with courtesan spitting
on wall
Eighteenth–early nineteenth century
Flattened sprinkled design (*togidashi
makie*); 20.9 x 25.1 x 6.3 cm.
Signed *Kanyōsai*; seal *Tō*
Ex collection: R. Matsumoto
Published: Boger, 1964, pl. 15;
Time, October 30, 1972, p. 77
Exhibited: New York, 1972, p. 130,no. 57

38. BOX with courtesan, cat, and butterflies
Early nineteenth century
Flattened sprinkled design (*togidashi
makie*); 21.3 x 27.4 x 11.7 cm.
Signed *Gyūhōsei*
Ex collection: R. Matsumoto
Exhibited: New York, 1972, p. 134, no. 66

39. STATIONERY BOX with genre scene
Nineteenth century
Flattened sprinkled design (*togidashi
makie*); 12.1 x 21.0 x 4.6 cm.
Ex collection: Victor Rienaecker,
Lernihan, R. Matsumoto, Demaree and
Dorothy Bess
Exhibited: New York, 1972, p. 127, no. 47

40. INRŌ with robins
Nakaoji Mōei; early nineteenth century
Four cases; raised sprinkled design
(*takamakie*) and flattened sprinkled
design (*togidashi makie*);6.3 x 7.8 x 2.5 cm.

Signed *Mōei;* seal *Mōei*
Ex collection: W. W. Winkworth, Ralph
Harari
Published: Winkworth, 1947, p. 49
NETSUKE: lacquer; signed *Kajikawa*
OJIME: lacquer

41. INRŌ with cat holding feather
Sekigawa Katsunobu; mid-nineteenth
century
Three cases; flattened sprinkled design
(*togidashi makie*); 6.3 x 6.8 x 2.1 cm.
Signed *Katsunobu saku* [made by
Katsunobu]; seal
Ex collection: Louis Gonse, Demaree
and Dorothy Bess
Exhibited: New York, 1972, p. 80, no.
145; Los Angeles, New York, 1976–77,
p. 173, no. 102
NETSUKE: wood
OJIME: metal

42. INRŌ with toy cats and paper dolls
Nineteenth century
Three cases; raised sprinkled design
(*takamakie*); 6.9 x 7.8 x 2.5 cm.
Ex collection: Alexander G. Moslé
Published: Moslé, 1933, no. 1730
Exhibited: New York, 1972, p.74, no. 125
NETSUKE: lacquer; signed *Tōyō,* with *kaō*
OJIME: wood and ivory; signature; seal *Ko*

43. INRŌ with chrysanthemums and birds
Nakayama Komin (1808–70)
Four cases; shell inlay; 6.1 x 8.8 x 1.8 cm.
Signed *Hokkyō Komin zō* [made by
Hokkyō Komin]
Ex collection: John Pierpont Morgan
Exhibited: New York, 1972, p. 82, no. 153
NETSUKE: wood and metal; signed
Temmin
OJIME: metal

44. INRŌ with swordguards
Nineteenth century
Five cases; raised sprinkled design
(*takamakie*) on sharkskin ground
(*samekawanuri*); 5.2 x 8.8 x 2.5 cm.
Ex collection: J. C. Hawkshaw, W. W.
Winkworth, Demaree and Dorothy Bess
Exhibited: New York, 1972, p. 47, no. 20

NETSUKE: metal
OJIME: metal; signature

45. INRŌ with crests
Nineteenth century
Five cases; lacquer imitating cloisonné
and level sprinkled design (*hiramakie*);
4.9 x 9.8 x 2.7 cm.
Seal *Bunsai*
Ex collection: Edward Gilbertson, R. A.
Pfungst, Demaree and Dorothy Bess
Exhibited: London, 1894, p. 73, no. 31A;
New York, 1972, p. 76, no. 130
NETSUKE: wood and metal; signed
Hirada Harunari
OJIME: cloisonné

46. INRŌ with design from legend of
Minamoto no Yoritomo (1147–99)
Nineteenth century
Three cases; various sprinkled tech-
niques (*makie*); 7.2 x 7.3 x 1.7 cm.
Signed *Inagawa;* seal
Ex collection: Rogers
NETSUKE: wood, signed *Joryū*
OJIME: metal; signed *Yoshitoshi*

47. WRITING BOX with Bodhisattva Kannon
Nineteenth century
Raised sprinkled design (*takamakie*);
15.2 x 16.9 x 2.1 cm.
Ex collection: T. B. Kitson
Exhibited: New York, 1972, p.130, no. 56

48. INRŌ with view of Uji
Nineteenth century
Five cases; various sprinkled tech-
niques (*makie*); 6.1 x 8.1 x 2.7 cm.
Signed *Kanshōsai*
NETSUKE: ivory; signed *Minkoku*
OJIME: coral

49. INRŌ imitating bamboo
Shirayama Shōsai (1853–1923)
Five cases; raised sprinkled design
(*takamakie*); 3.8 x 7.5 x 1.8 cm.
Signed *Shōsai,* with *kaō*
Exhibited: New York, 1972, p. 87, no.
167; Los Angeles, New York, 1976–77,
p. 177, no. 123
NETSUKE: bone: signed *Sōichi*
OJIME: glass

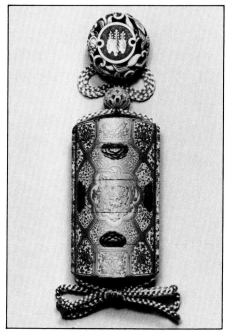

Fig. 151. Inrō *no. 32*

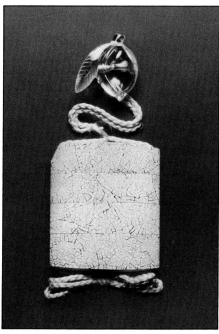

Fig. 152. Inrō *no. 33*

50. INCENSE CONTAINER in shape of
buriburi toy
Late nineteenth century
Flattened sprinkled design (*togidashi
makie*); 13.9 x 6.5 x 6.5 cm.

51. INRŌ with deer
Seventeenth century
Three cases; shell inlay; 6.4 x 7.6 x 2.0 cm.
Ex collection: Heber R. Bishop
NETSUKE: lacquer
OJIME: ivory

52. WRITING BOX with rabbit
Early seventeenth century
Raised sprinkled design (*takamakie*)
and level sprinkled design (*hiramakie*);
17.0 x 28.0 x 5.1 cm.
Ex collection: S. Bing, Vicomte de
Sartiges, Charles Vignier, Demaree and
Dorothy Bess
Published: Boger, 1964, pl. 16; *Time,*
October 30, 1972, p. 77
Exhibited: New York, 1972, p. 127, no.
48; Los Angeles, New York, 1976–77,
p. 178, no. 125

53. INRŌ with carriage fight, from *Aoi*
chapter, *The Tale of Genji*
Tsuchida Sōetsu; late seventeenth
century
Three cases; raised sprinkled design
(*takamakie*); 5.6 x 6.1 x 1.7 cm.
Signed *Tsuchida Sōetsu*
Ex collection: Hayashi Tadamasa,
Ancelot, Demaree and Dorothy Bess
Exhibited: New York, 1972, p. 46, no. 16
NETSUKE: lacquer
OJIME: lacquer

54. INRŌ with double-petaled bellflowers
Eighteenth century
Three cases; shell and pewter inlay;
5.4 x 5.9 x 1.6 cm.
Signed *Hokkyō Kōrin zō* [made by
Hokkyō Kōrin], with *kaō*
Ex collection: Louis Comfort Tiffany
Foundation
Exhibited: New York, 1972, p. 61, no. 79;
Los Angeles, New York, 1976–77,
p. 170, no. 97

NETSUKE: ivory
OJIME: wood

55. WRITING BOX with deer
Eighteenth century
Raised sprinkled design (*takamakie*);
19.2 x 25.9 x 4.8 cm.
Signed *Hokkyō Kōrin,* with *kaō*
Ex collection: S. Bing, Vicomte
de Sartiges, Charles Vignier, Demaree
and Dorothy Bess
Exhibited: New York, 1972, p. 131, no. 61

56. INRŌ with Ukifune and Prince Niou,
from *Ukifune* chapter, *The Tale of Genji*
Eighteenth century
Three cases; level sprinkled design
(*hiramakie*) with shell and pewter inlay;
6.7 x 6.4 x 2.1 cm.
Ex collection: Alexander G. Moslé
Published: Moslé, 1933, no. 1720
Exhibited: New York, 1972, p. 61, no. 80
NETSUKE: lacquer and ceramic; seal *Kan*
OJIME: metal

57. INRŌ with bridge and plovers
Eighteenth century
One case; shell inlay; 8.0 x 5.7 x 2.4 cm.
Ex collection: Demaree and Dorothy
Bess
Exhibited: New York, 1972, p. 46, no. 17
NETSUKE: wood
OJIME: stone

58. INCENSE CONTAINER with two deer
Late nineteenth century
Shell inlay and level sprinkled design
(*hiramakie*); 6.8 x 6.8 x 2.5 cm.

59. INRŌ with snow, moon, and flowers
Hara Yōyūsai (1772–1845); design
based on drawing by Sakai Hōitsu
(1761–1828)
Three cases; raised sprinkled design
(*takamakie*); 7.8 x 7.0 x 2.0 cm.
Drawing signed *Hōitsu Kishin hitsu*
[drawn by Hōitsu Kishin]; *inrō* signed
Yōyūsai
Exhibited: New York, 1972, p. 77, no. 134
NETSUKE: wood and metal; signed
Natsuo
OJIME: ivory

Fig. 153. *Writing box no. 47*

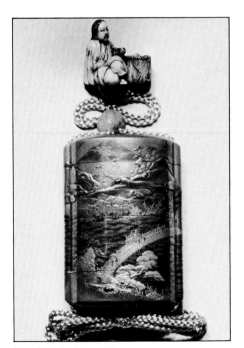

Fig. 154. Inrō *no. 48*

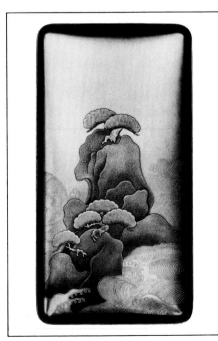

Fig. 155. *Letter box no. 62*

60. OTOSHI with bamboo
 Hara Yōyūsai (1772–1845); design based on drawing by Sakai Hōitsu (1761–1828)
 Two cases; flattened sprinkled design (*togidashi makie*); 5.1 x 5.1 x 2.0 cm.
 Drawing signed *Hōitsu hitsu* [drawn by Hōitsu]; *otoshi* signed *Yōyūsai*
 Exhibited: New York, 1972, p. 76, no. 133
NETSUKE: lacquer and metal
OJIME: metal

61. INRŌ with violets, ferns, and scouring rushes
 Hara Yōyūsai (1772–1845)
 Four cases; raised sprinkled design (*takamakie*) and shell inlay; 5.7 x 8.7 x 2.1 cm.
 Signed *Yōyūsai*
 Ex collection: Alexander G. Moslé
 Published: Moslé, 1933, no. 1743
 Exhibited: New York, 1972, p. 76, no. 131
NETSUKE: lacquer; signed *Yōyūsai;* seal *Hōitsu*
OJIME: jade

62. LETTER BOX with Matsushima
 Nineteenth century
 Raised sprinkled design (*takamakie*); 11.2 x 21.5 x 7.8 cm.
 Ex collection: S. N. Nickerson

63. INRŌ with *bugaku* helmet and instruments
 Ogawa Haritsu (1663–1747)
 Four cases; raised sprinkled design (*takamakie*); 4.4 x 6.5 x 2.5 cm.
 Seal *Kan*
 Ex collection: Alexander G. Moslé
 Published: Moslé, 1933, no. 1709, pl. 110
 Exhibited: New York, 1972, p. 62, no. 83
NETSUKE: wood; signed *Ryūkei,* seal *Kō*
OJIME: coral

64. SHEATH INRŌ with phoenix and dragon
 Ogawa Haritsu (1663–1747); dated *hinoe saru shūjitsu* [1716 autumn day]
 Three cases inside sheath; raised lacquer with ceramic inlay; D. 7.6, H. 1.6 cm.
 Signed *Ritsuō sei* [made by Ritsuō]; seal *Kan*

 Ex collection: Vicomte de Sartiges, Demaree and Dorothy Bess
 Exhibited: New York, 1972, p. 63, no. 86
NETSUKE: wood, seal *Kan*
OJIME: ivory

65. INRŌ with elephant
 Ogawa Haritsu (1663–1747)
 Four cases; raised sprinkled design (*takamakie*) and inlay; 10.3 x 12.9 x 3.8 cm.
 Signed *Ritsuō;* seal *Kan*
 Ex collection: Howard Mansfield
 Published: Boger, 1964, pl. 20
 Exhibited: New York, 1972, p. 64, no. 90
NETSUKE: lacquer
OJIME: wood

66. INRŌ with owl and clappers
 Ogawa Haritsu (1663–1747)
 Two cases; ceramic inlay and raised sprinkled design (*takamakie*); 7.1 x 6.6 x 2.7 cm.
 Signed *Ritsuō,* seal *Kan*
 Ex collection: Hans Mueller
 Published: Boger, 1964, pl. 19
 Exhibited: New York, 1972, p. 64, no. 88; Los Angeles, New York, 1976–77, p. 170, no. 99
NETSUKE: wood, signed *Ikkyū*
OJIME: wood; signed *Hasutomi*

67. INRŌ with Chinese ship and falcon
 Ogawa Haritsu (1663–1747)
 Three cases; raised sprinkled design (*takamakie*) and inlay; 9.0 x 11.2 x 3.0 cm.
 Signed *Ukanshi Ritsuō;* seal *Kan*
 Ex collection: Hans Mueller
 Published: *Time,* October 30, 1972, p. 77
 Exhibited: New York, 1972, p. 62, no. 82
NETSUKE: wood
OJIME: crystal

68. INRŌ with Chinese ship and musical instruments
 Mochizuki Hanzan; mid-eighteenth century
 Three cases; raised sprinkled design (*takamakie*) and inlay; 7.1 x 7.8 x 2.5 cm.

 Signed *Hanzan sei* [made by Hanzan]
 Ex collection: Alexander G. Moslé
 Published: Moslé, 1933, no. 1724, pl. 113
 Exhibited: New York, 1972, p. 60, no. 76
NETSUKE: lacquer
OJIME: ivory

69. WRITING BOX with quail and millet
 Mochizuki Hanzan; mid-eighteenth century
 Raised sprinkled design (*takamakie*) and inlay; 20.6 x 24.3 x 4.7 cm.
 Seal *Hanzan*
 Ex collection: M. A. Huc, Gadiot, Demaree and Dorothy Bess
 Published: Boger, 1964, pl. 17
 Exhibited: New York, 1972, p. 131, no. 59; Los Angeles, New York, 1976–77, p. 180, no. 128

70. INRŌ with goose
 Mochizuki Hanzan; mid-eighteenth century
 Four cases; inlay and raised sprinkled design (*takamakie*); 7.6 x 7.6 x 2.2 cm.
 Seal *Kan*
 Ex collection: Louis Gonse
 Exhibited: New York, 1972, p. 63, no. 87; Los Angeles, New York, 1976–77, p. 170, no. 98
NETSUKE: ceramic; signed *Shinshō*
OJIME: ceramic

71. INRŌ with mice and peppers
 Sakai Chūbei (1736–1802)
 Four cases; raised sprinkled design (*takamakie*) and inlay; 4.5 x 8.7 x 2.1 cm.
 Signed *Ritsusō sei* [made by Ritsusō]
 Ex collection: Alexander G. Moslé
 Published: Moslé, 1933, no. 1712, pl. 110
 Exhibited: New York, 1972, p. 62, no. 84
NETSUKE: wood, signed *Ittan,* with *kaō*
OJIME: coral

72. INRŌ with Chinese inksticks
 Shibata Zeshin (1807–91)
 Three cases; raised lacquer; 5.8 x 7.9 x 2.1 cm.
 Signed *Zeshin*
 Ex collection: R. A. Pfungst, Demaree and Dorothy Bess
 Exhibited: New York, 1972, p. 86, no. 163

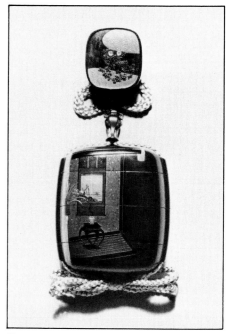

Fig. 156. Inrō *no. 81*

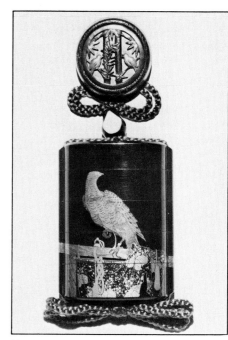

Fig. 157. Inrō *no. 87*

NETSUKE: wood
OJIME: cloisonné

73. INRŌ imitating Chinese inkstick with tiger and dragon
 Ogawa Haritsu (1663–1747)
 Four cases; raised lacquer; 5.1 x 8.2 x 2.8 cm.
 Seal *Kan*
 Ex collection: Henri Vever, Marianne Densmore, Demaree and Dorothy Bess
NETSUKE: lacquer; seal *Kan*
OJIME: metal with cloisonné

74. INCENSE CONTAINER imitating Chinese inkstick with tiger and dragon
 Shibata Zeshin (1807–91)
 Raised lacquer; D. 7.2. H. 1.9 cm.
 Ex collection: Charles Vignier, Demaree and Dorothy Bess
 Exhibited: New York, 1972, p. 126, no. 39

75. BOX with *ominaeshi* flowers and fence
 Shibata Zeshin (1807–91)
 Raised lacquer with shell and pewter inlay; 9.0 x 12.6 x 5.3 cm.
 Signed *Zeshin*
 Ex collection: Michael Tomkinson, Victor Rienaecker, Demaree and Dorothy Bess
 Exhibited: New York, 1972, p. 122, no. 22

76. INRŌ with chestnuts and evergreen
 Shibata Zeshin (1807–91)
 One case; raised sprinkled design (*takamakie*); 6.7 x 7.9 x 1.8 cm.
 Signed *Zeshin*
 Exhibited: New York, 1972, p. 85, no 161; Los Angeles, New York, 1976–77, p. 177, no. 122
NETSUKE: lacquer; signed *Zeshin*
OJIME: glass

77. INRŌ with design based on story of Shain
 Shibata Zeshin (1807–91)
 Four cases; raised sprinkled design (*takamakie*); 5.3 x 7.3 x 1.6 cm.
 Signed *Zeshin*
 Ex collection: W. W. Winkworth, Demaree and Dorothy Bess
 Exhibited: New York, 1972, p. 84, no. 157

NETSUKE: wood; signed *Zeshin*
OJIME: lacquer

78. LAYERED FOOD BOX with extra lid; design of grain-laden boats and plovers
 Shibata Zeshin (1807–91)
 Five cases; raised sprinkled design (*takamakie*); 24.4 x 22.9 x 40.9 cm.
 Signed *Zeshin*
 Ex collection: W. W. Winkworth, Demaree and Dorothy Bess
 Exhibited: New York, 1972, p. 119, no. 3; Los Angeles, New York, 1976–77, p. 178, no. 124

79. SHEATH INRŌ with Shōki and devil behind barred windows
 Shibata Zeshin (1807–91)
 One case inside sheath; raised sprinkled design (*takamakie*) and flattened sprinkled design (*togidashi makie*); 6.0 x 8.0 x 1.6 cm.
 Signed *Zeshin*
 Ex collection: Henri Vever, Marianne Densmore, Demaree and Dorothy Bess
 Exhibited: New York, 1972, p. 86, no. 164
NETSUKE: lacquer; signed *Zeshin*
OJIME: metal

80. INRŌ with devil-woman
 Shibata Zeshin (1807–91)
 Four cases; raised sprinkled design (*takamakie*); 6.1 x 8.1 x 2.0 cm.
 Signed *Zeshin*
 Ex collection: Harry Seymour Trower, Simpson, W. W. Winkworth, Demaree and Dorothy Bess
 Exhibited: New York, 1972, p. 84, no. 158
NETSUKE: lacquer, shell, and ceramic
OJIME: metal

81. INRŌ with alcove, incense burner, and painting
 Late nineteenth century
 Three cases; raised sprinkled design (*takamakie*); 6.5 x 6.7 x 2.2 cm.
 Signed *Zeshin*
 Exhibited: New York, 1972, p. 85, no. 162
NETSUKE: wood and lacquer; signed *Zeshin*
OJIME: metal

82. INRŌ with butterflies
 Kōami Masamine; early eighteenth century
 Two cases; raised sprinkled design (*takamakie*); 8.0 x 6.3 x 3.2 cm.
 Signed *Masamine,* with *kao*
 Ex collection: Efrem Zimbalist
 Exhibited: New York, 1972, p. 46, no. 15
NETSUKE: wood
OJIME: bone

83. INRŌ with children and screen
 Kōami Nagayoshi; mid-eighteenth century
 Four cases; raised sprinkled design (*takamakie*); 6.2 x 7.5 x 2.2 cm.
 Signed *Kōami Nagayoshi,* with *kao*
 Ex collection: Alexander G. Moslé,
 Published: Moslé, 1933, no. 1731, pl. 114; Boger, 1964, pl. 19
 Exhibited: New York, 1972, p. 57, no. 62
NETSUKE: ivory; signed *Tomonobu*
OJIME: coral

84. INRŌ with rope curtain and vine
 Yamada Jōka; late seventeenth century
 Six cases; raised sprinkled design (*takamakie*); 4.9 x 9.2 x 3.5 cm.
 Inscribed *Kamo sha*[?]*ki kōdei Aodare kore* [*o*] *hajimu* [According to the record of Kamo Shrine, this design was originated by the priest of imperial blood, Aodare]
 Signed *Yamada Jōka zō* [made by Yamada Jōka], with *kao*
 Ex collection: John Pierpont Morgan
 Exhibited: New York, 1972, p. 69, no. 104
NETSUKE: wood
OJIME: ivory

85. INRŌ with butterflies
 Yamada Jōka; design based on drawing by Hanabusa Itchō (1652–1724); early eighteenth century
 Five cases; raised sprinkled design (*takamakie*); 6.3 x 9.7 x 2.8 cm.
 Drawing signed *Hanabusa Itchō zu* [drawing by Hanabusa Itchō]; *inrō* signed *Jōkasai*
 Ex collection: Alexander G. Moslé

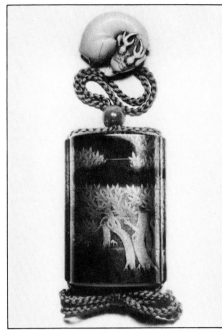

Fig. 158. Inrō no. 90

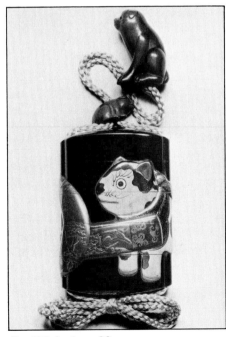

Fig. 159. Inrō no. 92

Published: Moslé, 1933, no. 1741
Exhibited: New York, 1972, p. 69,
no. 105
NETSUKE: lacquer; signed *Yōsei zō*
[made by Yōsei]
OJIME: lacquer

86. INRŌ imitating ink painting
Yamada Jōka; design based on paint-
ing by Kanō Hidenobu (1717–63); mid-
eighteenth century
Three cases; flattened sprinkled design
imitating ink painting (*sumie togidashi
makie*); 7.8 x 8.5 x 2.0 cm.
Drawing signed *Hōgen Jotekisai ga*
[painting by Hōgen Jotekisai]; *inrō*
signed *Jōkasai*
Ex collection: Alexander G. Moslé
Published: Moslé, 1933, no. 1740, pl. 116
Exhibited: New York, 1972, p. 70, no.
106; Los Angeles, New York, 1976–77,
p. 171, no. 100
NETSUKE: ivory; signed *Shōunsai*
OJIME: amber

87. INRŌ with falcon and dog
Yamada Jōka; eighteenth century
Four cases; flattened sprinkled design
(*togidashi makie*); 5.9 x 7.7 x 2.5 cm.
Signed *Jōka saku* [made by Jōka]
Ex collection: G. G. Davies, Demaree
and Dorothy Bess
Exhibited: New York, 1972, p. 45, no. 13
NETSUKE: wood and metal
OJIME: wood and ivory

88. INRŌ with painted shells
Koma Kyūhaku (died 1715?)
Four cases; raised sprinkled design
(*takamakie*); 6.1 x 9.1 x 1.6 cm.
Signed *Koma Yasutada saku* [made by
Koma Yasutada]
Exhibited: New York, 1972, p. 59, no. 72
NETSUKE: coral
OJIME: metal, signed *Hōgen Shunmei*

89. INRŌ with horseback rider
Eighteenth–nineteenth century
Four cases; flattened sprinkled design
(*togidashi makie*); 6.2 x 9.1 x 1.9 cm.
Signed *Koma Yasutada saku* [made by
Koma Yasutada]

Ex collection: Alexander G. Moslé
Published: Moslé,1933,no. 1734,pl. 115
Exhibited: New York, 1972, p. 59, no. 71
NETSUKE: lacquer; signed *Teiji*
OJIME: coral

90. INRŌ with maple trees in mist
Early eighteenth century
Four cases; flattened sprinkled design
(*togidashi makie*); 5.8 x 7.7 x 2.6 cm.
Signed *Koma Kyūhaku saku* [made by
Koma Kyūhaku]
Ex collection: Alexander G. Moslé
Published: Moslé, 1933, no. 1721, pl. 112
Exhibited: New York, 1972, p. 58, no. 65
NETSUKE: ivory
OJIME: amber

91. INRŌ with lizard
Koma Kyūhaku (died 1732)
Two cases; raised lacquer; 7.6 x 5.8 x
2.4 cm.
Signed *Koma Yasuaki saku* [made by
Koma Yasuaki]
Ex collection: Walter Lionel Behrens
Exhibited: New York, 1972, p. 59, no. 70;
Los Angeles, New York, 1976–77,
p. 169, no. 96
NETSUKE: wood; signed *Ikkyū*
OJIME: metal

92. INRŌ with toy dog
Koma Sadahisa; eighteenth century
Four cases; raised lacquer; 5.9 x 8.9 x
2.0 cm.
Signed *Koma Sadahisa saku* [made by
Koma Sadahisa]
Ex collection: S. Ambrose Lee,
Demaree and Dorothy Bess
Exhibited: New York, 1972, p. 59, no. 69;
Los Angeles, New York, 1976–77,
p. 169, no. 95
NETSUKE: wood; signed *Tadayoshi*
OJIME: wood

93. INRŌ with actor Ichikawa Danjūrō V
(1741–1806)
Koma Kyūhaku (died 1794); design
based on print by Katsukawa Shunshō
(1726–92)
Four cases; flattened sprinkled design

(*togidashi makie*); 5.5 x 8.0 x 2.4 cm.
Drawing signed *Shunshō ga* [painting
by Shunshō]; *inrō* signed *Koma Kyū-
haku saku* [made by Koma Kyūhaku]
Published: Murase, 1977, p. 41
Exhibited: New York, 1972, p. 57, no. 64
NETSUKE: lacquer
OJIME: metal

94. INRŌ with warrior's helmet and armor
Eighteenth–early nineteenth century
Three cases; raised sprinkled design
(*takamakie*) and inlay; 9.4 x 8.5 x
2.0 cm.
Signed *Koma Kyūhaku saku* [made by
Koma Kyūhaku]
Ex collection: Hans Mueller
Published: *Time,* October 30,1972,p. 77
Exhibited: New York, 1972, p. 57, no. 63
NETSUKE: wood; signed *Deme Uman*
OJIME: coral

95. INRŌ with harvested rice by hut
Late eighteenth–early nineteenth
century
Three cases; raised sprinkled design
(*takamakie*); 7.5 x 7.6 x 1.8 cm.
Signed *Koma Kyūhaku saku* [made by
Koma Kyūhaku]
Ex collection: Oscar Correia, Demaree
and Dorothy Bess
Exhibited: New York, 1972, p. 58, no. 66
NETSUKE: lacquer
OJIME: glass

96. INRŌ with chrysanthemums
Koma Kansai; nineteenth century
Four cases; raised lacquer; 5.4 x 9.5 x
2.3 cm.
Signed *Koma Kansai*
Ex collection: Victor Rienaecker,
Demaree and Dorothy Bess
Exhibited: New York, 1972, p. 81, no. 149
NETSUKE: lacquer; signed *Kansai*
OJIME: metal

97. INRŌ with scene from story of forty-
seven *rōnin*
Koma Kansai; nineteenth century
Two cases; raised sprinkled design
(*takamakie*), flattened sprinkled design

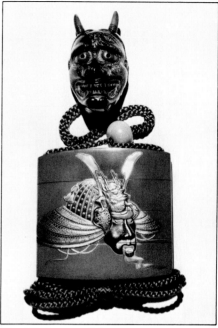

Fig. 160. Inrō no. 94

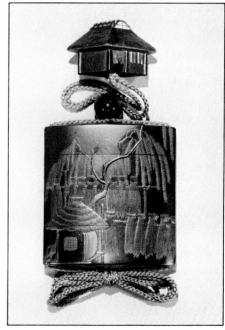

Fig. 161. Inrō no. 95

(togidashi makie), and inlay; D. 10.7,
H. 3.4 cm.
Signed *Koma Kansai*, with *kaō*
Ex collection: J. B. Gaskell, Victor
Rienaecker, Demaree and Dorothy
Bess
Exhibited: New York, 1972, pp. 80–81,
no. 147
NETSUKE: lacquer; signed *Kansai*
OJIME: stone

98. INRŌ with iris
Koma Kansai; nineteenth century
Three cases; flattened sprinkled design
(*togidashi makie*); 6.9 x 7.0 x 2.0 cm.
Signed *Kansai saku* [made by Kansai]
Ex collection: Walter Lionel Behrens,
Demaree and Dorothy Bess
Exhibited: New York, 1972, p. 81, no.
148; Los Angeles, New York, 1976–77,
p. 172, no. 103
NETSUKE: wood; signature
OJIME: metal; signed *Tomoyuki*

99. INRŌ with bean vine
En'ami Shigemune; eighteenth century
Four cases; raised sprinkled design
(*takamakie*) and shell inlay; 5.5 x 7.9 x
3.4 cm
Signed *En'ami;* seal *Shigemune*
Ex collection: Stuart Samuel, Demaree
and Dorothy Bess
Published: London, 1894, p. 67, no. 53
Exhibited: New York, 1972, p. 53, no. 44
NETSUKE: lacquer; signed *Kansai*
OJIME: metal

100. INRŌ with bands of designs
Kajikawa Bunryūsai; late seventeenth
century
Four cases; various sprinkled tech-
niques (*makie*); 5.5 x 7.4 x 2.0 cm.
Signed *Kankō Kajikawa Bunryūsai* [Offi-
cial Craftsman Kajikawa Bunryūsai];
seal *Tei* [?]
Ex collection: Walter Lionel Behrens,
J. B. Gaskell, R. A. Pfungst, G. G.
Davies, Demaree and Dorothy Bess
Exhibited: New York, 1972, p. 79, no. 141
NETSUKE: metal
OJIME: metal

101. INRŌ with *kusudama* and *buriburi* toy
Eighteenth century
Four cases; raised sprinkled design
(*takamakie*) and inlay; 5.8 x 7.9 x 2.2 cm.
Signed *Kajikawa saku* [made by
Kajikawa], with *kaō*
Ex collection: Michael Tomkinson,
Walter Lionel Behrens, Henry Charles
Clifford, W. W. Winkworth, Demaree and
Dorothy Bess
Published: Weber, 1923, pl. 5
Exhibited: New York, 1972, p. 46, no. 14
NETSUKE: lacquer; signed *Kōzan*
OJIME: stone

102. INRŌ with rope curtain and swallows
Early nineteenth century
Four cases; raised sprinkled design
(*takamakie*); 5.9 x 8.1 x 2.4 cm.
Signed *Kajikawa saku* [made by
Kajikawa]; seal *Ei*
Ex collection: Walter Lionel Behrens,
C. P. Peak, W. W. Winkworth, Demaree
and Dorothy Bess
Published: Weber, 1923, pl. 40
NETSUKE: lacquer
OJIME: ivory; signed *Sōichi*

103. INRŌ with snake
Early nineteenth century
Three cases; raised sprinkled design
(*takamakie*); 7.3 x 7.1 x 2.1 cm.
Signed *Kajikawa saku* [made by
Kajikawa]; seal *Ei*
Ex collection: Rogers
Exhibited: New York, 1972, p. 56, no. 59
NETSUKE: wood; signed *Ryūkei*
OJIME: lacquer

104. INRŌ with ferry
Attributed to Yamamoto Shunshō
(1610–82); seventeenth–eighteenth
century
Four cases; flattened sprinkled design
(*togidashi makie*); 5.9 x 8.1 x 2.4 cm.
Ex collection: Alexander G. Moslé
Published: Moslé, 1933, no. 1716, pl. 114
Exhibited: New York, 1972, p. 71, no. 110
NETSUKE: ivory
OJIME: stone

105. INRŌ with death of Buddha

Eighteenth–nineteenth century
Four cases; flattened sprinkled design
(*togidashi makie*); 7.5 x 7.5 x 2.2 cm.
Signed *Shunshō;* seal *Keishō*
Ex collection: Rogers
Exhibited: New York, 1972, p. 71, no. 112
NETSUKE: ivory; signed *Kyūji* [?]
OJIME: wood; signature

106. INRŌ with cat and peony
Eighteenth century
Four cases; raised sprinkled design
(*takamakie*) and flattened sprinkled
design (*togidashi makie*); 7.1 x 7.2 x
1.9 cm.
Ex collection: Alexander G. Moslé
Published: Moslé, 1933, no. 1715, pl. 112
Exhibited: New York, 1972, p. 71, no. 111
NETSUKE: wood and cloisonné; signed
Narikado, with *kaō*
OJIME: coral

107. INRŌ with writing courtesan
Shunshō Seishi (1774–1831); design
based on print by Hosoda Eishi (1756–
1815)
Four cases; flattened sprinkled design
(*togidashi makie*); 5.8 x 8.5 x 1.4 cm.
Drawing signed *Eishi zu* [drawing by
Eishi]; *inrō* signed *Shunshō;* seal
Ex collection: T. B. Kitson
Exhibited: New York, 1972, p. 88, no. 169
NETSUKE: wood
OJIME: lacquer

108. INRŌ with rice fields, storage shed,
and scarecrow
Shiomi Masanari (1647–ca. 1722); late
seventeenth century
Four cases; various sprinkled tech-
niques (*makie*); 6.0 x 7.7 x 2.3 cm.
Seal *Shiomi Masanari*
Ex collection: Alexander G. Moslé
Published: Moslé, 1933, no. 1727
Exhibited: New York, 1972, p. 67, no. 96
NETSUKE: wood
OJIME: stone

109. INRŌ with travelers taking shelter
from rain
Shiomi Masanari (1647–ca. 1722);
design based on painting by Hanabusa

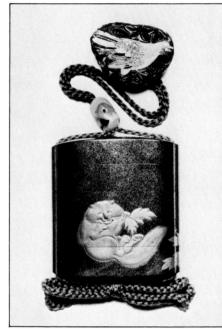

Fig. 162. Inrō no. 106

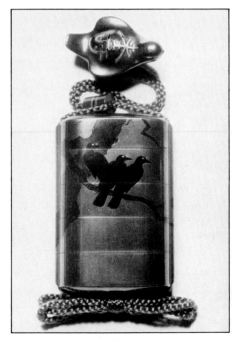

Fig. 163. Inrō no. 118

Itchō (1652–1724)
Three cases; flattened sprinkled design
(*togidashi makie*); 8.3 x 7.2 x 2.0 cm.
Seal *Shiomi Masanari*
Ex collection: Henry Walters
Exhibited: New York, 1972, p. 67, no. 98
NETSUKE: horn and metal
OJIME: stone

110. INRŌ with dragonfly and praying
mantis
Shiomi Masanari (1647–ca. 1722)
Four cases; flattened sprinkled design
(*togidashi makie*) and raised sprinkled
design (*takamakie*); 5.9 x 6.9 x 2.5 cm.
Inscribed *Shōtoku roku hinoe saru* [*no*]
*toshi chūshun gyōnen nanajūssai
okina* [the old man in his seventieth
year, middle of spring, *Shōtoku* 6
(1716)]; seal *Shiomi Masanari*
Exhibited: New York, 1972, p. 67, no. 95
NETSUKE: wood; signed *Toyomasa*
OJIME: stone

111. INRŌ with dragonfly
Shiomi Masakage; eighteenth century
Four cases; raised sprinkled design
(*takamakie*); 6.1 x 7.6 x 2.4 cm.
Signed *Shiomi Masakage;* seal
Masakage
Ex collection: Walter Lionel Behrens,
Louis Gonse, Charles Vignier, Demaree
and Dorothy Bess
Exhibited: New York, 1972, p. 87, no.
166; Los Angeles, New York, 1976–77,
p. 173, no. 104
NETSUKE: wood; signed *Tadanari*
OJIME: stone

112. DOUBLE INRŌ with cat and mouse
Shiomi Masanari (1647–ca. 1722)
Four cases; flattened sprinkled design
(*togidashi makie*); 6.0 x 8.7 x 3.4 cm.
Seals *Shiomi Masanari, Shiomi,* and
Masakage
Ex collection: J. C. Hawkshaw,
J. B. Gaskell, H. Gordon Bois,
W. W. Winkworth, Demaree
and Dorothy Bess
Exhibited: London, 1916, p. 75, no. 35;
New York, 1972, p. 66, no. 92

NETSUKE: lacquer
OJIME: metal

113. INRŌ with ox and herdsboy
Eighteenth–nineteenth century; design
based on painting by Shiomi Masanari
(1647–ca. 1722)
Four cases; flattened sprinkled design
(*togidashi makie*); 6.9 x 7.8 x 2.9 cm.
Signed *Shiomi Masanari;* seal *zu*
Exhibited: New York, 1972, p. 66, no. 94
NETSUKE: ivory
OJIME: coral

114. INRŌ with Taira no Kagekiyo (died
1196) confronted by Hatakeyama
Shigetada (1164–1205)
Eighteenth century
Four cases; flattened sprinkled design
(*togidashi makie*); 6.2 x 8.4 x 2.6 cm.
Seal *Shiomi Masanari*
Ex collection: Alexander G. Moslé
Published: Moslé, 1933, no. 1726, pl. 113
Exhibited: New York, 1972, p. 67, no. 97
NETSUKE: wood
OJIME: stone

115. INRŌ with Takasago legend and cranes
Iizuka Tōyō; mid–late eighteenth
century
Four cases; incised design and flat-
tened sprinkled design (*togidashi
makie*); 5.5 x 8.3 x 2.0 cm.
Signed *Tōyō*
Ex collection: Alexander G. Moslé
Published: Moslé, 1933, no. 1733, pl. 115
Exhibited: New York, 1972, p. 54, no. 49
NETSUKE: ivory; signed *Masatsugu*
OJIME: metal

116. INCENSE CONTAINER with birds in
cage
Iizuka Tōyō; mid–late eighteenth
century
Raised sprinkled design (*takamakie*)
and inlay; D. 10.7, H. 4.2 cm.
Signed *Kanshōsai,* with *kaō*
Ex collection: Demaree and Dorothy Bess
Exhibited: New York, 1972, p. 122,
no. 18; Los Angeles, New York, 1976–77,
p. 181, no. 129

117. INRŌ with pheasant in plum tree
Late eighteenth century; design based
on painting by Kanō Michinobu
(1730–90)
Six cases; flattened sprinkled design
(*togidashi makie*); 4.6 x 7.7 x 2.3 cm.
Drawing signed *Hakugyokusai Hōgen
Eisen Fuji Michinobu; inrō* signed *Tōyō,*
with *kaō*
Exhibited: New York, 1972, p. 55, no. 52
NETSUKE: wood; signed *Tōyō,* with *kaō*
OJIME: metal

118. INRŌ with crows
Late eighteenth century
Four cases; flattened sprinkled design
(*togidashi makie*); 6.2 x 8.8 x 2.6 cm.
Signed *Kanshōsai,* with *kaō*
Ex collection: G. G. Davies, Demaree
and Dorothy Bess
Exhibited: New York, 1972, p. 55, no. 53;
Los Angeles, New York, 1976–77,
p. 168, no. 94
NETSUKE: lacquer
OJIME: metal

119. INRŌ with *kusudama*
Eighteenth century
Five cases; various sprinkled tech-
niques (*makie*) and inlay; 3.8 x 10.1 x
2.5 cm.
Signed *Tōyō,* with *kaō*
Ex collection: Walter Lionel Behrens,
Ralph Harari
NETSUKE: wood; signed *Miwa;* seal
OJIME: stone

120. INRŌ with lion dance and battledore
Eighteenth century
Five cases; inlay and raised sprinkled
design (*takamakie*); 5.1 x 9.1 x 3.1 cm.
Signed *sa Haritsuō Tōyō* [maker
Haritsuō Tōyō], with *kaō*
Ex collection: J. C. Hawkshaw,
Demaree and Dorothy Bess
Exhibited: New York, 1972, p. 54, no. 50
NETSUKE: wood; signed *Miwa;* seal
OJIME: metal

121. INRŌ with Chinese figure
Eighteenth century

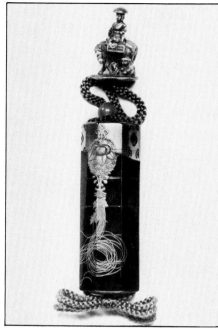
Fig. 164. Inrō *no. 119*

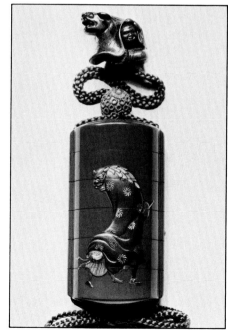
Fig. 165. Inrō *no. 120*

Three cases; raised sprinkled design
(*takamakie*); 5.2 x 6.6 x 2.2 cm.
Signed *Tatsuke Kōkyō* [Tatsuke the
mirror maker]: seal *Tokufū*
Ex collection: Walter Lionel Behrens,
W. W. Winkworth, Demaree and Dorothy
Bess
Exhibited: New York, 1972, p. 68,
no. 101
NETSUKE: lacquer
OJIME: metal

122. INRŌ with camellia and deer
Tatsuke Kōkōsai; early nineteenth
century
Six cases; raised sprinkled design
(*takamakie*); 3.6 x 11.0 x 1.9 cm.
Signed *Tatsuke Kōkōsai*
Ex collection: Alexander G. Moslé
Published: Moslé, 1933, no. 1739
Exhibited: New York, 1972, p. 88, no. 170
NETSUKE: wood and metal; signed
Mitsuyoshi tō
OJIME: metal

123. INRŌ with peaches and peonies
Tatsuke Hisahide (1756–1829)
Two cases; flattened sprinkled design in
colors (*iroe togidashi makie*); 5.7 x 7.2 x
2.0 cm.
Signed *Hisahide;* seal *Tōkei*
Ex collection: Edward Gilbertson,
H. Gordon Bois, W. W. Winkworth,
Demaree and Dorothy Bess
Exhibited: New York, 1972, p. 89, no. 171
NETSUKE: lacquer
OJIME: lacquer

124. INCENSE CONTAINER with blossom-
ing plum
Late seventeenth–eighteenth century
Carved red lacquer (*tsuishu*); D. 9.5,
H. 3.5 cm.
Exhibited: New York, 1972, p. 124, no. 33

125. INRŌ with plum, pine, and bamboo
Tsuishu Yōsei; eighteenth century
Four cases; carved red and green lac-
quer (*kōka ryokuyō*); 5.6 x 7.4 x 2.2 cm.
Signed *Yōsei zō* [made by Yōsei]
NETSUKE: carved lacquer
OJIME: metal

126. INRŌ with flowers in basket
Tsuishu Yōsei; eighteenth century
Five cases; carved lacquer;
5.6 x 9.4 x 2.5 cm.
Signed *Yōsei zō* [made by Yōsei]
Ex collection: Edward Gilbertson, Henry
Charles Clifford
Exhibited: London, 1894, p. 46, no. 44;
New York, 1972, p. 72, no. 114; Los
Angeles, New York, 1976–77, p. 172,
no. 101
NETSUKE: lacquer; signed *Yōsei zō*
[made by Yōsei]
OJIME: coral

127. INRŌ with praying mantis and wheel
Early nineteenth century
Four cases; raised and carved lacquers;
6.0 x 7.6 x 2.5 cm.
Signed *Zonsei,* with *kaō*
Ex collection: W. W. Winkworth,
Demaree and Dorothy Bess
Exhibited: New York, 1972, p. 90, no. 175
NETSUKE: horn; signed *Fuhaku*
OJIME: ivory

128. INRŌ with tea ceremony utensils
Eighteenth century
One case; carved lacquer;
8.1 x 5.5 x 2.7 cm.
Signed *Yōsei zō* [made by Yōsei]
Ex collection: Michael Tomkinson
Exhibited: New York, 1972, p. 72, no. 115
NETSUKE: wood; signed *Masatoshi*
OJIME: metal

129. INRŌ with cranes and pine
Matsuki Hōkei; nineteenth century
Four cases; carved red lacquer
(*tsuishu*); 5.8 x 8.5 x 2.7 cm.
Signed *Hōkei*
Ex collection: G. G. Davies
Exhibited: New York, 1972, p. 82, no. 151
NETSUKE: lacquer
OJIME: lacquer

130. INCENSE CONTAINER with heron
Tamakaji Zōkoku; late nineteenth century
Carved red lacquer (*tsuishu*); D. 7.2,
H. 2.7 cm.
Signed *Zōkoku*
Exhibited: New York, 1972, p. 124, no. 32

131. INRŌ with chrysanthemums
Late eighteenth–nineteenth century
Four cases; carved black lacquer
(*tsuikoku*); 4.7 x 7.7 x 2.4 cm.
Ex collection: Victor Rienaecker,
Demaree and Dorothy Bess
Exhibited: New York, 1972, p. 52, no. 40
NETSUKE: wood
OJIME: metal

132. INCENSE CONTAINER
Eighteenth–nineteenth century
Deeply incised lacquer (*guri*); D. 7.7,
H. 2.7 cm.

133. INRŌ with scroll pattern
Nineteenth century
Deeply incised lacquer (*guri*);
5.3 x 6.8 x 2.5 cm.
Ex collection: Alexander G. Moslé
Published: Moslé, 1933, no. 1759, pl. 117
Exhibited: New York, 1972, p. 75, no. 127
NETSUKE: lacquer; signed *Hōsen*
OJIME: lacquer

134. INRŌ with gourd vine
Early seventeenth century
Five cases; shallow incising (*chinkin-
bori*); 3.1 x 13.7 x 1.6 cm.
Seal *Tsuigyokushi*
Exhibited: New York, 1972, p. 56, no. 60
NETSUKE: narwhal ivory
OJIME: coral

135. INRŌ with flowers in basket
Eighteenth century
Five cases; shallow incising (*chinkin-
bori*); 3.8 x 9.9 x 1.9 cm.
Signed *Chin'ei*
NETSUKE: wood; signed *Bairi*
OJIME: wood and metal

136. INRŌ with prawn
Onko Chōkan Nagasato; early eigh-
teenth century
Two cases; shallow incising (*chinkin-
bori*) and carved red lacquer (*tsuishu*);
7.9 x 5.7 x 2.4 cm.
Signed *Onko Chōkan Nagasato*
Ex collection: Victor Rienaecker,
Demaree and Dorothy Bess
Exhibited: New York, 1972, p. 62, no. 81

NETSUKE: lacquer; signed *Onko Chōkan
Takenaga*
OJIME: lacquer

137. INRŌ with birds by shore
Eighteenth century
Four cases; inlay and raised sprinkled
design (*takamakie*); 4.7 x 6.3 x 1.6 cm.
Ex collection: Demaree and Dorothy Bess
Exhibited: New York, 1972, pp. 46–47,
no. 18
NETSUKE: lacquer
OJIME: coral

138. INRŌ with textile patterns
Nineteenth century
Four cases; inlay and flattened sprin-
kled design (*togidashi makie*);
5.1 x 9.5 x 2.7 cm.
Exhibited: New York, 1972, p. 50, no. 33
NETSUKE: lacquer
OJIME: lacquer

139. INRŌ with cherry blossoms at Yoshino
Nineteenth century
Six cases; inlay and raised sprinkled
design (*takamakie*); 5.5 x 8.9 x 2.7 cm.
Ex collection: Frederic E. Church
Exhibited: New York, 1972, p. 48, no. 26
NETSUKE: bamboo
OJIME: metal; signed *Rakuyoku* [?]

140. INRŌ with Benkei (died 1189) and
Minamoto no Yoshitsune (1159–89)
Hara Yōyūsai (1774–1845)
Four cases; inlay and raised sprinkled
design (*takamakie*); 5.8 x 9.0 x 2.2 cm.
Signed *Yōyūsai*
Ex collection: Heber R. Bishop, Frederic
E. Church
Exhibited: New York, 1972, p. 76, no. 132
NETSUKE: ivory; signed *Tōkōsai*
OJIME: coral

141. INRŌ with birds and flowers
Nineteenth century
Five cases; inlay; 5.2 x 9.5 x 3.1 cm.
Seal *Shibayama*
Ex collection: Edward Gilbertson,
Demaree and Dorothy Bess
NETSUKE: ivory; signed *Shibayama Sōichi*
OJIME: ivory

Glossary of Technical Terms

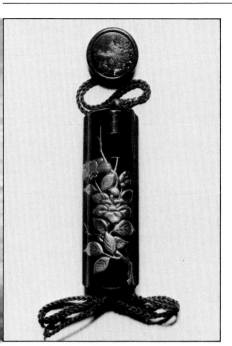

Fig. 166. Inrō no. 122

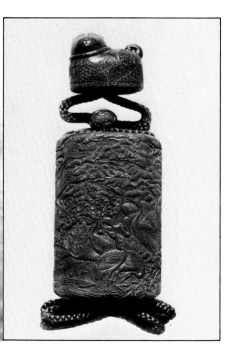

Fig. 167. Inrō no. 129

Aogai "Green shell." Thinly sliced abalone shell used for inlay or sprinkling. See no. 14 and the cloth beneath the falcon on no. 87.

Chinkinbori Shallowly incised lacquer. The incised design is usually colored with a powder or leaf, commonly gold, that contrasts with the ground. See nos. 134, 135.

Fundameji Powder ground. Ground in which a fine metal powder is densely sprinkled or dusted over the wet lacquer, covered with a thin protective coat of lacquer after hardening, and polished. Before 1600, this type of surface was called *ikakeji*. More general terms include *kinji* when gold powder is used, and *ginji* when silver is used. See nos. 59, 61.

Guri Deeply incised lacquer. Deep V-shaped cuts are carved in layers of lacquer of varying colors, usually in repeating sequences of yellow, green, red, and black. See nos. 132, 133.

Gyōbu nashiji Dense aventurine. *Nashiji* in which the metal flakes are larger and more irregular than ordinary and are individually set into the wet lacquer, rather than sprinkled, minimizing the spaces between flakes. In some cases, the surface beneath the *nashiji* is first covered with gold leaf. See inside no. 99.

Hiramakie "Level sprinkled design." *Makie* in which the design is raised above the surface of the ground only by the thickness of the lacquer with which it was drawn. A thin protective coat of lacquer is usually applied over the sprinkled design; after it hardens, the design is polished. See no. 19.

Hirameji Flat flake ground. Ground in which relatively flat and thick flakes of metal, usually gold, are sprinkled in wet lacquer, then covered with layers of lacquer and polished until they are exposed flush with the surrounding lacquer. See ground on no. 6.

Iroe togidashi makie Flattened sprinkled design in colors. *Togidashi makie* in which the sprinkled powders are made of colored lacquer rather than metal. See no. 123.

Kirikane "Cut foil." Cut pieces of gold or silver leaf that are sprinkled or set into a design or ground. See no. 138 and the rocks on the lid of no. 1.

Kōka ryokuyō "Red flowers green leaves." Carved lacquer in which layers of green lacquer are applied over layers of red. By varying the depth of the carving, the artist incorporates both red and green into the design. See no. 125.

Makie "Sprinkled design." Method of lacquer decoration in which the design is drawn in lacquer and sprinkled with powders before the lacquer hardens. The powders are usually metallic, primarily gold and silver, occasionally tin or lead; but they may also be colored lacquer or charcoal. See no. 1.

Muranashiji Uneven aventurine. *Nashiji* in which the gold flakes are not evenly distributed across the ground, but applied in cloudlike concentrations, as on inside of no. 69.

Nashiji Aventurine. Decoration in which relatively large and irregular flakes of metal are uniformly scattered over wet lacquer. Additional layers of translucent lacquer, often tinted yellow, are applied over the flakes and lightly polished. The polishing is not enough to expose the flakes and the surface texture is often uneven. See the ground outside and inside no. 1, Fig. 4.

Okihirameji Positioned flat flake ground. *Hirameji* in which the flakes are individually set in place rather than sprinkled. See nos. 15, 83.

Roiro Deep black lacquer polished to a high gloss. The lacquer, colored black by the addition of iron filings or lampblack, often turns brown due to exposure or to contact with hot liquids. See the ground on the lid of no. 16.

Sabiurushi Filler lacquer. Lacquer thickened with a powder, usually of soft stone or unglazed pottery. Used for priming surfaces and for raising designs.

Samekawanuri "Lacquered sharkskin." The depressions in bumpy sharkskin are filled in with *sabiurushi;* when this hardens, heavy polishing grinds down the highest bumps on the sharkskin and smooths the surface, which then receives a protective coat of lacquer and a final polish. See no. 44.

Shibuichi Copper-silver alloy, consisting of three parts copper to one part silver. The alloy is usually darkened by pickling. See face and hat of Benkei on the front of no. 140.

Shishiai togidashi makie Combination sprinkled design. *Makie* design that uses both the *takamakie* and *togidashi makie* techniques. Frequently used in landscapes, where such elements as rocks, clouds, or mountains are done in a raised sprinkled design that gently slopes into a flattened sprinkled design. See the clouds on the lid of no. 2.

Sumie togidashi makie Flattened sprinkled design imitating ink painting. *Togidashi makie* in which the sprinkled powders imitate the effects of ink painting. Powdered camellia-wood charcoal is used for deep black, lighter black is made from powdered black lacquer, and white is suggested by silver, gold, or tin powders. Shades of gray are produced by mixing the powders. Also called *togikiri makie*. See nos. 31, 86.

Takamakie "Raised sprinkled design." *Makie* in which the design is raised above the surface of the ground by one or more foundation layers that include a thickening agent, usually clay or charcoal powder. The powders are then sprinkled over the wet top layer of this raised design, given a protective coat of lacquer to keep them in place, and polished. See pheasant on lid of no. 15.

Togidashi makie Flattened sprinkled design. *Makie* in which the lacquer is thickly applied over the sprinkled design, then repeatedly polished over the entire surface until the design becomes flush with the background. See Fig. 14, no. 107.

Tsuikoku Carved black lacquer. Method of decoration in which the design is carved into black lacquer that has been built up out of many thin layers. See no. 131.

Tsuishu Carved red lacquer. The design is carved into red lacquer built up out of many thin layers. See no. 130, Fig. 137.

137

Bibliography

KEY TO SHORTENED REFERENCES

Andō, 1961

Andō Kōsei. *Nihon no Miira* [Japanese Mummies]. Tokyo: Mainichi Shimbunsha, 1961.

Aomori, 1958

Tsugaruhan Kyūki Denrui [Old Records of the Tsugaru Clan]. Aomori: Aomoriken Bunkazai Hogokyōkai, 1958.

Arakawa, 1978

Arakawa Hirokazu. *Makie* [Sprinkled-Design Lacquer]. Nihon no Shitsugei, vol. 4. Tokyo: Chūōkōronsha, 1978.

Asaoka, 1850

Asaoka Okisada, ed. *Zōtei Koga Bikō* [References Concerning Old Paintings]. 1850. 4 vols. Revised and expanded. Tokyo: Yoshikawa Kōbunkan, 1912.

Boger, 1964

Boger, H. Batterson. *The Traditional Arts of Japan: A Complete Illustrated Guide.* Garden City: Doubleday and Co., 1964.

Chuang, 1968

Chuang Tzu. *The Complete Works of Chuang Tzu.* Translated by Burton Watson. New York: Columbia University Press, 1968.

De Bary, 1972

De Bary, William Theodore, ed. *The Buddhist Tradition in India, China and Japan.* New York: Random House, 1972.

Fujita, 1687

Fujita Rihei. *Edo Kanoko* [Miscellaneous Places in Edo]. 1687. Asakura Haruhiko, ed. Kohanchishi Sōsho, vol. 8. Tokyo: Sumiya Shobō, 1970.

Fujita, 1690

Fujita Rihei. *Edo Sōganoko Meisho Taizen* [Encyclopedia of Famous Sites and All Miscellaneous Places of Edo]. 1690. Edo Sōsho, vols. 3, 4. Tokyo: Edo Sōsho Kankōkai, 1916.

Fukuoka, 1978

Kuroda Sampan Bungenchō [Record of Retainer Allowances for the Three Kuroda Fiefs]. Fukuoka: Fukuoka Chihōshi Danwakai, 1978.

Gempūan, 1930

Gempūan Shūjin. "Meikō Tamakaji Zōkoku" [The Famous Artisan Tamakaji Zōkoku]. *Shoga Kottō Zasshi* 261 (1930), pp. 22–23.

"Ginza Shodōgu Rakusatsu," 1714

"Ginza Shodōgu Rakusatsu" [Auction of Various Utensils from the Silver Guild]. 1714. *Kokuhō* 5 (1942): no. 1, pp. 19–22; no. 2, pp. 41–44; no. 3, pp. 65–66; no. 4, pp. 83–88; no. 5, pp. 130–132.

Hashimoto, 1965

Hashimoto Hiroshi, ed. *Daibukan* [Lists of Feudal Families]. 3 vols. Revised and expanded. Tokyo: Meicho Kankōkai, 1965.

Hōrin, 1636–68

Hōrin Oshō. *Kakumeiki* [A Record of the Gap Between Auspicious Omens]. 1636–68. Akamatsu Toshihide, ed. 6 vols. Kyoto: Jin'enji, 1964.

Huth, 1971

Huth, Hans. *Lacquer of the West: The History of a Craft and an Industry, 1550–1950.* Chicago: University of Chicago Press, 1971.

Inaba, 1781

Inaba Michitatsu. *Sōken Kishō* [Appreciation of Superior Sword Furnishings]. 7 vols. Osaka, 1781.

Inoue, 1705

Inoue Chazenshi. *Hiinagata Itoshigusa* [An Instructional Pattern Book]. 2 vols. Kyoto, 1705.

Ise (1717–84), n.d.

Ise Sadafumi. *Ansai Zuihitsu* [Essays of Ansai]. N.d. Imaizumi Teisuke, ed. Zōtei Kojitsu Sōsho, vols. 18, 20. Tokyo: Yoshikawa Kōbunkan, 1928–31.

Itō, 1979

Itō Seizō. *Nihon no Urushi* [Japanese Lacquer]. Tokyo: Tōkyō Bunko Shuppanbu, 1979.

Jahss, 1971

Jahss, Melvin; and Betty Jahss. *Inro and Other Miniature Forms of Japanese Lacquer Art.* Rutland, Vt.: Charles E. Tuttle, 1971.

Kanenishiki, 1773

Kanenishiki Saeryū. *Tōsei Fūzoku Tsū* [Guide to Present-Day Fashion]. Edo, 1773.

Kanroji, ca. 1500

Kanroji Chikanaga. *Shichijūichiban Utaawase* [Poetry Competition in Seventy-One Rounds]. Ca. 1500. Gunjo Ruijū, vol. 28, pp. 464–606. Tokyo: Zoku Gunjo Ruijū Kanseikai, 1933.

Keijun, 1814

Keijun. *Yūreki Zakki* [Miscellaneous Records of Wanderings]. Preface dated 1814. Edo Sōsho, vols. 3–7. Tokyo: Edo Sōsho Kankōkai, 1916.

Kitamura, 1830

Kitamura Nobuyo. *Kiyūshōran* [A Bemused Look at Pleasurable Amusements]. Preface dated 1830. Hamano Tomosaburō et al., eds. Nihon Geirin Sōsho, vols. 6, 7. Tokyo: Rokugōkan, 1927.

Kōami, 1683

Kōami Iyo. "Kōami Kadensho, Meibutsu Suzuribako" [Koami Family Documents (1683), Famous Writing Boxes (1686)]. *Bijutsu Kenkyū* 98 (1940), pp. 495–509.

Kōami, 1718

Kōami Iyo. "Mume ga E Suzuribako Nikki, Tada Isshin" [Diary of the Making of a Writing Box with a Plum-Branch Design (1718), Singleminded Concentration (1720)]. *Bijutsu Kenkyū* 99 (1940), pp. 101–106.

Kobayashi, 1978

Kobayashi Tadashi and Sakakibara Satoru. *Morikage, Itchō.* Nihon Bijutsu Kaiga Zenshū, vol. 16. Tokyo: Shūeisha, 1978.

Kokushō, 1937

Kokushō Iwao and Horie Yasuzō, eds. *Ogyū Sorai, Miura Baien Shū* [Collection of Ogyū Sorai and Miura Baien]. Tokyo: Seibundō Shinkōsha, 1937.

Kurokawa, 1878

Kurokawa Mayori. *Zōtei Kōgei Shiryō* [Materials on Crafts]. 1878. Annotated by Maeda Yasuji. Revised and expanded. Tōyō Bunko, no. 254. Tokyo: Heibonsha, 1974.

London, 1894

Burlington Fine Arts Club. *Catalogue of Specimens of Japanese Lacquer and Metal Work Exhibited in 1894.* London, 1894.

London, 1916

Joly, Henri Louis; and Kumasaku Tomita. *Japanese Art and Handicraft: An Illustrated Record of the Loan Exhibition Held in Aid of the British Red Cross in October–November 1915.* London: Yamanaka and Company, 1916.

Los Angeles, New York, 1976–77

Stern, Harold P. *Birds, Beasts, Blossoms, and Bugs.* New York: Harry N. Abrams, 1976.

Matsuda, 1964

Matsuda Gonroku. *Urushi no Hanashi* [Conversations about Lacquer]. Tokyo: Iwanami Shoten, 1964.

Matsushita, 1903

Matsushita Daizaburō and Watanabe Fumio, eds. *Kokka Taikan* [Compendium of Japanese Poetry]. Tokyo: Kyōbunsha, 1903.

Matsushita, 1925–26

Matsushita Daizaburō, ed. *Zoku Kokka Taikan* [Compendium of Japanese Poetry, Continued]. Tokyo: Kigensha, 1925–26.

Matsuura, 1821–41

Matsuura Seizan. *Kasshi Yawa* [Writings Begun on the Night of the First Day of the Rat, 11th Month]. 1821–41. Nakamura Yukihiko and Nakano Mitsutoshi, eds. 6 vols. Tōyō Bunko, nos. 306, 314, 321, 333, 338, 342. Tokyo: Heibonsha, 1978.

Miyake, 1732

Miyake Yarai. *Bankin Sugiwaibukuro* [Collection of Lucrative Occupations]. 1732. Tsūzoku Keizai Bunko, vol. 20. Tokyo: Tsūzoku Keizai Bunko Kankōkai, 1917.

Moslé, 1933

The Moslé Collection: Descriptive Catalogue Vol. 2. Leipzig: Poeschel and Trepte, 1933.

Mukōyama, 1838–56

Mukōyama Gendayū. *Edo Jitsujō Seisai Zakki* [Miscellaneous Records of Events in Edo]. 1838–56. Edo Sōsho, vols. 8–11. Tokyo: Edo Sōsho Kankōkai, 1916–17.

Murasaki, 1976

Murasaki Shikibu [Lady Murasaki]. *The Tale of Genji.* Translated by Edward G. Seidensticker. 2 vols. New York: Alfred J. Knopf, 1976.

Murase, 1977

Murase, Miyeko. *The Arts of Japan*. New York: McGraw-Hill, 1977.

Nagasada, 1700–23

Nagasada Nyūdō. *Shodō no Shiki* [The Pattern of All the Arts]. Copy of manuscript, 1700–23. Tokyo: Tōkyō Kokuritsu Bunkazai Kenkyūjo, 1934.

Nagata, 1705

Nagata Chōbei. *Hiinagata Kyō no Mizu* [A Kyoto Pattern Book]. Kyoto, 1705.

Narushima, 1849

Narushima Motonao, ed. *Tokugawa Jikki* [Tokugawa Records]. 1849. Kokushi Taikei, vols. 38–47. Tokyo: Kokushi Taikei Kankōkai, 1929–35.

New York, 1972

Japan House Gallery. *The Magnificent Three: Lacquer, Netsuke and Tsuba: Selections from the Collection of Charles A. Greenfield*. Exhibition catalogue by Harold P. Stern. New York: Japan Society, 1972.

Nihon Gakushiin, 1957

Nihon Gakushiin [The Japan Academy] and Nihon Ryōgakushi Kankōkai [Association for the Publication of Japanese Science History], eds. *Meijizen Nihon Yakubutsu Gakushi* [History of Pre-Meiji Pharmacology]. Tokyo: Nihon Gakujutsu Shinkyōkai, 1957.

Okada, 1978

Okada Jō. *Tōyō Shitsugeishi no Kenkyū* [Study of the History of Far Eastern Lacquer]. Tokyo: Chūōkōron Bijutsu Shuppan, 1978.

Rienaecker, 1938–39

Rienaecker, Victor. "Japanese Lacquer." *Transactions and Proceedings of the Japan Society, London* 36 (1938–39), pp. 53–76.

Ringyōya, 1768

Ringyōya Magobei. *Yoshiwara Taizen* [Encyclopedia of Yoshiwara]. 1768. Hayakawa Junzaburō, ed. Kinsei Bungei Sōsho, vol. 10. Tokyo: Kokusho Kankōkai, 1911.

Rokkaku, 1932

Rokkaku Shisui. *Tōyō Shikkōshi* [History of Lacquer in the Far East]. Tokyo: Yūsankaku, 1932.

Saitō, 1849–50

Saitō Gesshin. *Bukō Nempyō* [Chronological Table of Edo]. 1849–50. 2 vols. Annotated by Kaneko Mitsuharu. Tōyō Bunko, nos. 116, 118. Tokyo: Heibonsha, 1968.

Saitō, 1970

Saitō Tadashi and Yoshikawa Itsuji. *Genshi Bijutsu* [Beginnings of Japanese Art]. Genshoku Nihon no Bijutsu, vol. 1. Tokyo: Shogakkan, 1970.

Sanada, ca. 1596–1623

Sanada Zōyo. *Meiryō Kōhan* [Examples of Wise Rulers and Faithful Retainers]. Ca. 1596–1623. Tokyo: Kokusho Kankōkai, 1912.

Sawaguchi, 1966

Sawaguchi Goichi. *Nihon Shikkō no Kenkyū* [Study of Japanese Lacquer]. Tokyo: Bijutsu Shuppansha, 1966.

Shūsanjin, 1844

Shūsanjin. *Ryūka Tsūshi* [Records of Geisha and the Pleasure Quarters]. 1844. Kinsei Bungei Sōsho, vol. 10. Tokyo: Kokusho Kankōkai, 1911.

Sōami, 1523

Sōami. *Onkazari no Ki* [Record of Displays]. 1523. Gunjo Ruijū, vol. 19, pp. 671–686. Tokyo: Zoku, Gunjo Ruijū Kanseikai, 1933.

Soken'ō, 1774

Soken'ō. *Fuki no Chiki* [Basis of Wealth and Honor]. 1774. Tsūzoku Keizai Bunko, vol. 6. Tokyo: Tsūzoku Keizai Bunko Kankōkai, 1917.

Ssu-ma, 1084

Ssu-ma Kuang. *Tzu-chih T'ung-chien* [General Mirror for the Aid of Government]. 1084. Nagasawa Kikuya, ed. Wakokubon Shiji Tsūgan. 4 vols. Tokyo: Kyūko Shoin, 1973.

Takagi, 1912

Takagi Josui. *Kokin Shikkō Tsūran* [A Guide to Ancient and Modern Lacquerers]. Kyoto: Matsuda Einosuke, 1912.

Takebe, 1957

Takebe Toshio, ed. *Ri Haku* [Li Po]. Chūgoku Shijin Zenshū, vols. 7, 8. Tokyo: Iwanami Shoten, 1957.

Takuan, 1629–40

Takuan Sōhō. *Takuan Oshō Zenshū* [Collected Works of Abbot Takuan]. 1629–40. Tokyo: Takuan Oshō Zenshū Kankōkai and Kōgeisha, 1928.

Tanaka, 1779

Tanaka Yūsuishi. *Seken Zenishinron* [Discussion of Money and God in Society]. Tsūzoku Keizai Bunko, vol. 6. Tokyo: Tsūzoku Keizai Bunko Kankōkai, 1917.

Tanaka, 1964

Tanaka Katsumi, ed. *Haku Rakuten* [Po Chü-yi]. Kanshi Taikei, vol. 12. Tokyo: Shūeisha, 1964.

Tani, ca. 1794–1829

Tani Bunchō. *Gagakusai Kagan Zukō* [Sketches of What Gagakusai Saw]. Ca. 1794–1829. Nakamura Yukihiko, ed. Daitōkyū Kinen Bunko Zenbon Sōkan, vol. 14. Tokyo: Daitōkyū Kinen Bunko, 1978.

Time, October 30, 1972

Time Magazine, October 30, 1972, pp. 76–80.

Tokyo, 1975

Meiji Bijutsu Kiso Shiryōshū [Basic Research Materials for Meiji Art]: *Naikoku Kangyō Hakurankai. Naikoku Kaiga Kyōshinkai*, nos. 1, 2. Tokyo: Tōkyō Kokuritsu Bunkazai Kenkyūjo, 1975.

Tokyo, 1978

Tokyo National Museum. *Tokubetsuten Zuroku Tōyō no Shikkōgei* [Oriental Lacquer Arts]. Exhibition catalogue. Tokyo: Tōkyō Kokuritsu Hakubutsukan, 1978.

Tomkinson, 1898

Tomkinson, Michael. *A Japanese Collection*. 2 vols. London: George Allen, 1898.

Ts'ao, 1960

Ts'ao Yin, ed. *Ch'üan T'ang Shih* [Complete T'ang Poems]. 12 vols. Peking: Chung-hua Shu-chü, 1960.

Uchida, 1964

Uchida Sennosuke et al., ed. *Monzen: Shihen* [Literary Selections: Poetry]. 2 vols. Shinyaku Kambun Taikei, vols. 14, 15. Tokyo: Meiji Shoin, 1964.

Wakamori, 1971

Wakamori Tarō. *Hana to Nihon Bunka* [Flowers and Japanese Culture]. Tokyo: Oharáryū Bunka Jigyōbu, 1971.

Washington, D.C., 1979

The Freer Gallery of Art. *Japanese Lacquer*. Exhibition catalogue by Ann Yonemura. Washington, D.C., 1979.

Weber, 1923

Weber, Victor Frédéric. *"Koji Hōten"* [Manual of Ancient Matters]: *Dictionnaire à l'usage des amateurs et collectionneurs d'objects d'art japonais et chinois....* 2 vols. Paris, 1923.

Weintraub, 1979

Weintraub, Steven; et al. "Urushi and Conservation: The Use of Japanese Lacquer in the Restoration of Japanese Art." *Ars Orientalis* 11 (1979), pp. 39–62.

Winkworth, 1947

Winkworth, W. W. "Japanese Lacquer: The Inrō." *The Antique Collector* 18 (1947), no. 2, pp. 46–50.

Yamane, 1962

Yamane Yūzō. *Konishike Kyūzō Kōrin Kankei Shiryō to Sono Kenkyū (The Life and Work of Kōrin, Vol. 1: The Konishi Collection)*. Tokyo: Chūōkōron Bijutsu Shuppan, 1962.

Yamane, 1965

Yamane Yūzō. "Kōrin Nempū ni Tsuite" [On the Chronology of Kōrin's Life]. Tanaka Ichimatsu, ed. *Kōrin*, pp. 18–25. Revised edition. Tokyo: Nihon Keizai Shimbunsha, 1965.

Yasui, 1972

Yasui Kosha, ed. *Shōmon Meika Kushū* [Collection of Poems by Bashō's Distinguished Pupils]. Koten Haibungaku Taikei, vols. 8, 9. Tokyo: Shūeisha, 1972.

Yorozu Kaimono Chōhōki, 1692

Yorozu Kaimono Chōhōki [Complete Shopping Guide]. 1692. Hanasaki Kazuo, ed. *Shokoku Kaimono Chōhōki*. Tokyo: Watanabe Shoten, 1972.

Yoshida, 1971

Yoshida Mitsukuni. *Kyō no Teshigoto* [Handicrafts of Kyoto]. Kyoto: Shinshindō, 197

OTHER SOURCES

Aimi Kōyū. "Kankō Geijitsu to Haritsu" [Haritsu and The Art of Inlay]. *Nihon Bijutsu Kyōkai Hōkoku* 33 (July 1934), pp. 8–21; 34 (October 1934), pp. 10–19.

Boyers, Martha. *The Walters Art Gallery Catalogue of Japanese Lacquers*. Baltimore: The Walters Art Gallery, 1970.

Bunkachō [Japanese Government Cultural Affairs Agency], ed. *Makie* [Sprinkled-Design Lacquer]. Mugeibunkazai Kiroku Kōgei Gijutsuhen, vol. 4. Tokyo: Daiichi Hōki Shuppan, 1973.

Bushell, Raymond. *The Inrō Handbook*. New York: Weatherhill, 1979.

Casal, U. A. "The Inro." *Transactions and Proceedings of the Japan Society, London* 37 (1939–41), pp. 1–53.

Davey, Neil K. *Netsuke: A Comprehensive Study Based on the M. T. Hindson Collection*. New York: Sotheby Parke Bernet, 1974.

Endō Motoo. *Nihon no Shokunin* [Japanese Craftsmen]. Tokyo: Jimbutsu Ōraisha, 1965.

_____. *Shokunin no Rekishi* [The History of Craftsmen]. Tokyo: Shibundō, 1956.

Fūzoku Emaki Zuga Kankōkai [Association for Publication of Genre Handscroll Illustrations], ed. *Makieshiden Nushiden* [Biographies of Lacquerers and Sprinkled-Design Artists]. Tokyo: Yoshikawa Kōbunkan, 1922.

Gilbertson, Edward. *Selections from the Descriptive Catalogue of Inros in the Gilbertson Collection*. London: Twiss and Son, 1888.

Haruko Mototaka. "Kinsei Makieshi Ryakuden" [Brief Biographies of Edo Period Sprinkled-Design Artists]. *Shoga Kottō Zasshi* 206–218 (1926–27).

Herberts, K. *Oriental Lacquer: Art and Technique*. London: Thames & Hudson, 1962.

Ise Sadatake. *Teijō Zakki* [Miscellaneous Record of Sadatake]. Ca. 1763. Imaizumi Teisuke, ed. Zōtei Kojitsu Sōsho, vol. 20. Tokyo: Yoshikawa Kōbunkan, 1928–31.

Itō Shuntarō et al., eds. *Nihonjin no Gijutsu* [Technical Skills of the Japanese]. Kōza Hikaku Bunka, vol. 5. Tokyo: Kenkyūsha, 1977.

Kaneko Seiji. *Nihon Kōgei Enkakushi* [History of the Development of Japanese Crafts]. Tokyo: Kyōritsusha, 1936.

Kitagawa Morisada. *Ruijū Kinsei Fūzokushi* [Classified History of Edo Period Customs]. Revised by Muromatsu Iwao et al. 2 vols. Tokyo: Kokugakuin Daigaku Shuppanbu, 1908.

Kitakōji Isamitsu. *Kōdō e no Shōtai* [Invitation to the Incense Ceremony]. Tokyo: Hōbunkan Shuppan, 1969.

Kodama Kōta et al., eds. *Kinseishi Handobukku* [Handbook of Edo Period History]. Tokyo: Kondō Shuppansha, 1972.

Kurokawa Michisuke. *Yōshū Fushi* [Records of Kyoto]. 1682. Yuasa Kichirō, ed. Kyōto Sōsho, vol. 14. Kyoto: Kyōto Sōsho Kankōkai, 1916.

Maeda Kasetsu. "Makieshi Yamamoto Shunshō Den" [The Tradition of the Lacquer Artist Yamamoto Shunshō]. *Shoga Kottō Zasshi* 98 (1916), pp. 6–8.

Masaki Tokuzō. *Hon'ami Gyōjōki to Kōetsu* [Kōetsu and the Hon'ami Family Record]. Tokyo: Chūōkōron Bijutsu Shuppan, 1965.

Matsushima Tanemi. *Zenshokubutsu Zukan* [Complete Illustrated Book of Plants]. Osaka: Kōjinsha, 1933.

Nakazato Toshikatsu et al. "Heian Jidai Shitsugei" [Heian Period Lacquerwork]. *Hozon Ryōgaku* 3 (1967), pp. 55–69.

Orange, James. *A Small Collection of Japanese Lacquer*. Yokohama: Kelly and Walsh, 1910.

Ragué, Beatrix von. *A History of Japanese Lacquerwork*. Translated by Annie R. de Wasserman. Toronto: University of Toronto Press, 1976.

_____. "Materielen zu Iizuka Tōyō, seinem Werk und seiner Schule." *Oriens Extremus* 11 (1964), no. 2, pp. 163–235.

Sanjōnishi Kinosa. *Kōdō* [The Incense Ceremony]. Kyoto: Tankōsha, 1971.

Sasama Yoshihiko. *Edo Bakufu Yakushoku Shūsei* [Compilation of Official Posts in the Edo Shogunate]. Revised. Tokyo: Yūzankaku, 1973.

Sase Hisashi and Yabe Michinori. *Edo no Shoshoku Fūzokushi* [Record of Various Crafts and Customs of Edo]. Tokyo: Tenbōsha, 1975.

Stalker, John; and George Parker. *A Treatise of Japanning and Varnishing*. 1688. Reprint. Chicago: Quadrangle Books, 1960.

Takahashi Ken'ichi. *Daimyōke no Kamon* [Daimyō Family Crests]. Tokyo: Akita Shoten, 1974.

Terajima Ryōan. *Wakan Sansai Zue* [Illustrated Encyclopedia of China and Japan]. Preface dated 1712. 2 vols. Tokyo: Nihon Zuihitsu Taisei Kankōkai, 1929.

Tsuishu Yōsei. "Tsuishubori" [Carved Lacquer]. *Kenchiku Kōgei Sōshi* 1 (1912), no. 2, p. 24.

Tsumura Sōan. *Tankai* [A Sea of Talk]. 1795. Vol. 5. Tokyo: Kokusho Kankōkai, 1917.

Urushi Kōgei Jiten [Dictionary of Lacquerwork]. Tokyo: Kōgei Shuppan, 1978.

Index

Colorplates by Otto E. Nelson
Black and white photographs: Otto E. Nelson,
Figs. 1, 2, 4−9, 14, 15, 17, 18, 20−27, 30, 32−
36, 40, 42−47, 49−62, 66−68, 70−74, 76−78,
80−91, 93−130, 132−167; Richard A. Taylor,
Figs. 3, 11, 28, 29, 31, 32, 37−39, 48, 92, 131

Assistant to designer: Colette Bellier
Composition by Typographic Images,
New York, New York
Printing by Colorcraft Lithographers, New York,
New York
Bound by A. Horowitz and Sons, Clifton,
New Jersey